ART IS THE HIGHEST FORM OF HOPE

FORM OF HOPE

& OTHER QUOTES BY ARTISTS

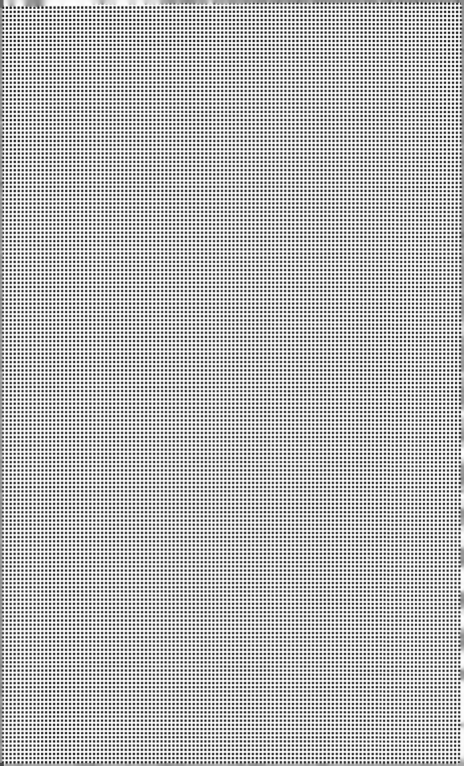

“

”

Preface 7 Drawing 138 Philosophy 232
Advice 8 Drugs + Alcohol 142 Photography 236
Art 22 Exhibition 148 Routine 244
Art Market 34 Failure 156 Scale 250
Art School 40 Frame 160 Sculpture 256
Artist 46 Identity 166 Sex 262
Audience 56 Influence 172 Studio 266
Beauty 64 Inspiration 180 Subject 274
Chance 72 Intention 188 Success 282
Childhood 78 Light 196 Technology 288
Collaboration 88 Limitation 202 Title 292
Color 94 Materials 204 Tools 298
Creative Process 110 Money 212 Weather 302
Day Job 126 Nature 222 Artist Index 309
Discipline 130 Originality 226 Sources 319

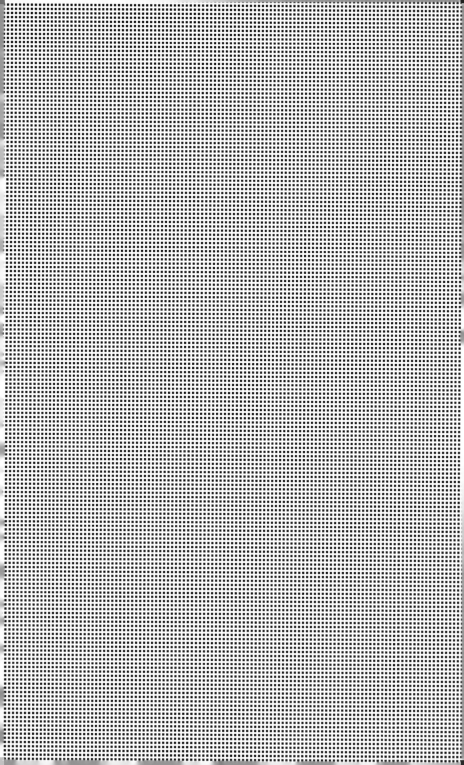

PREFACE

An air of mystery surrounds the inner lives of painters, sculptors, photographers, and other visual artists. Many are private, protecting their solitude and time to focus on their practice. While we are familiar with the works they create, the individuals behind the art are often more elusive.

Art Is the Highest Form of Hope collects hundreds of moments when artists have stepped away from their tools and materials, studios and foundries to share their intuitive perceptions, hard-earned advice, and unvarnished opinions. They weigh in on subjects as diverse as color, discipline, day jobs, inspiration, light, sex, failure, collaboration, and more.

The profound sits beside the practical as the artists' inner worlds emerge. They tell us what ignites their imagination and why art is essential. But they also reveal the persistent, longstanding challenge of balancing the inspired with the mundane. It is easy to relate to Henri de Toulouse-Lautrec when he is despondent after two rainy days prevent him from painting outside. Time collapses with the shared experience of dealing with moody weather and "unsettled" skies. It is humbling to learn that Edgar Degas, Claude Monet, and Judy Chicago (to name just a few) struggled to make ends meet—that artists have always forged ahead tirelessly regardless of public and financial recognition. In the encouraging words of Vincent van Gogh, "One must go on working silently, trusting the result to the future."

What is striking is how many artists' revelations, admissions, and philosophies are universal, transcending centuries and the creative process. When Salvador Dalí reframes failure by writing that "mistakes are almost always of a sacred nature," his message resonates beyond the world of art. And we can all learn from the rules of life Laurie Anderson shares: 1. Don't be afraid of anyone. 2. Get a really good BS detector and learn how to use it. 3. Be really tender.

These excerpts were discovered in a variety of sources—diaries, letter collections, notebooks, interviews, monographs, etc. If "quotable quotes are coins rubbed smooth by circulation," as Louis Menand writes in The New Yorker, this collection offers insights that haven't been recycled and worn smooth over time. Source notes can be found in the back of the book for those inspired to read the words in context.

"Art is the highest form of hope" is a quotation by Gerhard Richter, and its own small packet of wisdom. Art has spanned time and cultures, lifted us up, and brought us together. Or, in the eloquent words of Dorothea Tanning, "Art has always been the raft on to which we climb to save our sanity." This book is also a raft—whether you read the collection from beginning to end or dip into any one section, you'll be enlightened, amused, inspired, and transported.

YOU ARE AS GOOD AS YOU EVER WILL BE AT THE MOMENT.

CONSTANTIN BRÂNCUȘI

DRAW LINES, YOUNG MAN, MANY LINES, FROM MEMORY OR FROM NATURE; IT IS IN THIS WAY THAT YOU WILL BECOME A GOOD ARTIST.

JEAN AUGUSTE DOMINIQUE INGRES

DON'T PRETEND THAT YOU'RE NOT PROUD OF YOUR WORK.

APRIL GORNIK

LET FRUSTRATION FUEL INSPIRATION.

SONIA BOYCE

THE MINUTE SOMETHING WORKS, IT CEASES TO BE INTERESTING. AS SOON AS YOU HAVE SPELLED SOMETHING OUT, YOU SHOULD SET IT ASIDE.

ROSEMARIE TROCKEL

IF A PAINTING DOESN'T WORK, THROW IT OUT.

FRANZ KLINE

Make sure to allow people to take care of you.

MICKALENE THOMAS

KEEP YOUR EYE ON YOUR INNER WORLD AND KEEP AWAY FROM ADS AND IDIOTS AND MOVIE STARS, EXCEPT WHEN YOU NEED AMUSEMENT.

DOROTHEA TANNING

THE ADVICE THAT I GIVE PEOPLE WANTING TO KNOW HOW TO "MAKE IT" AS AN ARTIST, BASED ON MY OWN LIMITED EXPERIENCE WITH THAT, IS TO CREATE SELF-INITIATED PUBLIC PROJECTS THAT AREN'T INTENDED FOR A COMMERCIAL GALLERY CONTEXT.

HARRELL FLETCHER

Sit down with a pencil and paper and think about what your life is about. What you are about. Don't even take a camera into your hands before you figure that out.

TINA BARNEY

TAKE A CANVAS. PUT A MARK ON IT PUT ANOTHER MARK ON IT.

JASPER JOHNS

DON'T GET RID OF NEGATIVE EMOTION, BUT JUST USE IT...LIKE THE SALT IN YOUR FOOD.

YOKO ONO

SOMETIMES IN A HOSTILE SITUATION YOU STICK AROUND, BECAUSE HOSTILITY ITSELF IS IMPORTANT

DOROTHEA LANGE

TRY TO PUT WELL
IN PRACTICE WHAT
YOU ALREADY KNOW;
AND IN SO DOING, YOU
WILL, IN GOOD TIME,
DISCOVER THE HIDDEN
THINGS WHICH YOU
NOW INQUIRE ABOUT.

REMBRANDT

I FEEL
LIKE I CAN
GIVE A LOT
TO YOUNGER
PAINTERS
BY JUST
TELLING THEM
TO RELAX.

ELIZABETH PEYTON

CULTIVATE A
WELL-ORDERED MIND,
IT'S YOUR ONLY ROAD
TO HAPPINESS; AND TO
REACH IT, BE ORDERLY IN
EVERYTHING, EVEN IN
THE SMALLEST DETAILS.

EUGÈNE DELACROIX

FIND YOUR EYES.

ALEC SOTH

FOR THE NEXT
WEEK TRY THE BEST YOU
CAN TO PAY ATTENTION
TO SOUNDS. YOU WILL
START HEARING ALL THESE
SOUNDS COMING IN.

ROBERT IRWIN

STARE. IT IS THE
WAY TO EDUCATE YOUR EYE,
AND MORE. STARE, PRY,
LISTEN, EAVESDROP.
DIE KNOWING SOMETHING.
YOU ARE NOT HERE LONG.

WALKER EVANS

ALL EXPERIENCE IS GREAT PROVIDING YOU LIVE THROUGH IT.

ALICE NEEL

THE BEST THING A YOUNG PHOTOGRAPHER CAN DO IS TO STAY CLOSE TO HOME. START WITH YOUR FRIENDS AND FAMILY, THE PEOPLE WHO WILL PUT UP WITH YOU.

ANNIE LEIBOVITZ

DON'T HIDE THE SCREW,
SHOW IT. ALWAYS SHOW
THE GLUE MARK. LET THE
TAPE SHOW THE DIRT
THAT IT PICKED UP WHILE
BEING HANDLED.

TOM SACHS

THE FIRST TIME YOU DO SOMETHING ONLY HAPPENS ONCE.

CHRIS BURDEN

INSTEAD OF LOOKING AT THINGS, LOOK BETWEEN THINGS.

JOHN BALDESSARI

YOUR PATH IS AT
YOUR FEET WHETHER
YOU REALIZE IT
OR NOT. THAT IS THE
MOST IMPORTANT
THING THAT I WILL
SAY BUT I WILL NOT
ENLARGE UPON IT.

AGNES MARTIN

AS FAR AS "DETOURS" ARE CONCERNED, THEY'RE <u>ALWAYS</u> MORE INTERESTING THAN THE MAIN ROAD.

MARY KELLY

I'M JUST GOING TO MENTION THESE THREE RULES THAT LOU [REED] AND I HAD....THE FIRST ONE IS DON'T BE AFRAID OF ANYONE. IMAGINE YOUR LIFE IF YOU'RE NOT AFRAID OF ANYONE. TWO, GET A REALLY GOOD BS DETECTOR AND LEARN HOW TO USE IT. WHO'S FAKING IT AND WHO IS NOT? THREE, BE REALLY TENDER. AND WITH THOSE THREE, YOU'RE SET.

LAURIE ANDERSON

LEARN TO SAY "FUCK YOU" TO THE WORLD ONCE IN A WHILE.

SOL LEWITT

MAKING ART IS HARD.

RICHARD PRINCE

I don't believe in the truth of art. As my mother says, "Let's not destroy a good story with the truth."

RAGNAR KJARTANSSON

ART SHOULDN'T PREACH. I DON'T WANT TO BE DIDACTIC.

MONA HATOUM

ART HAS ALWAYS BEEN THE RAFT ON TO WHICH WE CLIMB TO SAVE OUR SANITY.

DOROTHEA TANNING

We must make our art like the Egyptians, the Chinese and the African and Island primitives—with their relation to life. It should meet the eye—direct.

ELLSWORTH KELLY

Art is a way of recognizing oneself, which is why it will always be modern.

LOUISE BOURGEOIS

I AM FOR AN ART THAT HELPS OLD LADIES ACROSS THE STREET.

CLAES OLDENBURG

I DO NOT BELIEVE IN THE ART WHICH IS NOT THE COMPULSIVE RESULT OF HUMANITY'S URGE TO OPEN ITS HEART.

EDVARD MUNCH

Ultimately, art is trying to see things that other people don't see.

TREVOR PAGLEN

WHEN PEOPLE LOOK AT MY PICTURES I WANT THEM TO FEEL THE WAY THEY DO WHEN THEY WANT TO READ A LINE OF A POEM TWICE.

ROBERT FRANK

ART HAS TO BE SOMETHING THAT MAKES YOU SCRATCH YOUR HEAD.

ED RUSCHA

THE REASON I MAKE ART IS TO TRY AND PRESENT ANOTHER CONFIGURATION TO FUCK UP THE ONE THAT I'M LIVING IN NOW.

LAWRENCE WEINER

I HAVE THIS VERY WHAT YOU CALL TODAY "SQUARE" IDEA THAT ART IS SOMETHING THAT MAKES YOU BREATHE WITH A DIFFERENT KIND OF HAPPINESS.

ANNI ALBERS

ART IS A COMPLETED PASS. YOU DON'T JUST THROW IT OUT INTO THE WORLD— SOMEONE HAS TO CATCH IT.

JAMES TURRELL

WHAT I DREAM OF IS AN ART OF BALANCE,
OF PURITY AND SERENITY DEVOID OF TROUBLE
AND DEPRESSING SUBJECT MATTER. AN ART
WHICH MIGHT BE FOR EVERY MENTAL WORKER,
BE HE BUSINESSMAN OR WRITER, LIKE AN
APPEASING INFLUENCE, LIKE A MENTAL SOOTHER,
SOMETHING LIKE A GOOD ARMCHAIR IN
WHICH TO REST FROM PHYSICAL FATIGUE.

HENRI MATISSE

WHAT IS IT ABOUT
PEOPLE THAT SINCE
THE DAWN OF TIME
WE'VE WANTED TO MARK
OUR PRESENCE SO
THAT OTHER PEOPLE
WILL SEE IT?

CHUCK CLOSE

IT IS ESSENTIAL TO DO THE SAME SUBJECT OVER AGAIN, TEN TIMES, A HUNDRED TIMES. NOTHING IN ART MUST SEEM TO BE CHANCE, NOT EVEN MOVEMENT.

EDGAR DEGAS

EVEN THE ACT OF PEELING A POTATO CAN BE A WORK OF ART IF IT IS A CONSCIOUS ACT.

JOSEPH BEUYS

WHAT I LOOK FOR IN
ART OF ANY PERIOD IS
IMAGINATIVE ENERGY,
RADIANCE, EQUILIBRIUM,
COMPOSURE, COLOR, LIGHT,
VITALITY, POISE, BUOYANCY,
A TRANSCENDENT ABILITY
TO SOAR ABOVE LIFE AND NOT
BE SUBJUGATED BY IT.

MARK ROTHKO

ART ALLOWS
YOU TO IMBUE THE
TRUTH WITH A SORT
OF MAGIC, SO IT CAN
INFILTRATE THE PSYCHE
OF MORE PEOPLE,
INCLUDING THOSE WHO
DON'T BELIEVE THE
SAME THINGS AS YOU.

WANGECHI MUTU

I'M USING ART AS A MEANS OF CHANGING MYSELF, AS A MEANS OF BREAKING OUT OF A CATEGORY.

VITO ACCONCI

ART IS ALWAYS FOR THE FUTURE.

ANTONY GORMLEY

ART HAS SAVED MY LIFE ON A REGULAR BASIS.

CARRIE MAE WEEMS

ART IS SUSTENANCE.

SARAH SZE

THROUGHOUT THE AGES, MAN HAS CONQUERED TRAGEDY WITH HIS ABILITY TO CREATE A WORK OF ART.

WILL BARNET

MUSEUMS HAVE TODAY BECOME THE NEW CHURCHES.

CHRISTIAN BOLTANSKI

ART WON'T LET YOU DOWN.

DAMIEN HIRST

ANY PICTURE IS FAIRLY PRICED, IF ITS SUBSEQUENT VALUE IS GREATER.

ROBERT MOTHERWELL

No more galleries—
ever! I'll sell
them myself—or keep
them. It doesn't
matter which.

JACKSON POLLOCK

ALL THE RAZZMATAZZ:
THE MARKET, THE
AUCTIONS. I'M QUITE
IMMUNE TO IT. I KNOW
T'S PART OF THE PROCESS.
BUT WHEN YOU GET
IN THE STUDIO, NONE OF
THAT WILL HELP YOU TO
MAKE A BETTER PAINTING.

JENNY SAVILLE

Our society is
evolving into this
very specialist world.
Everybody is good at
one very specific thing.
That's particularly
clear in the art market.
People want to be able
to classify you.

FRANCIS ALŸS

I LOOK FOR DEALERS WHO CHALLENGE ME.

KATHARINA GROSSE

You will have noticed
that I have not said a
word about the price....
All artists, and myself
in particular, loathe these
discussions of numbers.

GUSTAVE COURBET

I HAVE JUST RECEIVED $400 IN GOLD FOR ONE OF THE PICTURES, AND HAVE SPENT IT NEARLY ALL FOR CURIOUS THINGS TO PAINT.

MARY CASSATT

I don't follow auctions.
The galleries do that,
I don't want to know how
much my work goes for.

MIKE KELLEY

WHEN I FIRST STARTED OUT, I WAS SO EXCITED TO GET $10 A PICTURE.

ROBERT FRANK

I MADE A BLANKET IN 1996 AND IT SOLD FOR £3,500 IN 1997. RECENTLY IT SOLD FOR £720,000 AT CHRISTIE'S. THERE IS NOTHING IN THE WORLD THAT CAN GIVE YOU A RETURN LIKE THAT.

TRACEY EMIN

NOW THE ART WORLD HAS BECOME THE ART MARKET.

ERIC FISCHL

I PRODUCE AS MANY WORKS AS I CAN. I'M NOT TRYING TO RESTRICT PRODUCTION.

JEFF WALL

IF I MAKE A CAST SCULPTURE, I MAKE <u>ONE</u> AND ALL THE MARKS ARE MINE. I DON'T APPROVE OF COPIES AND I DON'T MAKE AND PRODUCE COPIES FOR THE SAKE OF MAKING MORE MONEY.

DAVID SMITH

I DON'T THINK YOU CAN REALLY PUT A MONETARY VALUE ON A PAINTING.

JACOB LAWRENCE

TO BE A TEACHER IS MY GREATEST WORK OF ART.

JOSEPH BEUYS

To trust your intuition is exactly the opposite of any sort of formal education.

CHRIS BURDEN

IT SHOULD NOT BE UNDERESTIMATED WHAT A RICH RESOURCE AN ART SCHOOL EDUCATION CAN BE.

PHYLLIDA BARLOW

Trying to get students to draw a white cup can take weeks and they ask me, "Do we really need to do this?" And I tell them it would be great if you could make a brilliant end run around all that stuff, but with painting there's no such thing—at least I haven't found it.

WAYNE THIEBAUD

I was an extremely hardworking student.... I studied the classics, but I did not obtain the least honorable mention, and my professors were unanimous in finding my painting execrable.

AUGUSTE RENOIR

When are you going to be able to spend two or three years where there's nothing to do but try to figure out how you can make work that may not work. It can fail, it can be experimental, it can be ugly, and everyone is going to be really willing to look at it and think about it.

AMY SILLMAN

YOU DON'T NEED A CERTIFICATE. JUST DO IT OR NOT DO IT.

LAWRENCE WEINER

I DON'T TEACH BECAUSE THERE REALLY ISN'T ANYTHING I CAN TEACH, EXCEPT WHAT I DO, WHICH IS THE LAST THING THAT WOULD BE HELPFUL TO ANYONE BUT ME.

SOL LEWITT

STUDENTS ARE THE FIRST TO TELL YOU YOU'RE FULL OF SHIT. I LIKE THAT KIND OF FEEDBACK.

JOHN BALDESSARI

ONE THING THAT I REALLY LIKE ABOUT TEACHING IS THAT YOU HAVE TO WORK VERY HARD NOT TO LOSE THE RESPECT OF YOUR STUDENTS.

TANIA BRUGUERA

EVEN THOUGH I HAD PLENTY OF ART SCHOOL, MY REAL EDUCATION BEGAN WHEN I STARTED PAINTING ON MY OWN.

LISA YUSKAVAGE

Martin Creed
actually said
I was the best
teacher who never
taught him.

PHYLLIDA BARLOW

My intention as
a teacher was not to
teach any rules or
"right ways"—there
aren't any. I tried to
locate within their
young work an impulse
toward some kind of
meaning, a direction
toward which it tended,
and then worked
with them to help
them realize it.

ELEANOR ANTIN

IF A NONARTIST
TEACHES
A SUBJECT
CALLED ART,
IT IS NONART.

RUTH ASAWA

ONE TEACHER
SAID, "YOU KNOW,
PETER, YOU DON'T
HAVE TO GO TO
THE STUDIO ONLY
TO PAINT." IT'S
GOOD TO LOOK.
SOMETIMES I SPEND
A LOT OF TIME
THERE JUST
LOOKING AT THINGS.

PETER DOIG

I TELL MY
STUDENTS,
"DON'T BE SO
SURE OF WHAT
YOU'RE DOING."

JIMMIE DURHAM

AFTER HAVING TAUGHT
FOR HALF A CENTURY,
I BELIEVE THAT ART AS
SUCH CANNOT BE TAUGHT,
BUT A LOT CAN BE DONE
TO OPEN EYES AND MINDS
TO MEANINGFUL FORM.

JOSEF ALBERS

PAINTING IS THE BEST WAY I'VE FOUND TO GET ALONG WITH MYSELF.

ROBERT RAUSCHENBERG

I DON'T KNOW WHAT KIND OF AN ARTIST I AM.

JASPER JOHNS

THE ARTIST MUST HAVE THE PATIENCE OF WATER THAT EATS AWAY THE ROCK DROP BY DROP.

AUGUSTE RODIN

I PAINT WITH THE STUBBORNNESS I NEED FOR LIVING, AND I'VE FOUND THAT ALL PAINTERS WHO LOVE THEIR ART DO THE SAME.

SUZANNE VALADON

MY ROLE IS
TO INTEGRATE,
IT'S JUST A JOB,
AND IT'S THE BASIC
TRADITION OF THE
ARTIST—IT GOES
ALL THE WAY BACK
TO THE WORK OF
THE MAGICIAN AND
THE SHAMAN.

PAWEL ALTHAMER

I AM THE PAINTER OF SPACE.

YVES KLEIN

My belief, based on my experience, is that one does not <u>choose</u> to be a painter. Painting is the way we choose to organize information, the way we organize experience, and we re-present it through the language of paint.

ERIC FISCHL

The idea of the suffering artist has never appealed to me. Being here is suffering enough.

WILLIAM EGGLESTON

If an artist does not have an erotic involvement with everything that he sees, he may as well give up.

LUCAS SAMARAS

THE ARTIST IS A CITIZEN, AND IT'S THE ARTIST'S BUSINESS TO KICK OUT THE JAMBS AND TO MARK THE WAY.

MARTHA ROSLER

ARTISTS MAKE
THEMSELVES
VERY VULNERABLE,
AND I FIND THAT
SUPER-HEROIC.

ELIZABETH PEYTON

EARLY ON I HAD BEEN INTRODUCED TO THE IDEA THAT BEING TAKEN SERIOUSLY AS AN ARTIST WAS MORE IMPORTANT THAN ANYTHING ELSE, EVEN ECONOMIC SUCCESS.

JUDY CHICAGO

BEING AN ARTIST IS A VERY, VERY LONG GAME. IT IS NOT A TEN-YEAR GAME.

ANISH KAPOOR

I DON'T BELIEVE IN ART. I BELIEVE IN THE ARTIST.

MARCEL DUCHAMP

PAINTING IS SELF-DISCOVERY. EVERY GOOD ARTIST PAINTS WHAT HE IS.

JACKSON POLLOCK

FOR A LONG PERIOD OF TIME, NO ONE IN MY FAMILY KNEW WHAT EXACTLY I DID FOR A LIVING.

ZHANG XIAOGANG

EVERYBODY I HAVE EVER KNOWN OR READ ABOUT WHO WAS REALLY A GREAT ARTIST HAS WORKED UNTIL THEY DROPPED DEAD.

ARNOLD NEWMAN

MY AMBITION IS ALWAYS TO BE IN AMONGST THE IMPORTANT ARTISTS OF THE HISTORY BOOKS.

KERRY JAMES MARSHALL

IF MY TIME HAS COME I SHALL HAVE NOTHING TO COMPLAIN OF. FOR FIFTY-THREE YEARS I HAVE BEEN PAINTING; SO I HAVE BEEN ABLE TO DEVOTE MYSELF ENTIRELY TO WHAT I LOVED BEST IN THE WORLD.

CAMILLE COROT

I PAINT ONLY FOR MYSELF.

EDWARD HOPPER

I can't paint the way they want me to paint and they know that too. Of course you will say that I ought to be practical and ought to try and paint the way they want me to paint. Well, I will tell you a secret. I have tried and I have tried very hard, but I can't do it. I just can't do it! And that is why I am just a little crazy.

REMBRANDT

MY FAN MAIL IS ENORMOUS—EVERYBODY IS UNDER SIX.

ALEXANDER CALDER

Bring the viewer to your side, include him in your thought. He is not a bystander.

DOROTHEA LANGE

IF YOU DON'T GET LOVE FROM YOUR FAMILY, YOU TURN TO OTHER THINGS TO GET IT. I GET THE LOVE I NEED FROM MY AUDIENCE.

MARINA ABRAMOVIĆ

IT IS NOT MY INTENTION THAT PEOPLE FROM THE ART WORLD WILL SEE MY REMOTE WORKS. THE THING I FIND INTERESTING IS THAT ART CAN BE SOMETHING THAT IS NOT NECESSARILY SEEN, OR THAT IS SEEN ONLY BY PEOPLE OUTSIDE OF THE ART WORLD—MAYBE A SHEPHERD, SOMEONE WHO WON'T RECOGNIZE IT AS ART.

RICHARD LONG

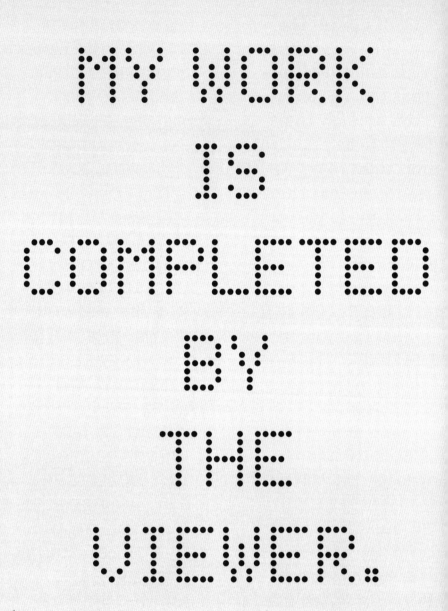

MY WORK IS COMPLETED BY THE VIEWER.

BRIDGET RILEY

IN 1952 I HAD A STUDIO WITH A
BALCONY OVERLOOKING A BUSY STREET.
WHEN I FINISHED THE FIRST PAINTING I HAD
DONE IN FIVE HORIZONTALLY GROUPED PANELS,
I HUNG IT ON THE BALCONY AND WENT OUT
TO HEAR COMMENTS. A FEW PEOPLE WHO NOTICED
THE PAINTING WERE PUZZLED AND SAID SO.
A CHILD, POINTING WITH HIS FINGER SAID,
"BLACK—ROSE—ORANGE—WHITE—BLUE—BLUE—
WHITE—ORANGE—ROSE—BLACK."

ELLSWORTH KELLY

I HAVE A VERY DEFINITE THEORY—LET'S CALL IT THEORY, SO THAT I CAN BE WRONG—THAT A WORK OF ART EXISTS ONLY WHEN THE SPECTATOR HAS LOOKED AT IT.

MARCEL DUCHAMP

I HAVE NO CONSCIOUS PREMISE WHILE WORKING OF WHY I AM WORKING, WHAT IT IS I AM MAKING, OR WHOM IT IS FOR. NOR DO I FEEL ANY KINSHIP WITH THOSE WHO EXHIBIT IT OR BUY IT.

DAVID SMITH

I REALLY TRUST AUDIENCES AS HAVING EXCELLENT TASTE, FOR THE MOST PART.

LAURIE ANDERSON

I DON'T BELIEVE IN PATRONIZING VIEWERS.

GILLIAN WEARING

WHEN I FIRST PAINTED IT
IN 1948, <u>CHRISTINA'S WORLD</u> HUNG
ALL SUMMER IN MY HOUSE IN
MAINE AND NOBODY PARTICULARLY
REACTED TO IT. I THOUGHT,
"BOY, IS THIS ONE EVER A FLAT TIRE."
NOW I GET AT LEAST A LETTER
A WEEK FROM ALL OVER THE WORLD,
USUALLY WANTING TO KNOW
WHAT SHE'S DOING.

ANDREW WYETH

THE PEOPLE
WHO WEEP
BEFORE MY
PICTURES ARE
HAVING THE
SAME RELIGIOUS
EXPERIENCE
I HAD WHEN
I PAINTED THEM.

MARK ROTHKO

I HAVE BEEN PHOTOGRAPHING OUR TOILET, THAT GLOSSY ENAMELED RECEPTACLE OF EXTRAORDINARY BEAUTY.

EDWARD WESTON

The unpleasant
and pleasant should
inexplicably overlap
in a sort of beautiful,
feverish madness,
in the end imploding
under an overwhelming
number of interpretive
possibilities.

PETER FISCHLI

**The Beautiful
implies a combination
of many different
qualities. Strength
alone, without elegance,
etc., is not beauty.
In a single word, the
broadest definition
would be Harmony.**

EUGÈNE DELACROIX

I THINK HAVING LAND
AND NOT RUINING IT IS
THE MOST BEAUTIFUL ART
THAT ANYBODY COULD
EVER WANT TO OWN.

ANDY WARHOL

"BEAUTY" IS A DANGEROUS WORD BECAUSE IT'S BEEN STANDARDIZED INTO SOMETHING KITSCH.

OLAFUR ELIASSON

I think a peasant girl
is more beautiful than a
lady, in her dusty, patched
blue skirt and bodice,
which get the most delicate
hues from weather, wind,
and sun. But if she puts
on a lady's dress, she loses
her peculiar charm.

VINCENT VAN GOGH

EXUBERANCE
IS BEAUTY.

WILLIAM BLAKE

**TO ME THE MOST
BEAUTIFUL THING IS
VULNERABILITY.**

ALEC SOTH

I AM NOT INTERESTED IN MAKING BEAUTIFUL OBJECTS.

THEASTER GATES

IF WE DROP BEAUTY, WHAT HAVE WE GOT?

JOHN CAGE

I'M IN THE BEAUTY BUSINESS. I HAVE NEVER MADE ANYTHING IN MY LIFE THAT WAS NOT AS BEAUTIFUL AS I CAN MAKE IT.

ROBERT IRWIN

I LONGED TO ARREST ALL BEAUTY THAT CAME BEFORE ME, AND AT LENGTH THE LONGING HAS BEEN SATISFIED.

JULIA MARGARET CAMERON

BLESSED ARE THEY WHO SEE BEAUTIFUL THINGS IN HUMBLE PLACES WHERE OTHER PEOPLE SEE NOTHING!

CAMILLE PISSARRO

FOR THE SUBLIME AND THE BEAUTIFUL AND THE INTERESTING, YOU DON'T HAVE TO LOOK FAR AWAY.

HEDDA STERNE

I BELIEVE
THAT HUMOR IS
A PART
OF BEAUTY.

MAX BECKMANN

THE WORK IS GOOD WHEN IT HAS A CERTAIN COMPLETENESS, AND WHEN IT'S GOT A CERTAIN COMPLETENESS, THEN IT'S BEAUTIFUL.

BRUCE NAUMAN

I NEVER SAW
AN UGLY THING
IN MY LIFE:
FOR LET THE FORM
OF AN OBJECT
BE WHAT IT MAY—
LIGHT, SHADE,
AND PERSPECTIVE
WILL ALWAYS MAKE
IT BEAUTIFUL.

JOHN CONSTABLE

I'M OFTEN ASTONISHED TO FIND HOW MUCH BETTER CHANCE IS THAN I AM.

GERHARD RICHTER

I NEVER HAVE TAKEN A PICTURE I'VE INTENDED. THEY'RE ALWAYS BETTER OR WORSE.

DIANE ARBUS

I am enjoying working with my left hand, it is very amusing and it's even better than what I would do with the right. I think it was a good thing to have broken my arm, it made me make some progress....

AUGUSTE RENOIR

I push things to the point where I have no idea what's going to happen.

CHARLINE VON HEYL

THERE'S SOMETHING ABOUT PLANNING THAT JUST TURNS ME OFF COMPLETELY AND I CAN'T FIND THE LUST TO WORK. SO, I LOOK FOR WAYS OF WORKING WHERE THERE IS AN ELEMENT OF SURPRISE.

IDA EKBLAD

I BELIEVE IN A DEEPLY ORDERED CHAOS AND IN THE RULES OF CHANCE.

FRANCIS BACON

MY WORK IS NOT PLANNED.

VANESSA BEECROFT

The idea of knowing exactly where you're going is overrated.

SARAH SZE

I LIKE DOING THINGS IN THE STUDIO WHICH ARE RESTAGINGS OF ACCIDENTS, LIKE PUSHING THINGS OFF TABLES OR KNOCKING THINGS OVER, OR CUTTING THROUGH THINGS SO THAT THEY BREAK.

PHYLLIDA BARLOW

I DON'T KNOW WHERE I'M GOING BUT I'LL GET THERE ON TIME.

ROBERT RAUSCHENBERG

I'LL ARRANGE WAYS FOR THINGS TO BE UNPREDICTABLE.

KIKI SMITH

THERE ARE MANY ACCIDENTS THAT ARE VERY RICH THAT YOU USE, BUT IF YOU EXPLOIT A DRIP IT'S VERY BORING AND FAMILIAR TO BEGIN WITH. DRIPS ARE DRIPS.

HELEN FRANKENTHALER

IF YOU USE,
AS I DO, CHANCE
OPERATIONS,
YOU DON'T HAVE
CONTROL EXCEPT
IN THE WAY OF
DESIGNING THE
QUESTIONS WHICH
YOU ASK. THAT
YOU CAN CONTROL.

JOHN CAGE

EVER SINCE
MY CHILDHOOD,
I WAS HAUNTED
BY THE SEARCH
FOR PERFECTION.
AN IMPERFECTLY
CUT PAPER
LITERALLY MADE
ME ILL, I WOULD
GUILLOTINE IT.

JEAN ARP

I WAS A REALLY LOUSY ARTIST AS A KID.... I'D NEVER WIN PAINTING CONTESTS. I REMEMBER LOSING TO A GUY WHO DID A PERFECT SPIDERMAN.

JEAN-MICHEL BASQUIAT

ONE OF MY FORMATIVE CREATIVE EXPERIENCES WAS WHEN, AT THE AGE OF TEN, I DEVELOPED MY FIRST BLACK AND WHITE PRINT IN A DARKROOM. WITNESSING THE CHEMICALLY INDUCED APPEARANCE OF AN IMAGE WAS EXTRAORDINARY SOMEHOW.

SIMON STARLING

I WOULD PLAY
MUSIC EVERY DAY
FROM THE TIME
I WAS ABOUT 4 OR
5 YEARS OLD.
EVERY TIME I WOULD
GO FROM ONE
END OF THE HOUSE
TO THE OTHER,
I WOULD PASS THE
PIANO AND PLAY
A FEW NOTES.

WILLIAM EGGLESTON

I had a very sensuous, physical, visceral childhood. This influence is certainly reflected in my creative process, in some of the ideas and materials I gravitate to.

JANINE ANTONI

WHEN I WAS GROWING UP THE LONE RANGER AND TONTO WERE AN IMPORTANT PART OF MY DAY.

RICHARD PRINCE

I want to be a child forever. Some people have always wanted to be fathers, others have wanted to be mistresses, others want to be saints. I prefer the cover of childhood.

LUCAS SAMARAS

I remembered when I was a boy, placing fern leaves in a printing frame with proof paper, exposing it to sunlight, and obtaining a white negative of the leaves.

MAN RAY

When I was I think 11 or 12 years old, you could on a certain evening find me speaking on a soap box at 137th Street and Broadway. I was just imitating other people— you know, socialists.

AARON SISKIND

I think I was always fascinated by sailboats as a kid, because my dad said, you know, that it's possible to sail upwind.

CHRIS BURDEN

WHEN I WAS TWELVE, I HAD MY FIRST ART SHOW. I REMEMBER BEING JEALOUS OF MOZART WHEN I LEARNED THAT HE HAD HIS FIRST CONCERT AT SEVEN.

MARINA ABRAMOVIĆ

I NEVER WANTED TO BE ANYTHING BUT AN ARTIST. I WAS DETERMINED TO BE AN ARTIST, AND I WAS OLD ENOUGH AT FIVE TO SPEAK UP FOR MY RIGHTS. EVERYBODY JUST HAD TO ACCEPT MY CHOICE. AS A MATTER OF FACT, NO ONE IN MY FAMILY PAINTED OR TALKED ABOUT PICTURES. BUT I HAD A SYMPATHETIC MOTHER WHO ENCOURAGED ME.

WILL BARNET

I WAS NEVER BROUGHT UP WITH THE IDEA THAT I COULD BE AN ARTIST, THAT I SHOULD BE AN ARTIST, OR THAT IT'S A GOOD JOB.

WOLFGANG TILLMANS

I FEEL
I HAVEN'T
LEARNED
ANYTHING
SINCE
THE AGE
OF FIVE.

CARL ANDRE

From the time that I was a child, after school I would go door to door selling things. I would sell gift-wrapping paper and bows and ribbons, or chocolates. I'd use mail order to buy twenty packages of something for a dollar a package, and then I'd sell it for two dollars. always enjoyed that.

JEFF KOONS

One of my favorite childhood games was to fill a sink with water and put nail polish into it to see what happened when the colors burst up the surface, merging into each other as floating, changing shapes.

HELEN FRANKENTHALER

THE MAGIC OF PHOTOGRAPHY BEGAN IN THE DARKROOM WHEN I WAS SIX. I WAS GIVEN A DARKROOM SET MADE BY KODAK FOR MY BIRTHDAY.

STEPHEN SHORE

My father is a psychoanalyst and in the early years had his office in the basement of our brownstone house in Brooklyn. I would put my ear to the floorboards above his office and listen to his sessions, trying to imagine what was going on, creating a mental image of what was happening downstairs.

GREGORY CREWDSON

I REMEMBER THE SMELL OF WET MUD.

MARISOL ESCOBAR

I SUPPOSE I WAS ALWAYS A BIT OF A LISTENER BECAUSE I DIDN'T SPEAK A LOT WHEN I WAS YOUNGER. I COULDN'T STRING A SENTENCE TOGETHER, WASN'T ABLE TO FOR SOME REASON. I GUESS I WAS MAYBE DRAWN TO PEOPLE AND LANGUAGE, HOW PEOPLE EXPRESS THEMSELVES.

GILLIAN WEARING

When I was very small, about 5 or 6, my most important Christmas present would be a coloring book.

ALICE NEEL

I REMEMBER THAT WHEN I WAS ABOUT FIVE YEARS OLD I MADE A SCULPTURE OF A WAVE; IT WAS MUCH TALKED ABOUT IN KINDERGARTEN AND MY MOTHER NEVER FORGOT IT.

ISAMU NOGUCHI

When I was about seven I did very large paper constructions of dinosaurs which in a funny way I suppose relate right up to the present in terms of the film I made on The Spiral Jetty. I used the prehistoric motif running through that....I guess there is not that much difference between what I am now and my childhood.

ROBERT SMITHSON

AS A LITTLE
FEMALE KID IN OHIO,
IT WAS HARD TO
IDENTIFY WITH
PICASSO: HIS LIFE
WITH HIS BABES
AND MY LIFE WITH
MY CAT WERE
RATHER DIFFERENT.

JENNY HOLZER

IT'S A COLLABORATION BETWEEN THE MATERIAL AND ME.

ANYA GALLACCIO

I CREATE SYSTEMS FOR
THE PEOPLE THAT WORK
WITH ME SO I CAN BE
RESPONSIBLE FOR EVERY
MARK. EVERYTHING
IS PERFORMING JUST LIKE
A FINGERTIP, SO I AM
RESPONSIBLE FOR IT ALL.

JEFF KOONS

I CHOSE TO BE AN
ARTIST BECAUSE I THOUGHT
IT WOULD ALLOW ME TO
WORK ALONE. NOW
I EMPLOY OVER 100
PEOPLE. THAT PART FEELS
A BIT "UNNATURAL."

TAKASHI MURAKAMI

I'VE WORKED WITH RIGGERS ALL MY LIFE....I ADMIRE PEOPLE WHO DO A HARD DAY'S WORK, WHATEVER IT IS.

RICHARD SERRA

—————————————

The problem with stone carving is that it takes months and months and months. I have a very dedicated, wonderful team of young fellows who do a lot of the preparatory work for me.

ANISH KAPOOR

—————————————

Any artist who wants to create a grand narrative on a grand scale has to sort of parse out some of the smaller aspects of painting or the more mundane aspects of painting to others.

KEHINDE WILEY

—————————————

I sometimes used a structural engineer. Not always, but certainly in situations where you are suspending things above people's heads, you want someone like that working with you.

NANCY RUBINS

—————————————

I HAVE VERY EARLY COLLABORATIVE IMPULSE MEMORIES. I LOVED DRAWING ON THE SAME PIECE OF PAPER WITH SOMEONE ELSE AND WOULD OFTEN DO THAT WITH MY DAD.

HARRELL FLETCHER

—————————————

I consider my production is experimentation and a search for the relationship between an artistic proposal and a spectator, trying to arrive at a quasi-coproduction.

JULIO LE PARC

IT IS "US" DOING IT TOGETHER.

GILBERT & GEORGE

I COULDN'T SEE MYSELF BEING AN ARTIST INDEPENDENTLY FROM NICK. OLIVER PAYNE IS NOT AN ARTIST. BUT OLIVER PAYNE AND NICK RELPH ARE.

OLIVER PAYNE

I DON'T DRAW, AND HE [CHRISTO] DOESN'T DO THE TAXES.

JEANNE-CLAUDE

THE DRAWINGS ARE THE SCHEME FOR THE PROJECT. AFTER THAT, WE DO EVERYTHING TOGETHER: CHOOSE THE ROPE, THE FABRIC, THE THICKNESS OF THE FABRIC, THE AMOUNT OF FABRIC, THE COLOR; WE ARGUE, AND WE THINK ABOUT IT.

CHRISTO

A GOOD COLLABORATION PRODUCES UNIVERSAL THINKING.

ROBERT RAUSCHENBERG

ONE CANNOT HAVE TOO MUCH YELLOW.

PIERRE BONNARD

When you go out to paint, try to forget what objects you have before you, a tree, a house, a field, or whatever. Merely think, here is a little square of blue, here an oblong of pink, here a streak of yellow, and paint it just as it looks to you, the exact color and shape, until it gives you your own naive impression of the scene before you.

CLAUDE MONET

THE BEST PICTURES, AND, FROM A TECHNICAL POINT OF VIEW, THE MOST COMPLETE, SEEN FROM NEAR BY, ARE BUT PATCHES OF COLOR NEXT TO EACH OTHER, AND ONLY MAKE AN EFFECT AT A CERTAIN DISTANCE.

VINCENT VAN GOGH

DON'T ASK ME WHY COLORS ARE DIFFICULT. I DON'T KNOW WHY BUT YELLOW RARELY EVER APPEARS IN MY PAINTINGS. IT IS ONE COLOR THAT I HAVEN'T BEEN ABLE TO LIVE WITH PEACEFULLY UNTIL NOW.

LEE KRASNER

Learning that color is a fiction of light is one of the primary shocks of growing up: that this hitherto deeply physical thing is just a reflection, and that nothing can keep its color under the cover of darkness, are monstrous things to understand, even for my adult mind.

TACITA DEAN

FULL, SATURATED COLORS HAVE AN EMOTIONAL SIGNIFICANCE THAT I WANT TO AVOID.

LUCIAN FREUD

COLOR IS THE PLACE WHERE OUR BRAIN MEETS THE UNIVERSE.

PAUL CÉZANNE

MY MOTHER WARNED ME TO AVOID THINGS COLORED RED.

CLAES OLDENBURG

RED IS A COLOR I'VE FELT VERY STRONGLY ABOUT. MAYBE RED IS A VERY INDIAN COLOR, MAYBE IT'S ONE OF THOSE THINGS THAT I GREW UP WITH AND RECOGNIZE AT SOME OTHER LEVEL. OF COURSE, IT IS THE COLOR OF THE INTERIOR OF OUR BODIES. RED IS THE CENTER.

ANISH KAPOOR

I LOVE RED SO MUCH THAT I ALMOST WANT TO PAINT EVERYTHING RED.

ALEXANDER CALDER

I'M MORE CONCERNED WITH LIGHT THAN COLOR.

EDWARD HOPPER

I DON'T THINK OF MY WORK AS WHITE PAINTINGS. THERE IS A LOT OF WHITE USED, BUT THE PURPOSE IS NOT TO MAKE WHITE PAINTINGS.

ROBERT RYMAN

THE WHITES, OF COURSE, TURNED YELLOW, AND MANY PEOPLE CALL YOUR ATTENTION TO THAT, YOU KNOW; THEY WANT WHITE TO STAY WHITE FOR EVER. IT DOESN'T BOTHER ME WHETHER IT DOES OR NOT. IT'S STILL WHITE COMPARED TO THE BLACK.

FRANZ KLINE

My blue comes out of a tube. Anyone can copy my paintings. All you have to know is which blue: cobalt, ultramarine, more or less thick. The quality comes from quantity and thickness.

HENRI MATISSE

I knew as a child that certain colors were supposed to produce certain feelings.

DONALD JUDD

IF I ONLY THINK OF GRAY, GREEN, AND WHITE, OF BLACKISH YELLOW, SULFURIC YELLOW AND VIOLET, A SHUDDER OF LUST RUNS DOWN MY SPINE.

MAX BECKMANN

YOU GO TO MEXICO
AND YOU WALK DOWN THE
STREET AND YOU ARE ASSAULTED
BY THE COLORS. IT IS AN
EXPLOSION THAT TAKES PLACE.
AND YOU FEEL THAT IT IS IN THE
HEART OF THAT CULTURE.

ALEX WEBB

I DON'T WANT
THE PICTURE TO BE
ABOUT COLOR. I WANT
THE PICTURE TO BE
ABOUT THIS LITTLE GIRL
IN TIBET WITH THE
CHINESE COAT.

STEVE MCCURRY

THE BLUE PERIOD
WAS NOT A
QUESTION OF
LIGHT OR COLOR.
IT WAS AN
INNER NECESSITY
TO PAINT
LIKE THAT.

PABLO PICASSO

You can do <u>plein air</u> painting indoors, by painting white in the morning, lilac during the day and orange-toned in the evening.

ÉDOUARD MANET

In the '70s if you were a serious photographer you had to work in black and white. I started using color in 1982, and I loved the kitsch language of color photography.

MARTIN PARR

Look! The color orange is at the door and says to the yellow, "You go first." But the yellow is also polite and says, "No, you go first." They are like good friends, and their conversation is very charming.

JOSEF ALBERS

Often, if I'm stuck, I'll go out for a walk and whether I'm out locally or in the center of London, something might strike me that's a key moment. The observation is often about color, which generally comes from just seeing two colors.

JANE HARRIS

I STARTED IN BLACK AND WHITE, WHICH CERTAINLY GIVES MORE CONTROL OVER THE END RESULT. JUST STUCK WITH IT.

ELLIOTT ERWITT

THERE'S ROOM FOR SAYING THINGS IN BRIGHT SHINY COLORS.

ED RUSCHA

I HAD FOUND THAT IF YOU PUT SILVER UNDERNEATH BLUE, THE BLUE SITS BACK, LIKE NIGHT, OR GLOWS LIKE MOONLIGHT.

CHRIS OFILI

IN THE HIERARCHY OF COLORS GREEN REPRESENTS THE SOCIAL MIDDLE CLASS, SELF-SATISFIED, IMMOVABLE, NARROW.

WASSILY KANDINSKY

I REALIZED IN THAT GREAT ROOM AT THE FRICK COLLECTION IN NEW YORK, WITH ALL THOSE INCREDIBLE PAINTINGS, THAT THE SECRET TO GREAT PAINTINGS IS BROWN. AND THAT IS ONE OF MY GREAT AMBITIONS, TO STRIVE TO DO A BROWN PAINTING.

CY TWOMBLY

I AM NOT ABLE TO RATIONALIZE MY INTEREST IN EXTREMES, BUT MY FAVORITE COLORS ARE BLACK AND WHITE.

VANESSA BEECROFT

IF I COULD FIND ANYTHING BLACKER THAN BLACK I'D USE IT.

J. M. W. TURNER

GRAY IS THE EPITOME OF NON-STATEMENT.

GERHARD RICHTER

REMEMBER THAT <u>GRAY</u> IS THE ENEMY OF ALL PAINTING.

EUGÈNE DELACROIX

GRAY GOES WITH ALL COLORS.

ELLSWORTH KELLY

CREATIVE PROCESS

I DO WHAT I'M FEELING AND WHAT I'M FEELING IS MONSTROUS. AND I DO IT IN THE NICEST POSSIBLE WAY.

KARA WALKER

A PAINTING OF MINE WORKS WHEN IT LOOKS AS THOUGH I HAD NOTHING TO DO WITH IT...WHEN SOMETHING ELSE TOOK OVER.

DOROTHEA ROCKBURNE

I want a picture to seem as if it had grown naturally, like a flower; I hate the look of interventions—of the painter always butting in.

WILLEM DE KOONING

Since my works are always projects with numerous parts, they usually take several years for me to play out their implications. Sometimes I feel like I'm peeling away the layers of an onion, at other times I'm opening up a peapod.

ELEANOR ANTIN

FOR MANY YEARS NOW, I'VE NEVER WORKED ON LOCATION. I ALWAYS GATHER THE NUTS AND BRING THEM HOME AND CHEW THEM OVER THERE AND ARRIVE AT A PICTURE.

CHARLES SHEELER

A picture is a succession of blobs that connect up and finally compose the subject, the piece over which the eye can stray without a hitch.

PIERRE BONNARD

I RESPOND COMPLETELY TO ALL MY INSTINCTS AND CHANNEL THEM INTO THE WORK. NEVER QUITE GET OUT OF CHILDHOOD. IT'S VERY COMFORTABLE.

RAY JOHNSON

I don't press the shutter. The image does. And it's like being gently clobbered.

DIANE ARBUS

BOREDOM IS PART OF MY WORK. I ACCEPT IT AND EMBRACE IT.

PAUL GRAHAM

WE DON'T LIKE WORK, WE ONLY LIKE THE RESULT AND THE EFFECT. WE DON'T LIKE THE "DOING" VERY MUCH.

GILBERT & GEORGE

FORGIVE ME FOR SAYING SO, BUT GOOD THINGS JUST HAVE TO GROW VERY SLOWLY.

PIET MONDRIAN

Seeing a painting is not as rewarding as seeing a painting in production. So I want to build the process into the work, to have the work exist in several stages, and to have the metamorphosis available to the viewers so that they can engage it in different ways.

MARK DION

I can make a picture in five minutes, but sometimes I run into so much trouble. I have to do them over and over. Or I don't have →

enough turpentine, and everything is sticky I did fifty Elvises one day. Half my California show. The roof of the firehouse leaked, and they were all ruined. I had to do them all over

ANDY WARHOL

The ground comes first—red, ochre, blue—and then I draw circles from the center, and then I spray around the edges and get it to float. Very simple methods It's no secret. Then I hand-paint from the center out So painting toward the center and painting out of the center gives a kind of pulse.

KENNETH NOLAND

IF YOU WANTED
TO WATCH ME
WORK, IT WOULD BE
TOTALLY BORING.
IT WOULD LOOK LIKE
A WARHOL FILM
WHERE NOTHING
HAPPENS. I SIT FOR
24 HOURS, THEN
I SCRATCH MYSELF.

ROBERT IRWIN

I WOULD NEVER LET
ANYBODY WATCH
ME PAINTING. I DON'T
WANT TO BE CONSCIOUS
OF MYSELF. I THINK IT
WOULD BE LIKE SOMEBODY
WATCHING YOU HAVE
SEX—PAINTING IS THAT
PERSONAL TO ME.

ANDREW WYETH

I WORKED WITH A CAMERA
WITH THE BLACK CLOTH OVER ME
BUT I ALWAYS HAD A CIGARETTE
IN MY MOUTH AND I DIDN'T EVEN
TAKE IT OUT EVEN WITH THE CLOTH.
I REMEMBER ONE GUY SAID—
"HEY, BUDDY, YOU ARE BURNING UP,"
AND I REALIZED IT WHEN HE SAW
THE SMOKE COMING OUT.

AARON SISKIND

ONE ALWAYS HAS TO SPOIL A PICTURE A LITTLE IN ORDER TO FINISH IT.

EUGÈNE DELACROIX

I HATE TO STOP WORKING ON SOMETHING.... DO YOU HAVE TROUBLE LETTING GO OF THE WORK, OR NOT?

VIJA CELMINS

I'M A SCISSOR MANIAC. I CUT EVERYTHING.

WANGECHI MUTU

I PAINT THE WAY I SPREAD BUTTER ON PUMPERNICKEL.

JOSEF ALBERS

SOMETIMES
I PAINT WITH
TWO HANDS.
SOMETIMES I USE
TWO BRUSHES,
SOMETIMES FOUR.
WITH THIS
NEW TECHNIQUE,
I CREATE AND
YET I DESTROY.

ZENG FANZHI

You take a thousand pictures to get a good one, like oysters with the rare pearl. It's true, and I used to say I'm not a good photographer. If anyone took as many pictures as I do, they'd be standing up here, too. It's a lot to do with generosity, just taking thousands and thousands of pictures, and then where the art comes in is the editing.

NAN GOLDIN

I am more than ever in favor of taking one's impression from memory; it is less the actual thing— vulgarity disappears, leaving only an aura of truth glimpsed, sensed.

CAMILLE PISSARRO

I used to have my film developed at a cheap lab; they made simple four-by-five machine prints in lieu of contact sheets. Those little prints, with all the dust and imperfections, became the paintings.

DAVID SALLE

CUTTING
STRAIGHT INTO
COLOR REMINDS
ME OF THE DIRECT
CARVING OF THE
SCULPTOR.

HENRI MATISSE

IF YOU GET A COUPLE OF GOOD PICTURES A YEAR, YOU'RE DOING VERY WELL. IT'S HARD TO GET A GREAT PICTURE. REALLY HARD. THE MORE YOU WORK AT IT, THE MORE YOU REALIZE HOW HARD IT IS.

MARY ELLEN MARK

You could say making a print is like preparing a pizza. You start with a white sheet of paper— that is, the "dough"— to which you add layers of images: cheese, mushrooms, sausage bits, tomato paste, immersed in overprinted inks. In the end, the "pizza" is "editioned"–that is, sliced and distributed for consumption.

CLAES OLDENBURG

The smudging makes the paintings a bit more complete. When they're not blurred, so many details seem wrong, and the whole thing is wrong too Then smudging can help make the painting invincible, surreal, more enigmatic— that's how easy it is.

GERHARD RICHTER

The process is what matters to me— making the work, how one work leads to another, and how showing the work and having people look at it and talk about it feeds it.

JESSICA STOCKHOLDER

MUSIC CAN MAKE OR BREAK A SHOOT.

ANNIE LEIBOVITZ

I FREQUENTLY DO PAINTINGS WHICH I DON'T ENJOY DOING.

JASPER JOHNS

I DO ALL THE DEVELOPING. IF SOMEBODY'S GOING TO GOOF MY FILM, I'D BETTER DO IT. I DON'T WANT TO GET THAT MAD AT ANYBODY ELSE.

GARRY WINOGRAND

I WASN'T THINKING IN TERMS OF PRECIOUS PRINTS OR ARCHIVAL QUALITY; I DIDN'T WANT THE WORK TO SEEM LIKE A COMMODITY (NO ONE WAS BUYING IT ANYWAY).

CINDY SHERMAN

I don't actually enjoy the process of making photographs, as it is an interruption of the quiet bservation that initiates it.... I greatly enjoy other parts of the process, selecting, cropping and combining images to create a certain type of rhythm.

UTA BARTH

YOU POSE A CERTAIN SET OF QUESTIONS IN ONE GROUP OF PAINTINGS AND YOU WANT TO ANSWER THEM IN THE NEXT.

CECILY BROWN

WHEN A PAINTING DOES NOT SATISFY ME, I FEEL PHYSICALLY UNCOMFORTABLE, AS THOUGH I WERE SICK, AS THOUGH MY HEART WERE NOT WORKING PROPERLY, AS THOUGH I COULDN'T BREATHE ANYMORE, AS THOUGH I WERE SUFFOCATING.

JOAN MIRÓ

OF COURSE YOU
CAN ALWAYS MAKE
IT BETTER, BUT
YOU HAVE TO LEAVE
IT AT SOME POINT
BECAUSE YOU CAN
KILL THINGS BY
BEING TOO NICE,
TOO WORKED OVER,
AND THEN YOU
END UP WITH
A CADAVER.

THOMAS DEMAND

THE PAINTING HAS A LIFE OF ITS OWN. I TRY TO LET IT COME THROUGH.

JACKSON POLLOCK

AT ONE TIME I WAS A BILL COLLECTOR IN HARLEM.

ALEX KATZ

I WORKED IN THE WHEAT FIELDS IN THE OLD DAYS WHEN THEY DIDN'T HAVE THRESHING COMBINES LIKE TODAY, THEY HAD HORSES.

LOUIS SCHANKER

MY FIRST JOB WAS AS A MESSENGER.

ROBERT RYMAN

I spent some time in the West trying to save up some money. I worked as a railroad switchman. I worked as a horse wrangler in Wyoming.

ROBERT MORRIS

I did freelance fashion illustration for Seventeen and Mademoiselle, line drawings.

BARBARA KRUGER

In the '70s, the job I liked the least was driving a cab in New York.

JULIAN SCHNABEL

My very last job was when I was 23. I was a car door unlocker; when people locked their keys in their car they would call a number and I would come and open it.

MIRANDA JULY

I didn't start photography until about 1939 and up until that time I had worked as a waiter on the railway, bartender and road gangs, played semi-professional basketball, semi-professional football, worked in a brick plant, you name it....

GORDON PARKS

I did odd jobs. I was a sign painter for a while.

JOHN MCCRACKEN

I was a day laborer with pick and shovel, a pearl-diver (dish washer), a candy mixer at the Loft candy factory, a biscuit maker at the Sunshine Biscuit factory, a hole puncher at the Life Saver Candy factory.

WEEGEE

WHEN I WAITED TABLES, I WOULD PUT MY ORDER IN AND I WILL ALWAYS REMEMBER THE COOK YELLING, "WHO WROTE THIS, A FOUR-YEAR-OLD?"

ELLEN GALLAGHER

I taught for eighteen and a half years in the public schools in New York, and that was wonderful . . . the little ones. Prekindergarten to about fourth grade, they're magic.

FAITH RINGGOLD

ONE SUMMER I WORKED IN A FACTORY, AND THAT WAS PRETTY BAD. I DIDN'T LAST TOO LONG. THEN I GOT A JOB IN THE STREET DEPARTMENT DIGGING A DITCH....

SOL LEWITT

I WORKED AS AN EXPERT WITH THE CITY ON THE GYPSIES.

ROMARE BEARDEN

FIND SOMETHING
TO DO THAT WILL MAKE
YOU SOME MONEY, THAT
CAN SUPPORT YOUR ART,
AND THAT YOU CAN
BECOME GOOD AT SO
YOU CAN MAKE A DECENT
WAGE AND THAT YOU
DON'T ACTUALLY HATE.

JANE HAMMOND

RENOIR PAINTED HIS WHOLE LIFE LONG, DOWN TO HIS VERY LAST DAY. HE PAINTED A LITTLE STILL LIFE OF FRUIT, IN BED, THE DAY BEFORE HE DIED.

HENRI MATISSE

IT'S THE HARDEST WORK IN THE WORLD TO TRY <u>NOT</u> TO WORK!

N. C. WYETH

I WORK WHEN I'M SICK, HAPPY, DEPRESSED, CONSTIPATED, JET-LAGGED. I SHOW UP.

MARK BRADFORD

INSPIRATION IS FOR AMATEURS— THE REST OF US JUST SHOW UP AND GET TO WORK.

CHUCK CLOSE

THE MOST DEMANDING PART
OF LIVING A LIFETIME AS AN
ARTIST IS THE STRICT DISCIPLINE
OF FORCING ONESELF TO
WORK STEADFASTLY ALONG
THE NERVE OF ONE'S OWN MOST
INTIMATE SENSITIVITY.

ANNE TRUITT

PAINTING IS MY WHOLE LIFE.

JACKSON POLLOCK

I'VE BEEN WILLING TO PAY ANY PRICE TO BE ABLE TO WORK.

JUDY CHICAGO

I REALLY WORK LIKE A DAY LABORER—HAVE BEEN PREPARING CANVAS AND IT IS REALLY HARD WORK BUT I'M DETERMINED TO PREPARE ENOUGH TO LAST FOUR OR FIVE YEARS SO HERE WILL ALWAYS BE LOTS OF EMPTY ONES AROUND.

GEORGIA O'KEEFFE

IT SOUNDS A BIT SQUARE, BUT I'VE FOUND THAT THE CHANCES OF GETTING A GOOD RESULT ARE JUST SO MUCH HIGHER WHEN YOU SPEND AT LEAST EIGHT HOURS A DAY ON YOUR WORK.

WOLFGANG TILLMANS

THE MOST IMPORTANT TOOL THE ARTIST FASHIONS THROUGH CONSTANT PRACTICE IS FAITH IN HIS ABILITY TO PRODUCE MIRACLES WHEN THEY ARE NEEDED.

MARK ROTHKO

I KNOW THERE IS
A TERRIFIC IDEA
THERE SOMEWHERE,
BUT WHENEVER
I WANT TO GET INTO IT,
I GET A FEELING
OF APATHY AND WANT
TO LIE DOWN AND
GO TO SLEEP.

WILLEM DE KOONING

ONE MUST GO ON WORKING SILENTLY, TRUSTING THE RESULT TO THE FUTURE.

VINCENT VAN GOGH

MAKE A DRAWING, BEGIN IT AGAIN, TRACE IT; BEGIN IT AGAIN AND TRACE IT AGAIN.

EDGAR DEGAS

I'M CONVINCED THAT I LEARNED HOW TO DRAW BY SKIING. THE EXPERIENCE OF SKIING THROUGH NEW SNOW HAD A LOT TO DO WITH DRAWING FINE LINES ON WHITE PAPER.

DOROTHEA ROCKBURNE

MY PARENTS WERE IN THE TAPESTRY RESTORATION BUSINESS, AND AS A YOUNG GIRL, I WOULD DRAW IN THE MISSING PARTS OF THE TAPESTRY THAT NEEDED TO BE RE-WOVEN.

LOUISE BOURGEOIS

WHEN I WAS QUITE YOUNG, AS FAR BACK AS I REMEMBER, I DREW, BUT THE GIFT IS NOTHING WITHOUT THE WILL TO MAKE IT WORTHWHILE.

AUGUSTE RODIN

BELIEVE IT OR NOT, I CAN ACTUALLY DRAW.

JEAN-MICHEL BASQUIAT

They used to sell wrapping paper at the League and we found out that it was pretty good for drawing. You folded a sheet into eight rectangles and it would fit in your pocket. With this we used to pass our time drawing people in the subway on our way to and fro.

ALEXANDER CALDER

I have wanted to do a drawing show for a long time. Whenever I look at a drawing, I always know where I made it and more or less what time of day it was when I made it.

RACHEL WHITEREAD

The only drawing that was in my paintings was explicit, and that was laid as a pencil line which was a guideline and that was it. The rest was paint.

FRANK STELLA

My contribution to the world is my ability to draw. I will draw as much as I can for as many people as I can for as long as I can. Drawing is still basically the same as it has been since prehistoric times.

KEITH HARING

I'VE BEEN DOODLING ALL MY LIFE.

JOAN MIRÓ

I did technical drawing at school, so I have done fabrication drawings, but I'm very lazy. I would probably go to somebody and have a fabrication drawing made from a doodle that I'd done. I don't even paint my own spots. If I can pay somebody else to do it, I will.

DAMIEN HIRST

THEY SAY NOBODY WANTS TO GROW UP AND BE A JUNKIE. I DID. AND DID.

NAN GOLDIN

IT IS A CERTAIN
FACT THAT I HAVE DONE
BETTER WORK THAN
BEFORE SINCE I STOPPED
DRINKING, AND THAT IS
SO MUCH GAINED.

VINCENT VAN GOGH

I OFTEN WORK BEST WITH A HANGOVER BECAUSE MY MIND IS CRACKLING WITH ENERGY AND I CAN THINK VERY CLEARLY.

FRANCIS BACON

I ONCE HAD
A DRINK WITH
BILLIE HOLIDAY,
AND I SMOKED
A JOINT WITH
LOUIS ARMSTRONG.
THOSE ARE
MY REAL CLAIMS
TO FAME.

JOHN CHAMBERLAIN

I WAS NEVER A BAR PERSON.

VITO ACCONCI

I DON'T DRINK OR SMOKE AND I HAVE NEVER TAKEN DRUGS. I AM PROBABLY THE MOST BORING PERSON YOU COULD MEET.

MARINA ABRAMOVIĆ

WHEN I CLOSE
THE DOOR ON MY
STUDIO AT THE
END OF THE DAY
I HAVE TO BE
CONVINCED THAT
THE PAINTING HAS
WORKED. THEN
I GO DRINKING.

LUC TUYMANS

THE SMELL
OF OPIUM IS THE
LEAST STUPID
SMELL IN THE
WORLD.

PABLO PICASSO

ALCOHOL HAS
DAMAGED AND KILLED
FRIENDS OF MINE,
BUT I'VE NEVER KNOWN
ANYONE HARMED BY
THE WEED, WHOSE
RELAXING PLEASURE
I HAVE ENJOYED FOR
40 YEARS.

DAVID HOCKNEY

I THINK ACID
WAS NOT BAD,
BUT ACID IS
VERY STRONG
SO YOU DON'T
TAKE IT
EVERY DAY.

YOKO ONO

I attribute
any possible
improvement to
my having greatly
diminished my
wine; I now
may almost say
that I take none
in daytime,
and much less
at night.

DANTE GABRIEL ROSSETTI

Certainly I would
advocate everybody
using drugs, but only
the drugs that are
given by prescription.

ANDY WARHOL

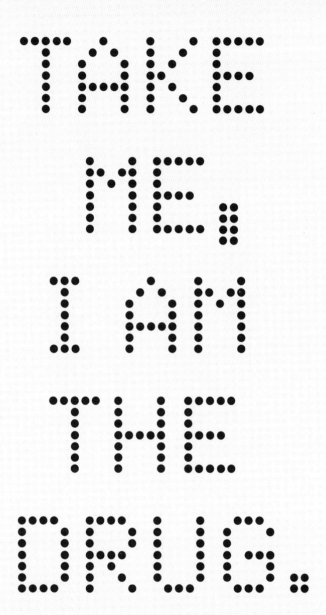

TAKE
ME,
I AM
THE
DRUG.

SALVADOR DALÍ

EXHIBITING MY ART IS LIKE LETTING PEOPLE TAKE A LOOK INTO MY BAG.

PIPILOTTI RIST

When you know you're going to have a show, you make the work for the experience of the gallery, and it automatically becomes more conceptual because you're imagining that destination as the visual container.

AMY SILLMAN

When you're offered a show and given a space to work with, it is an invitation. My concern is how to invite the space back, how to send back the invitation as an invitation!

ANRI SALA

I'M THE FIRST AFRICAN-AMERICAN WOMAN TO HAVE A RETROSPECTIVE AT THE GUGGENHEIM. →

NOT TO SOUND PRETENTIOUS, BUT I SHOULD BE HAVING A SHOW THERE. BY NOW, IT SHOULD BE A MOOT POINT FOR A BLACK ARTIST— BUT IT'S NOT.

CARRIE MAE WEEMS

HOW CAN YOU BUILD ANY STRENGTH IF IT'S EASY TO BE EXHIBITED?

ROBERT RAUSCHENBERG

I've spent a great deal of time and energy this year on two exhibitions, packing, shipping, writing letters, supervising. Can you imagine what it's like to pack an exhibition in a tiny remote New Mexican town?

GEORGIA O'KEEFFE

I'VE NEVER FELT THAT WHAT I DO IS REALLY TRANSLATABLE INTO AN EXHIBITION SITUATION.

GORDON MATTA-CLARK

MY PAINTING DOESN'T HANG EASILY IN GROUP SHOWS.

AD REINHARDT

I HAVE ONLY ONE
WORRY IN THE WORLD.
IT IS THAT MY PAINTINGS
WILL SHOW DOWNTOWN
AND FAIL THERE. THEY WILL
FAIL BECAUSE THEY ARE
NON-AGGRESSIVE—THEY ARE
NOT EVEN OUTGOING.

AGNES MARTIN

ART NEEDS
TO BE DEFENDED.
IT'S FRAGILE. IF A WORK
IS SHOWN TOO MANY
TIMES, SOMETHING GETS
STOLEN FROM IT.

MATTHEW BARNEY

I WAS…GIVEN THE LARGEST GALLERY IN THE EXHIBITION… I AM ALMOST ASHAMED TO HAVE BEEN HONORED SO HIGHLY— BUT THEN, IT WAS THEIR OPINION. HOPEFULLY, THEY WON'T REGRET IT.

EDVARD MUNCH

THE EXHIBIT IS OVER.
THE NAKED BALCONY WALLS
PRESENTED A SAD AND STRIPPED
VOID AS WE GLANCED BACK
TO BE ASSURED NO PRINT WAS
FORGOTTEN; BUT NO TIME
FOR TEARS, FOR ALREADY A
NEW EXHIBIT IS ON!

EDWARD WESTON

IT'S NICE TO HAVE AN AUDIENCE, BUT IT COULD BE JUST ONE OR TWO PEOPLE.

RAYMOND PETTIBON

A RETROSPECTIVE
MAKES IT POSSIBLE FOR
AN ARTIST TO REREAD
HIMSELF. YOU SEE, AN
ARTIST IS SOMEONE WHO
KEEPS A JOURNAL IN THE
FORM OF PAINTINGS IN
A BOOK THAT ONE CANNOT
LEAF THROUGH. AN ARTIST
IS ALWAYS FORCED TO
SEPARATE HIMSELF FROM
THE "MANUSCRIPT."

PIERRE ALECHINSKY

RETROSPECTIVES ARE NOT VERY GOOD FOR YOU.

MARLENE DUMAS

HAVING A RETROSPECTIVE IS MAKING A WILL.

ROBERT MOTHERWELL

FAILURE

THE ONLY THING WE CAN DO IS HONESTLY LEARN FROM OUR FALLS.

AI WEIWEI

I AM DISTRESSED,
ALMOST DISCOURAGED,
AND FATIGUED TO
THE POINT OF FEELING
SLIGHTLY ILL. WHAT
I AM DOING IS NO GOOD,
AND IN SPITE OF YOUR
CONFIDENCE I AM
VERY MUCH AFRAID THAT
MY EFFORTS WILL
ALL LEAD TO NOTHING.

CLAUDE MONET

USUALLY I DON'T HAVE ANY WORK THAT I WOULD CALL A FAILURE. USUALLY I WORK THE PAINTINGS THROUGH SO THAT THEY ARE OKAY IN THE END.

ROBERT RYMAN

I began with no knowledge of the art. I did not know where to place my dark box, how to focus my sitter, and my first picture I effaced to my consternation by rubbing my hand over the filmy side of the glass.

JULIA MARGARET CAMERON

THE FEAR OF FAILURE CONSPIRED TO MAKE EVERYONE INTO A BRAND.

PAUL CHAN

I WIPE OUT, I START OVER, I THINK THE YEAR WILL GO BY WITHOUT ONE CANVAS, AND THAT'S WHY I TURN DOWN VISITS FROM PAINTERS.

AUGUSTE RENOIR

I THINK THE MOMENT YOU THINK YOU ARE SUCCESSFUL, FAILURE WILL BE THERE FOR YOU

MAURIZIO CATTELAN

MISTAKES ARE ALMOST ALWAYS OF A SACRED NATURE.

SALVADOR DALÍ

I'm really more interested in failure than in success. So often the narrative that runs through my work in terms of sound will indicate things not going well, even while you're looking at this formalist fluorescent bulb object on the floor.

MATTHEW MCCASLIN

YOU HAVE
TO LEARN
TO FEEL
CONFIDENT
ABOUT THE
PROSPECT
OF FAILING,
BECAUSE
IT'S SO
INEVITABLE.

ANDREA ZITTEL

TAKE A MONDRIAN PAINTING, MOVE THE EDGE...AND THE WHOLE COMPOSITION JUST FALLS APART.

UTA BARTH

STIEGLITZ WOULDN'T
CUT A QUARTER OF AN INCH
OFF A FRAME. I WOULD CUT
ANY NUMBER OF INCHES
OFF MY FRAMES IN ORDER TO
GET A BETTER PICTURE.

WALKER EVANS

**WHAT HAPPENS WHEN SOMETHING
IS CUT OFF BY THE EDGE? WHAT HAPPENS
IF YOU DON'T CUT OFF AN OBJECT?
WHAT HAPPENS WHEN YOU HAVE A
DIAGONAL GOING INTO A CORNER?
WHAT HAPPENS WHEN A DIAGONAL GOES
ABOVE OR BELOW A CORNER? THESE
LITTLE QUESTIONS ARE ABOUT HOW
TO PUT A PICTURE TOGETHER.**

STEPHEN SHORE

I DON'T THINK YOU CAN ESCAPE THE PRIMACY OF THE RECTANGLE.

ROBERT SMITHSON

IF IT MAKES A BETTER
PICTURE BY CROPPING, I CROP.
I DON'T SEE ANY POINT IN
SAYING I NEVER DO THIS—
IF I SEE SOMETHING LATER THAT
I DIDN'T SEE, AND IT'S A
BETTER PICTURE, I GO FOR IT.

ROBERT MAPPLETHORPE

I'VE ALWAYS ADMIRED THE WAY SOME PAINTERS PHYSICALLY BREAK THE FRAMING BORDER.

DAVID REED

IF YOU START CUTTING OR CROPPING A GOOD PHOTOGRAPH, IT MEANS DEATH TO THE GEOMETRICALLY CORRECT INTERPLAY OF PROPORTIONS.

HENRI CARTIER-BRESSON

IN GENERAL, I AGREE WITH CARTIER-BRESSON, WHO SAYS HE ALWAYS USES THE WHOLE NEGATIVE. THAT'S THE BEST WAY TO WORK. IT'S ONLY WHEN YOU KNOW HOW TO WORK THAT WAY THAT YOU HAVE THE RIGHT TO CROP.

PAUL STRAND

IT'S WHAT'S OUTSIDE THE FRAME THAT'S SCARY.

MATTHEW BARNEY

WHO IS THIS MONET WHOSE NAME SOUNDS JUST LIKE MINE AND WHO IS TAKING ADVANTAGE OF MY NOTORIETY?

ÉDOUARD MANET

I RAN INTO THE GUY AT A PARTY THE OTHER NIGHT AND SAID TO HIM…"I AM THE ART WORLD."

RICHARD PRINCE

MAYBE I'M JUST SIMPLE, REAL AND HUMAN AFTER ALL.

AD REINHARDT

I NEVER THOUGHT OF MYSELF AS A WOMAN IN ANY CONSCIOUS WAY. I'M AN ARTIST.

SONIA DELAUNAY

YOU MAY BE A WOMAN AND YOU MAY BE AN ARTIST; BUT THE ONE IS A GIVEN AND THE OTHER IS YOU.

DOROTHEA TANNING

AT HEART, I'M AN ANTHROPOLOGIST. I TRY TO JUMP OUT OF MY SKIN.

LAURIE ANDERSON

I discovered myself by considering at first my earliest works. They rarely deceive.

HENRI MATISSE

I don't want people to think I'm only a video artist— the guy who did "The Clock." I make so many different things.

CHRISTIAN MARCLAY

I STILL THINK OF MYSELF AS AN OLD CHILD.

CHANTAL AKERMAN

I MUST BE MANY THINGS SIMULTANEOUSLY BUT NOT BECAUSE I'M AN ARTIST, YOU KNOW. BECAUSE I'M A HUMAN. EVEN MY <u>CAT</u> IS SIMULTANEOUSLY MANY THINGS.

SOPHIE CALLE

I CONSIDER MYSELF A HERETIC OF THE ART WORLD.

YAYOI KUSAMA

I THINK I'M A MUTANT.

TERENCE KOH

THE TWO LUCKIEST
THINGS THAT CAN HAPPEN
TO A CONTEMPORARY PAINTER
ARE, FIRST, TO BE SPANISH
AND, SECOND, TO BE NAMED
SALVADOR DALÍ. BOTH
HAVE HAPPENED TO ME.

SALVADOR DALÍ

THE "ONE" THAT
I AM IS COMPOSED
OF NARRATIVES
THAT OVERLAP, RUN
PARALLEL TO, AND
OFTEN CONTRADICT
ONE ANOTHER.

GLENN LIGON

I WANTED TO BE SOFT LIKE ROTHKO AND RUTHLESS LIKE AD REINHARDT.

JENNY HOLZER

The first grown-up book I read was <u>Crime and Punishment</u> and I was sick in bed. I think I was in the 6th grade though possibly I was in junior high already. Maybe I was in seventh grade. I don't remember. But it was an incredible revelation, an emotional experience.

ELEANOR ANTIN

I was a bird watcher when I was a little boy. My grandmother gave me a bird book, and I got to like their colors. I said, "Jesus, a little blackbird with red wings." That was one of the first birds I saw in the pine tree →

behind my house, and I followed it as he flew into one of the trees—like he was leading me on. In a way, that little bird seems to be responsible for all of my paintings.

ELLSWORTH KELLY

I was influenced by seeing Picasso's work, which I very much admire. I am not ashamed to mention this influence, for I think it better to hold oneself open to improvement than to remain satisfied with one's imperfections....

PIET MONDRIAN

CURRENTLY I AM PAINTING WITH VENOMOUS PLEASURE ON THEMES FROM A GERMAN SENTIMENTAL POET.

PAUL KLEE

EGON SCHIELE
HAS NEVER BEEN
DEAD TO ME. JUST
BECAUSE SOMEONE
ISN'T WALKING
AROUND ANYMORE
DOES NOT MEAN
THEY DO NOT HAVE
PRESENCE.

TRACEY EMIN

THE MOST IMPORTANT EXPERIENCE WAS SEEING THE WORK OF EL GRECO IN THE FLESH. I WAS SIXTEEN OR SEVENTEEN, AND FOR THE FIRST TIME I REALIZED WHAT PAINTING REALLY MEANT.

LUC TUYMANS

I LEARNED EVERYTHING I KNOW FROM FILMS.

NAN GOLDIN

I SAW THREE SHORT
BECKETT PLAYS WHEN I WAS
SIXTEEN, AND I DIDN'T
KNOW WHAT IT WAS BUT
IT HIT ME LIKE A TRAIN.
IT WAS INTENSE ENOUGH
FOR ME TO NEVER FORGET IT.
MY ROAD TO DAMASCUS.

PAUL CHAN

WHEN I FIRST STARTED TO PAINT, I BOUGHT A LITTLE BOOK IN PARIS WHICH HAD RATHER BEAUTIFUL COLOR ILLUSTRATIONS OF DISEASES OF THE MOUTH, AND IT AFFECTED ME VERY MUCH.

FRANCIS BACON

PUNK DEFINITELY HAD AN INFLUENCE ON THE DEVELOPMENT OF MY WORK.

ZHANG HUAN

I feel less kinship to Seurat than I do to Byzantine mosaics, where an image is built out of discrete incremental marks— chunks of stone or glass—that fit together.

CHUCK CLOSE

I GET TATTOOS COMPULSIVELY ALL OVER MY BODY, AND I'VE ALSO TRIED TO MAKE SCULPTURES WITH TATTOOS, WHICH COMES FROM LOOKING AT AFRICAN BRONZES AND INDIAN ART, WITH ALL THE SURFACE DRAWINGS ON THEM.

KIKI SMITH

When I first looked at Walker Evans's photographs, I thought of something Malraux wrote: "To transform destiny into awareness." One is embarrassed to want so much for oneself. But, how else are you going to justify your failure and your effort?

ROBERT FRANK

I HAVE HAD THREE MASTERS— NATURE, VELÁZQUEZ, AND REMBRANDT.

FRANCISCO DE GOYA

OF COURSE, IN HISTORY, THERE IS NO ONE I CANNOT BE INSPIRED BY. IT'S A SPECTRUM.

PAWEL ALTHAMER

INSPIRATION IS THE BEGINNING THE MIDDLE AND THE END.

AGNES MARTIN

I use the gallery as if it were a doctor. I come for ideas and help— to look at situations within paintings, rather than whole paintings.

LUCIAN FREUD

I LIKE TO PUT THINGS AROUND MY BED ALL THE TIME. PICTURES OF MINE I LIKE AND OTHER THINGS, AND I CHANGE IT EVERY MONTH OR SO. THERE'S SOME FUNNY SUBLIMINAL THING THAT HAPPENS. IT ISN'T JUST LOOKING AT IT. IT'S LOOKING AT IT WHEN YOU'RE NOT LOOKING AT IT. IT REALLY BEGINS TO ACT ON YOU IN A FUNNY WAY.

DIANE ARBUS

I remember first seeing the Giotto frescoes at the Arena Chapel in Padua. We had to wait to have someone open the door for us and we were the only ones there....I had never seen such beauty, such a chalky, glorious blue....

VIJA CELMINS

I love cave painting.

KARLA BLACK

The plate that a peasant eats his soup out of is much more interesting to me than the ridiculously rich plates of rich people.

JOAN MIRÓ

AS A KID, I WAS INSPIRED BY MY MOTHER AND BY BIBLE SCHOOL TO DRAW.

JACOLBY SATTERWHITE

WRITING ON
PAINTINGS, FRIED EGGS
AND BAD FOOD,
THE PUMPKINS EARLIER
ON, NOW BREAK-
DANCING OLD DUDES.
THESE ARE THE
THINGS I REALLY GET
EXCITED ABOUT.

NIGEL COOKE

I HAVE
LOVED BOOKS
SO MUCH—
I'M ALMOST A
PATHOLOGICAL
BIBLIOPHILE.

WALKER EVANS

I HAVE THIS JUVENILE FASCINATION WITH THINGS THAT ARE REPULSIVE.

CINDY SHERMAN

OFTEN, WHEN I GO SOMEWHERE, I'LL TRY TO FIND THE STRANGEST OBJECT. THERE IS, FOR EXAMPLE, A PENIS ASHTRAY I FOUND IN EGYPT. WHAT A BIZARRE OBJECT....THINGS LIKE THAT I DON'T NECESSARILY LOOK FOR, I JUST FIND THEM.

RACHEL WHITEREAD

I MUST SEE
NEW THINGS AND
INVESTIGATE
THEM. I WANT
TO TASTE DARK
WATER AND
SEE CRACKLING
TREES AND
WILD WINDS.

EGON SCHIELE

I AM FASCINATED BY THE INDECISIVE MOMENT AND THE PERIPHERAL VIEW.

DOUG AITKEN

THE FLOWERS RAISE THEIR HEADS, THE BIRDS FLUTTER HITHER AND THITHER. A COUNTRYMAN ON A WHITE HORSE RIDES AWAY DOWN THE STEEP-BANKED LANE. THE LITTLE ROUNDED WILLOWS ON THE BANK OF THE STREAM LOOK LIKE BIRDS SPREADING THEIR TAILS. IT'S ADORABLE! AND ONE PAINTS! AND PAINTS!

CAMILLE COROT

I LOVE READING THE DICTIONARY.

ANN HAMILTON

I'M ONLY TRYING TO DO WHAT I CAN'T DO.

LUCIAN FREUD

I WANT TO MAKE WORK SO PEOPLE CAN BE MOVED BY A SENSE OF THE POSSIBLE.

ZHANG HUAN

I make art because it centers me in my body, and by doing so I hope to offer that experience to someone else.

JANINE ANTONI

AT THE BOTTOM OF EVERYTHING I HAVE DONE, THE MOST RADICAL EFFECTS, IS THE DESIRE TO TOUCH AND BE TOUCHED. EACH THING IS AN INSTRUMENT OF SENSUOUS COMMUNICATION.

CLAES OLDENBURG

I WANT TO MAKE PAINTINGS THAT LOOK AS IF THEY WERE MADE BY A CHILD.

JEAN-MICHEL BASQUIAT

I WANT TO SHOW THAT THERE IS NO DISTANCE IN THE WORLD ANY MORE.

CHANTAL AKERMAN

What I want to say is, this is what we were like as a people, and this is how we lived. These are the places. And here are some of the faces.

STEVE MCCURRY

I see myself as a well-working lens, a perceiver of something that exists independently of me: don't look at me, look at what I've found.

HEDDA STERNE

MY WISH: USE ART TO TURN THE WORLD INSIDE OUT.

JR

I MAKE DRAWINGS TO SUPPRESS THE UNSPEAKABLE.

LOUISE BOURGEOIS

I DON'T PAINT OUT OF RESPONSIBILITY. I PAINT OUT OF NEED.

JIM DINE

IT IS NOT
MY INTENTION
TO MAKE
ANYTHING
COMPREHENSIBLE.

RENÉ MAGRITTE

THERE ARE TWO THINGS I WANTED TO DO. I WANTED TO SHOW THE THINGS THAT HAD TO BE CORRECTED. I WANTED TO SHOW THE THINGS THAT HAD TO BE APPRECIATED.

LEWIS HINE

I WANT TO MAKE AN ART THAT HAS TO DO WITH SURVIVAL, THAT THINKS ABOUT WHERE HUMAN BEINGS FIT IN THE CHAIN OF BEING, THAT ASKS WHO WE ARE, AND WHERE WE'RE GOING....

ANTONY GORMLEY

CAN I DO
SOMETHING IN MY
LIFETIME THAT
CAN HELP CHANGE
THE WAY WE ARE....
CAN I HELP, IN
A LITTLE TINY
FRACTION, MAKE IT
BETTER HERE?

MAYA LIN

THE SEARCH FOR TRUTH IS MY OBSESSION.

ALFRED STIEGLITZ

I WANTED TO EXPERIENCE FOREVER THE PEOPLE AND PLACES BEFORE ME, BECAUSE I KNEW THEY WERE ABOUT TO VANISH. I WANTED TO CHANGE HISTORY AND PRESERVE HUMANITY, BUT IN THE PROCESS, I CHANGED MYSELF AND PRESERVED MY OWN.

DANNY LYON

MY AIM IN LIFE IS TO PAY THE LIGHT BILL.

SAUL LEITER

LIGHT IS A DELICATE THING.

GEORGES BRAQUE

I WILL NOT PUT ON THE ELECTRIC LIGHT UNLESS IT'S A TOTALLY FREAK SITUATION.

ALEX KATZ

I SHARE WITH MANY PEOPLE THE FEELING THAT THERE IS A SWEETNESS AND CONSTANCY TO LIGHT THAT FALLS INTO A STUDIO FROM THE NORTH SKY THAT SETS IT BEYOND ANY OTHER ILLUMINATION.

IRVING PENN

ONE MIGHT
NOT THINK OF LIGHT
AS A MATTER OF
FACT, BUT I DO.
AND IT IS, AS I SAID,
AS PLAIN AND
OPEN AND DIRECT
AN ART YOU WILL
EVER FIND.

DAN FLAVIN

I LIKE TO WORK IN THE AFTERNOONS, BUT BEST OF ALL AT NIGHT. YOU SEE THESE THICK CURTAINS SHUT OUT THE DAYLIGHT. ARTIFICIAL LIGHT SUITS ME A GREAT DEAL BETTER; IT'S ABSOLUTELY STEADY, AND MUCH MORE EXCITING.

PABLO PICASSO

I LOVE CHRISTMAS TREE BULBS AND I STARTED PUTTING THEM IN MY PAINTINGS. YOU'VE GOT TO PLUG THIS PAINTING IN, AND IT'S GOT A RIG IN THE BACK, SO THAT EACH ONE CAN BE REPLACED IF IT BURNS OUT.

DAVID LYNCH

I treat sound and light very similarly. I learned a long time ago that when you work with light, and the surfaces are hard, either you pay attention to the sound or it's just going to be chaos.

JAMES TURRELL

THE SUBJECT EXISTS INSIDE OF ITS SHADOWS. THAT'S PART OF THE WAY WE SEE THE SUBJECT. IT'S NOT ABOUT DRAGGING SOMETHING OUT INTO THE LIGHT, SOME GLARING GAZE. IT'S ABOUT SOMETHING BEING DEVELOPED OR CARESSED BY SHADOWS, OR REVEALED WITHIN SHADOWS, OR JUST FALLING INTO SHADOW.

DAVID SALLE

A BROAD LIGHT HIGH UP AND NOT TOO STRONG WILL RENDER THE DETAILS OF OBJECTS VERY AGREEABLE.

LEONARDO DA VINCI

DAYLIGHT IS TOO EASY. WHAT I WANT IS DIFFICULT—THE ATMOSPHERE OF LAMPS OR MOONLIGHT.

EDGAR DEGAS

I HAVE SEIZED THE LIGHT. I HAVE ARRESTED ITS FLIGHT!

LOUIS DAGUERRE

"LIMITS" IS A RELATIVE TERM. LIKE BEAUTY, IT IS OFTEN IN THE EYE OF THE BEHOLDER.

CHRIS BURDEN

The rules are always the same, the limitations I give myself, but within that the potential seems endless, the possibilities for variation.

JANE HARRIS

LIMITATIONS ARE REALLY GOOD FOR YOU. THEY ARE A STIMULANT. IF YOU WERE TOLD TO MAKE A DRAWING OF A TULIP USING FIVE LINES, OR ONE USING A HUNDRED, YOU'D HAVE TO BE MORE INVENTIVE WITH THE FIVE.

DAVID HOCKNEY

One of the things holding me back is my conscience. I have all these negatives that have never been fully realized, never been printed.

ANSEL ADAMS

I was intrigued by the idea that you could do more with less. I know that's a cliché now, but at the time the limitations of film needed to be pushed.

TONY CONRAD

I work with colored pencil, graphite, architectural stencils, French curves, compasses, and rulers on the pages of the ledger books. Occasionally, I use white ink and gold or copper leaf. I love how something that seems very limited can end up opening onto vast possibilities.

LOUISE DESPONT

TIRES HAVE GIVEN ME MUCH JOY.

CAROL RAMA

I WORK PURELY OUT OF DESIRE. I LOVE OILS AND GELS AND PASTES AND POWDERS, AND I'VE JUST LET MYSELF USE THEM.

KARLA BLACK

Pastel is a nutty, superfussy material, very interesting, don't you think?

KIKI SMITH

I WANTED TO DEAL WITH LIGHT DIRECTLY RATHER THAN WITH PAINT.

JAMES TURRELL

TRADITIONALLY, ARTISTS WORK WITH CERTAIN MATERIALS AND SPEND THEIR LIVES PERFECTING THEIR SKILLS. BUT WHEN YOU →

WORK WITH IDEAS, WHAT MATTERS ABOVE ALL IS THE GOAL—WHAT YOU WANT TO ACHIEVE, TO PROVOKE WITH A WORK.

MONA HATOUM

I often work with the specific context of the place for which I produce a piece— both the physical as well as the social and political context. They're part of the materials I work with; they're like bronze or paint on canvas.

HANS HAACKE

I'M USING TONS OF STEEL TO MAKE THE SITUATION LOOK LIGHTER.

RICHARD SERRA

I'VE ALWAYS HAD A THING ABOUT GLASS.

DAMIEN HIRST

THE MATERIAL THAT I AM REALLY STILL EAGER TO WORK WITH IS RUBBER.

EVA HESSE

SOME
MATERIALS
HAVE A
MEMORY,
OTHERS
DON'T.

SHEILA HICKS

SPACE
IS A
MATERIAL.
IT IS
PHYSICAL.

ANISH KAPOOR

I FEEL THE CLAY;
I AM THE CLAY,
SO TO SPEAK.

LYNDA BENGLIS

Stone to some extent has a system to it. But with wood every branch is totally different. I always look at the branches laid out on the grass before I begin and I think, "Oh fuck, here we go."

ANDY GOLDSWORTHY

Tape, cardboard, paper, photocopies, mailing tubes, silver paper: it's very important to me to have materials that are in everyday use.

THOMAS HIRSCHHORN

I WANTED TO WORK WITH A MATERIAL THAT CELEBRATED THE IDEA OF MEMORIALIZING SOMEONE. →

HISTORICALLY THINKING ABOUT WHAT MATERIAL IN THE WORLD DOES THAT, BRONZE CAME TO MIND.

MICKALENE THOMAS

I USE THE MATERIAL FROM PERFORMANCES, I RECYCLE IT.

JOAN JONAS

THE BOUNDARIES OF PAINTING EXCITE ME. YOU'VE GOT THE SAME OLD MATERIALS— JUST OILS AND A CANVAS—AND YOU'RE TRYING TO DO SOMETHING THAT'S BEEN DONE FOR CENTURIES.

CECILY BROWN

EVERYTHING
I DO HAS AN ELEMENT
OF ENGINEERING
IN IT—PARTICULARLY
SINCE I DISLIKE
GLUING PARTS
TOGETHER OR TAKING
ADVANTAGE OF
SOMETHING THAT IS
NOT INHERENT
IN THE MATERIAL.
I'M LEERY OF WELDING
OR PASTING. IT
IMPLIES TAKING
AN UNFAIR ADVANTAGE
OF NATURE.

ISAMU NOGUCHI

To work with threads
seemed sissy to me.
I wanted something
to be conquered. But
circumstances held me
to threads and they won
me over. I learned
to listen to them and to
speak their language.

ANNI ALBERS

I LIKE CLOTHING AS
A MATERIAL. FOR ME IT IS
NOT SIMPLY CLOTH,
BUT A "SECOND SKIN"
THAT CARRIES MANY
OTHER THINGS, LIKE
PERSONAL MEMORY AND
DIFFERENT HISTORICAL
EPOCHS AND SOCIAL
BACKGROUNDS.

YIN XIUZHEN

TRUTH IS,
I USE TEMPERA
PARTLY BECAUSE
IT'S SUCH A DULL
MEDIUM—THOSE
MINUTE STROKES
PUT A BRAKE ON
MY REAL NATURE—
MESSINESS.

ANDREW WYETH

One thing gets born
out of another. I work
with things left over
from other things.

JULIAN SCHNABEL

I glued male sexual patterns on women's clothes and sprayed them completely with silver paint. Initially, I used white paint, but began to use silver and gold sprays around 1963 as I found them to be more durable.

YAYOI KUSAMA

I'm still managing to work a little, but paints are hard to come by here and very expensive, depression, depression! Let's hope, let's hope that there's a sale. For that we would sacrifice a golden calf.

PAUL CÉZANNE

I like to use local materials like tree branches or garbage. It makes for a more direct, intimate relationship with the viewer.

XU BING

I DON'T MAKE "DEMATERIALIZED ART. I COMPLICATE ACTUAL SITUATIONS, AND THIS IS AS MATERIAL AS ANYTHING ELSE.

FRED SANDBACK

Everything can be used—but of course one doesn't know it at the time. How does one know what a certain object will tell another?

JOSEPH CORNELL

Art can be expressed just as well by means of wool, paper, ivory, ceramics glass as by painting, stone, wood, clay.

JEAN ARP

GIVE ME A PIECE OF CHARCOAL AND I WILL MAKE YOU A PICTURE.

FRANCISCO DE GOYA

THERE'S NOTHING SACROSANCT ABOUT MATERIALS.

DONALD JUDD

BECOMING AN ARTIST IS NOT A GOOD BUSINESS PLAN.

CAROL BOVE

I DON'T MIND
SAYING I FIND
IT DIFFICULT
TO SQUARE UP
THE MONEY
AND THE FAME
WITH THE ART
AND INTEGRITY.

DAMIEN HIRST

I AM LITERALLY PENNILESS HERE, OBLIGED TO PETITION PEOPLE, ALMOST TO BEG FOR MY KEEP, NOT HAVING A PENNY TO BUY CANVAS AND PAINTS.

CLAUDE MONET

When I was broke, I needed hope as a currency. I needed to know that even though I didn't have very much, this work that I was doing was very important.

THEASTER GATES

I went to see Monet yesterday. I found him heartbroken and completely on the rocks. He asked me to find him someone who would take from →

ten to twenty of his pictures, at their choice, for 100 fr. apiece…. I had thought of a dealer or of some collector or other; but it is just possibl they might refuse.

ÉDOUARD MANET

I live month to month. I'm barely keeping it together. I have no security, I own nothing.

JUDY CHICAGO

I remember when I had to struggle to buy paint, and when I had to allow the size of things I made to be determined by what I could afford. It sucks.

KEHINDE WILEY

I never had a penny to my name, so I changed my name.

RICHARD PRINCE

PAINTING AND
SCULPTURE, HARD WORK
AND FAIR DEALING
HAVE BEEN MY RUIN
AND THINGS GO
CONTINUALLY FROM
BAD TO WORSE. IT WOULD
HAVE BEEN BETTER
HAD I BEEN PUT TO
MAKING MATCHES IN
MY YOUTH, THAN TO BE
IN SUCH A FRET!

MICHELANGELO

LIFE IS MUCH MORE FUN WHEN YOU HAVE TO WORRY ABOUT MONEY COMING IN.

AUGUSTE RENOIR

MONEY IS
A FRAGILE THING;
LET US EARN
SOME OF IT, SINCE
WE MUST, BUT
LET US KEEP
TO OUR ROLE....

CAMILLE PISSARRO

I don't see anything wrong with artists making money. And art really isn't that expensive compared with other luxury goods—a painting costs less than a sports car. If art makes you feel something, then the expense is worth it.

THOMAS DEMAND

Usually the people who are the most generous are people who have the least to give. I learned this firsthand as a newspaper carrier when I was 12 years old. The biggest tips came from the poorest people.

KEITH HARING

I'M SHOCKED THAT I CAN LIVE PRETTY WELL, OR REASONABLY, OR MAKE A CERTAIN AMOUNT OF MY LIVING, ANYWAY, OFF OF PRINTS. I GUESS IT'S NUTS I DON'T BELIEVE IN IT. I NEVER ANTICIPATED IT.

GARRY WINOGRAND

I THINK
BEING
REASONABLY
POOR,
THAT IS,
NOT HUNGRY,
IS VERY
GOOD FOR
PEOPLE.

IMOGEN CUNNINGHAM

ART
IS
MY
CAPITAL.

PAUL GAUGUIN

I DON'T MAKE SCULPTURES
THAT COST MILLIONS....I USED TO
PUSHPIN THE WORK, NOW I FRAME IT.
OK, BIG DIFFERENCE. BEFORE I DID
THE PHOTO MYSELF, NOW I GIVE IT
TO A LAB. DOES IT CHANGE THE WORK?
NO, I DON'T THINK SO.

SOPHIE CALLE

IT'S A LOT OF PRESSURE
TO PRODUCE SOMETHING
FOR $25 WHEN YOU REALLY
NEED $25. IT DOESN'T
MATTER IF THE PRESSURE IS
FOR $2,500 OR $25,000–
IT'S THE SAME PRESSURE.

FRANK STELLA

I HAVE HAD THE
POSSIBILITY OF GREAT RICHES,
BUT THEY HAVE NEVER
MEANT ANYTHING TO ME.
I HAVE WANTED LITTLE,
WHICH IS IN REALITY MUCH.

ALFRED STIEGLITZ

MONEY IS NOT FOR SAVING.

YAYOI KUSAMA

YOUR PICTURES WOULD HAVE BEEN FINISHED A LONG TIME AGO IF I WERE NOT FORCED EVERY DAY TO DO SOMETHING TO EARN MONEY.

EDGAR DEGAS

I'M IN LOVE WITH THE SUN AND WITH THE REFLECTIONS IN THE WATER, AND TO PAINT THEM I WOULD GO AROUND THE WORLD.

AUGUSTE RENOIR

AUTUMN IS QUITE BEAUTIFUL HERE BUT ALL THE SAME HAS A FUNEREAL AIR, LIKE ALL BEAUTIFUL AUTUMNS—SOMETHING LIKE A FUNEREAL RELAXATION OF THINGS.

MARCEL DUCHAMP

THERE IS ALWAYS SOMETHING SPIRITUAL ABOUT THE APPROACH OF WINTER. YOU RETIRE INTO YOUR INNERMOST CHAMBERS AND CAMP NEAR THE SMALL GLOW YOU FIND THERE.

PAUL KLEE

I HAVE NO OTHER WISH THAN A CLOSE FUSION WITH NATURE....

CLAUDE MONET

THE BLUE LIGHT IS
CREEPING OVER BLVD.
MONTPARNASSE
AND THE SPARROWS
ARE CHIRPING IN THE
TREES WAITING
FOR A WINDFALL.

MAN RAY

THE LOUVRE IS A
GOOD BOOK TO CONSULT
BUT IT MUST ONLY
BE AN INTERMEDIARY.
THE REAL AND IMMENSE
STUDY THAT MUST BE
TAKEN UP IS THE MANIFOLD
PICTURE OF NATURE.

PAUL CÉZANNE

THE DIFFICULTY OF SKIES
IN PAINTING IS VERY GREAT,
BOTH AS TO COMPOSITION AND
EXECUTION; BECAUSE, WITH ALL THEIR
BRILLIANCY, THEY OUGHT NOT TO
COME FORWARD, OR, INDEED, BE
HARDLY THOUGHT OF ANY MORE
THAN EXTREME DISTANCES ARE....

JOHN CONSTABLE

THE SKY IS EVERYTHING.

ROBERT IRWIN

EVERYONE REPEATS THEMSELVES.

RACHEL WHITEREAD

Plagiarism,
of which I have been
a constant victim,
is not as painful when
a thing is copied
outright as when it is
istorted and vulgarized
in an attempt to
disguise the theft.

ISAMU NOGUCHI

I THINK IT'S COPYING WHEN YOU DON'T ADD ANYTHING TO IT.

JOHN BALDESSARI

I COULD NOT
BELIEVE THE CAVALIER
MANNER IN WHICH
MY WORK WAS BEING
PLAGIARIZED. I SAW MY
IMAGES APPEARING
ON WOMEN'S DRESSES,
ON MATCHBOXES,
ON LINENS, ON TOWELS—
YOU NAME IT!

BRIDGET RILEY

THE <u>NEW</u>
IS VERY OLD;
YOU MIGHT
EVEN SAY THAT
IT IS THE
OLDEST THING
OF ALL.

EUGÈNE DELACROIX

**IT'S WONDERFUL
WHEN WHOLE
GREAT AVENUES
ARE BLOCKED
OFF FOR YOU BY
GIANTS BECAUSE
YOU HAVE TO
FIND YOUR OWN
LITTLE CORNER.**

CARL ANDRE

IT IS ALL VERY
WELL TO COPY WHAT
YOU SEE, BUT IT
IS MUCH BETTER
TO DRAW ONLY WHAT
YOU STILL SEE IN
YOUR MEMORY.

EDGAR DEGAS

THE FACT
IS THAT
MOST PEOPLE
DON'T DO
ANYTHING
SPECIAL
ENOUGH
TO BE
RIPPED OFF.

JOHN CURRIN

MY WORK IS ACTUALLY
DIFFERENT FROM COMIC STRIPS
IN THAT EVERY MARK IS
REALLY IN A DIFFERENT PLACE,
HOWEVER SLIGHT THE
DIFFERENCE SEEMS TO SOME.
THE DIFFERENCE IS OFTEN
NOT GREAT, BUT IT IS CRUCIAL.

ROY LICHTENSTEIN

I HAVEN'T MADE ONE ORIGINAL STATEMENT.

AD REINHARDT

I'D RATHER HAVE NO STYLE THAN ANY STYLE.

ED RUSCHA

I HAVEN'T BEEN WORRIED ABOUT CREATING A SO-CALLED SIGNATURE STYLE, ALTHOUGH I THINK MY PAINTINGS ARE QUITE RECOGNIZABLE.

CHARLINE VON HEYL

YOU THINK YOU'RE
DOING SOMETHING
ENTIRELY YOUR OWN,
AND A YEAR LATER,
YOU LOOK AT IT AND
YOU SEE ACTUALLY
THE ROOTS OF WHERE
YOUR ART COMES
FROM WITHOUT YOUR
KNOWING IT AT ALL.

MARCEL DUCHAMP

I DON'T HAVE A PHILOSOPHY. I HAVE A CAMERA.

SAUL LEITER

I USE THE EXPRESSION "ACT OF FAITH" A LOT, BECAUSE I HAVE TO BELIEVE THAT IT'S GOING TO BE ALL RIGHT AND SOMETIMES IT FEELS LIKE IT'S NOT.

TACITA DEAN

I BELIEVE IN TEMPORARY ART WHOLEHEARTEDLY. WHATEVER YOU THINK TO DO SHOULD NOT BE A FUTURE BURDEN. IT SHOULD BE DESTRUCTIBLE.

DAN FLAVIN

I DON'T BELIEVE IN FUNERALS.

YOKO ONO

I don't believe in heroes. In heroines, perhaps.

HITO STEYERL

WOMAN'S NAKEDNESS IS WISER THAN THE TEACHINGS OF THE PHILOSOPHERS.

MAX ERNST

I BELIEVE THAT IT'S VERY IMPORTANT TO EXPERIENCE A RADICAL RUPTURE, DISCONTINUITY OR TRANSFORMATION OF MEANING DURING YOUR LIFE, BUT THE EARLIER IT HAPPENS THE BETTER.

ANRI SALA

I feel that if one accepts things which one does not approve of, it is the beginning of the end, and by and by you get more things of a similar nature.

ALEXANDER CALDER

I BELIEVE THAT YOU ALWAYS HAVE TO BELIEVE.

GERHARD RICHTER

MY CLOUD PHOTOGRAPHS ARE <u>EQUIVALENTS</u> OF MY MOST PROFOUND LIFE EXPERIENCE, MY BASIC PHILOSOPHY OF LIFE.

ALFRED STIEGLITZ

IN A BURNING BUILDING, I WOULD SAVE A CAT BEFORE A REMBRANDT.

ALBERTO GIACOMETTI

WHO PAYS ATTENTION TO YOU, REALLY, A HUNDRED PERCENT? YOUR DOCTOR, YOUR DENTIST, AND YOUR PHOTOGRAPHER. THEY REALLY LOOK AT YOU, AND IT'S NICE.

DOROTHEA LANGE

NO ONE WILL
EVER KNOW WHAT
I WENT THROUGH
TO SECURE THOSE
NEGATIVES. THE
WORLD CAN NEVER
APPRECIATE IT.
IT CHANGED THE
WHOLE COURSE
OF MY LIFE.

MATHEW BRADY

From the time we started
taking pictures when we
were 13, photography struck us
as a stale medium that needed
to be broken wide open....
We want to show the guts of
photography—mainly because
we love it so much.

DOUG STARN

IT IS IMPORTANT TO
SEE WHAT IS INVISIBLE TO
OTHERS—PERHAPS
THE LOOK OF HOPE OR THE
LOOK OF SADNESS.

ROBERT FRANK

No photograph, no
matter how good it is,
is worth hurting people.

ARTHUR LEIPZIG

There is an old Arab
saying, "The apparent
is the bridge to the real."
All I have to work with
as a photographer are
surfaces. The surface of
a thing is an indication
of deeper forces.

STEPHEN SHORE

My favorite
picture? How can
I tell? Was it Cocteau's
hands? Or James
Joyce's black patch?
Norris Dam, or Cities
Service Building?
Old cigar store Indians,
or tugs on the East
River? Why should
I love it more than
other pictures?

BERENICE ABBOTT

NOTHING IS MORE HATEFUL TO ME THAN PHOTOGRAPHY SUGARCOATED WITH GIMMICKS, POSES, AND FALSE EFFECTS.

AUGUST SANDER

I AM NOT INTERESTED IN RULES AND CONVENTIONS. PHOTOGRAPHY IS NOT A SPORT. IF I THINK A PICTURE WILL LOOK BETTER BRILLIANTLY LIT, I USE LIGHTS, OR EVEN FLASH. IT IS THE RESULT THAT COUNTS, NO MATTER HOW IT WAS ACHIEVED.

BILL BRANDT

PART OF WHAT EXCITES
ME ABOUT PHOTOGRAPHY
IS ITS VERY UNCERTAINTY,
THE FACT THAT IT IS NOT
JUST THE PHOTOGRAPHER,
BUT THE VAGARIES OF
THE WORLD THAT RESULT
IN THE PHOTOGRAPH.

ALEX WEBB

I DON'T TAKE PICTURES; PICTURES TAKE ME.

CHARLES HARBUTT

THE TERM "PHOTOGRAPHY" IS NOW SO WELL KNOWN, THAT AN EXPLANATION OF IT IS PERHAPS SUPERFLUOUS.

WILLIAM HENRY FOX TALBOT

I'M HAPPY TO HAVE FOUND INTERESTING QUESTIONS, PERHAPS UNANSWERABLE ONES. PHOTOGRAPHY IS WELL-SUITED TO THIS, TO PINNING FLEETING MOMENTS DOWN, PIERCING THE OPAQUE MEMBRANE THAT SURROUNDS US.

PAUL GRAHAM

YOU LEARN THINGS
THROUGH TAKING
PHOTOGRAPHS;
PHOTOGRAPHY IS
YOUR TEACHER.
THE MAIN THING IS
TO KEEP ON TAKING
PHOTOGRAPHS
FOR EVER AND EVER.

NOBUYOSHI ARAKI

I'D LIKE TO KNOW WHO FIRST GOT IT IN HIS HEAD THAT DREAMINESS AND MIST IS ART. TAKE THINGS AS THEY ARE; TAKE GOOD PHOTOGRAPHS AND THE ART WILL TAKE CARE OF ITSELF.

EDWARD STEICHEN

Street photography doesn't interest me at all.

ROBERT MAPPLETHORPE

I didn't start taking pictures until I was in college. I had a crush on a girl who was a photo major, and followed her into a photography class. My Photo 1 teacher was Laurie Simmons, and my crush went from the girl to my teacher. As soon as I took my first pictures, my crush shifted from the teacher to photography.

GREGORY CREWDSON

The majority of my work is about preparation. The act of taking photographs is actually a very small part of the process.

TARYN SIMON

If you are a shy kid, it's great to be a photographer. It is your handshake to the outside world. Sometimes if I have to go to a party, instead of sitting myself at the bar, I become the most popular person because I have a camera.

BRUCE WEBER

Painting is an additive practice. You start out with a white canvas and make your marks. Photography is subtractive, you have the whole world and you edit and select a small rectangle or square of it.

UTA BARTH

YOU HAVE TO HOLD THE BUTTON DOWN.

ARNOLD NEWMAN

IT IS IMPORTANT TO ME TO EAT ONLY EVERYTHING THAT IS IN SEASON.

SALVADOR DALÍ

I THINK MY SYSTEM OF HAVING ONLY ONE MEAL A DAY CERTAINLY SUITS ME MUCH BETTER.

EUGÈNE DELACROIX

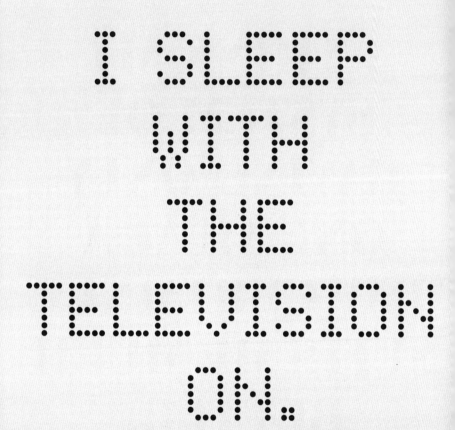

I SLEEP WITH THE TELEVISION ON.

ANDY WARHOL

I'VE GOT THE OLD EIGHTH STREET HABIT OF SLEEPING ALL DAY AND WORKING ALL NIGHT PRETTY WELL LICKED.

JACKSON POLLOCK

MY LIFE HAS BEEN REGULATED BY INSOMNIA.

LOUISE BOURGEOIS

I GO SWIMMING EVERY DAY.

THOMAS DEMAND

I LIKE GETTING UP WITH THE SUN AND MAKING BREAKFAST AND WALKING ALL DAY, BEING TIRED IN A VERY PHYSICAL, SIMPLE WAY. APART FROM ANYTHING ELSE, IT IS JUST A VERY GOOD WAY TO LIVE LIFE. SOMEHOW I HAVE FOUND A WAY TO MAKE IT INTO ART.

RICHARD LONG

I get up, I move
around, I go to
bed. I get up fairly
early, usually have
breakfast at eight
o'clock. I like
to spend my mornings
in the darkroom.
I'm trying to catch
up on the negatives
I've got that I've
never printed.

ANSEL ADAMS

BEING LIFTED
OUT OF YOUR
NORMAL ROUTINE
COMPLETELY
CHANGES YOUR
PERCEPTION
OF EVERYTHING.
I OFTEN THINK
THAT THIS TIME
TWIST IS LIKE
TAKING A DRUG,
IT ALTERS YOUR
CONSCIOUSNESS.

ANDREA ZITTEL

IN THE END,
IT DOESN'T REALLY
MATTER WHAT YOU
PAINT. IT'S ALL JUST A
ROUTINE TO CONNECT
YOURSELF FINALLY
WITH OTHER PEOPLE.

CHRIS OFILI

It is impossible
for me to do something
like wake up every
morning at six to run,
as people do. I like to
make rules and change
them all the time.
Even when I buy the
milk in Amsterdam,
I find new ways to go
around the canal.

MARINA ABRAMOVIĆ

I WORK ONE
DAY ON, ONE
DAY OFF NOW.
I WORKED
YESTERDAY.

JOHN CHAMBERLAIN

THERE IS A RIGHT PHYSICAL SIZE FOR EVERY IDEA.

HENRY MOORE

WHEN I HAVEN'T DONE ANYTHING FOR A LONG TIME, I ALWAYS START SMALL, ON PAPER.

GERHARD RICHTER

I LIKE SQUARISH FORMS.
SO I MAKE PAINTINGS 7 TO 8; 70 BY
80 INCHES. IF I WANT IT BIGGER,
I MAKE IT 77 BY 88 INCHES. THAT IS
KIND OF SQUARISH. I LIKE IT, BUT I HAVE
NO MYSTIQUE ABOUT IT.... I LIKE A
BIG PAINTING TO LOOK SMALL. I LIKE
TO MAKE IT SEEM INTIMATE THROUGH
APPEARING SMALLER THAN IT IS.

WILLEM DE KOONING

I THINK YOU CAN
HAVE GIANT PHYSICAL
SIZE WITH NO
STATEMENT ON IT
SO THAT IT IS AN
ABSURD BLOW-UP OF
NOTHINGNESS.

LEE KRASNER

ART HAS
BEEN SUBJECT TO
THE INFLUENCE
OF GIGANTISM.
THINGS HAVE TO
BE BIG.

RICHARD HAMILTON

I PAINT VERY LARGE PICTURES.

MARK ROTHKO

I SHRINK THE
BUILDINGS OF A CITY
DOWN UNTIL THEY
CAN BE PUT IN A
SUITCASE AND CARRIED.
WITH THE HUMAN
ORGANS, I MAGNIFY
THEM UNTIL YOU
CAN STEP INSIDE THEM.

YIN XIUZHEN

I tend to be excited with either a tiny, or a very large format. It's the format, not the subject that determines a lot in the painting. I don't like to use the usual "easel-size" canvas; a different size, greater or smaller, sharpens one's sense of space.

ROBERT MOTHERWELL

THE ONLY CHANCE I HAVE EVER HAD TO WORK ON A LARGE SURFACE, AND I FAILED TO MAKE GOOD USE OF IT, AS USUAL.

PIERRE BONNARD

I DON'T LIKE TO MAKE MINIATURE PAINTINGS AND I FREQUENTLY DO IT, BUT EVERY TIME I MAKE ONE I SAY "I'LL NEVER MAKE ANOTHER ONE," AND I CONSTANTLY HAVE SOME IMPULSE TO DO IT.

JASPER JOHNS

I THINK I COULD CONTROL THE ENVIRONMENT IF I WANTED TO WITH SOMETHING THE SIZE OF A BOOK.

EVA HESSE

THE TRUE SIZE IS ONLY REALIZED IN THE VIEWER'S IMAGINATION.

ISA GENZKEN

I KNOW HOW TO CARVE. NO CREDIT TO ME. I WAS JUST BORN LIKE THAT.

BARBARA HEPWORTH

I LOVE MY
SCULPTURES,
AND I WAS LUCKY
I HAD THEM FOR
FIFTY YEARS
BECAUSE NO ONE
WOULD LOOK AT
THEM, AND I REALLY
LIKED HAVING
THEM AROUND.

CY TWOMBLY

**THE FIRST HOLE
MADE THROUGH
A PIECE OF STONE
IS A REVELATION.**

HENRY MOORE

I THOUGHT THAT
OUTDOOR SCULPTURE
WAS USUALLY BIG
AND DURABLE, BUT
THAT SEEMED VERY
DUMB, BECAUSE IT'S
ALREADY VERY NICE
OUTSIDE, WITH TREES
AND FIELDS, AND I
DIDN'T WANT TO PUT →

SOMETHING THERE
AND CHANGE IT ALL.
SO I THOUGHT I'D
MAKE SOMETHING WHICH
FELL APART AFTER A
WHILE—WHICH WOULD
RETURN TO NATURE.
LIKE DIRT OR PAPER.

BRUCE NAUMAN

Up to a certain time,
I was cutting into things.
Then I realized that
the thing I was cutting
was the cut. Rather than
cut into the material,
I now use the material
as the cut in space.

CARL ANDRE

Some sculptures
give off a strong,
clear perfume, easy
to define; in others
the smell, the title,
is as hard to grasp as
catching a shadow.

ANTHONY CARO

ONE OF MY
FAVORITE DEFINITIONS
OF THE DIFFERENCE
BETWEEN ARCHITECTURE
AND SCULPTURE
IS WHETHER THERE IS
PLUMBING OR NOT.

GORDON MATTA-CLARK

SCULPTURES ARE PAINTINGS THAT STAND ON THEIR OWN.

FRANK STELLA

SCULPTURE IS LIKE FARMING. IF YOU JUST KEEP AT IT, YOU CAN GET QUITE A LOT DONE.

RUTH ASAWA

SCULPTURE SHOULD WALK ON THE TIPS OF ITS TOES, UNOSTENTATIOUS, UNPRETENTIOUS, AND LIGHT AS THE SPOOR OF AN ANIMAL IN SNOW.

JEAN ARP

I WAS IN
ANALYSIS, AND
I TOLD MY
ANALYST I WANTED
TO BE THE
BEST SCULPTOR
IN THE WORLD,
AND HE SAID,
"RICHARD,
CALM DOWN."

RICHARD SERRA

GRAVITATION IS THE ONLY LOGICAL FACTOR A SCULPTOR HAS TO CONTEND WITH.

DAVID SMITH

WHOM ONE GETS INTO BED WITH IS NO LIGHT MATTER.

PAUL GAUGUIN

Sex? I had to relearn it. I used to think, my god what is this? Because I had sex totally drunk for years.

DAMIEN HIRST

THE MOST EXCITING THING IS NOT-DOING-IT. IF YOU FALL IN LOVE WITH SOMEONE AND NEVER DO IT, IT'S MUCH MORE EXCITING.

ANDY WARHOL

CLUBBING AND SEX HAVE GREAT POTENTIAL TO GO STALE AND BECOME BORING AND REPETITIVE.

WOLFGANG TILLMANS

IF I SEE SEX IN A MOVIE, I WANT TO TURN AWAY.

JEAN-MICHEL BASQUIAT

I think the pictures I take dealing with sexuality are probably the most potent of pictures that I have ever taken.

ROBERT MAPPLETHORPE

I was obsessed with magic when I was a kid. I used to wait for a magician to come on TV and saw a woman in half, or hypnotize a woman and make her float in the air. I think it was my first sexual thrill.

LAURIE SIMMONS

My best works are erotic displays of mental confusions (with intrusions of irrelevant information).

MARLENE DUMAS

I have the taste of almonds from your lips in my mouth.

FRIDA KAHLO

I WASN'T TRYING TO BE SENSATIONAL BY HAVING SEX ON CAMERA.

JACOLBY SATTERWHITE

THE EROTIC OR THE SEXUAL IS THE ROOT OF "ART"; ITS FIRST IMPULSE.

CLAES OLDENBURG

I AM MOST
ANXIOUS TO GET
INTO MY LONDON
PAINTING-ROOM,
FOR I DO NOT
CONSIDER MYSELF
AT WORK UNLESS
I AM BEFORE A
SIX-FOOT CANVAS.

JOHN CONSTABLE

I TURNED MY COAL-HOUSE INTO MY DARK ROOM, AND A GLAZED FOWL HOUSE I HAD GIVEN TO MY CHILDREN BECAME MY GLASS HOUSE! THE HENS WERE LIBERATED, I HOPE AND BELIEVE NOT EATEN.

JULIA MARGARET CAMERON

I HAD RENTED AN OLD SUPERMARKET IN KINGSBURG AND TURNED ITS MAIN ROOM INTO A CLEAN WHITE STUDIO, THE BACK SPACE INTO A SPRAY BOOTH, THE MEAT LOCKER INTO MY OFFICE, AND A SMALL STORAGE AREA INTO MY LIVING QUARTERS.

JUDY CHICAGO

I WASN'T AN ARTIST WHO WAS DOING STUFF IN A STUDIO, AND THEN STUFF WAS TRANSFERRED FROM STUDIO TO SHOWING PLACE.... INSTALLATION MEANT SOMETHING VERY, VERY LITERAL FOR ME.

VITO ACCONCI

I am on the eleventh floor, facing the north sky. This is like a very traditional nineteenth-century painter's studio in Paris—a brownstone building—the painter usually takes the top floor, facing north, so you never get the direct sunlight but the beautiful reflection of the sky.

HIROSHI SUGIMOTO

WE HAD THIS BIG OLD HOUSE, AND IN A CORRIDOR DOWNSTAIRS, THERE WAS THIS WEIRD CUPBOARD. I KEPT NOSYING AROUND IT, AND EVENTUALLY MY MOTHER GAVE IT TO ME: IT BECAME MY FIRST STUDIO, AND NO ONE ELSE WAS ALLOWED IN.

JENNY SAVILLE

When works leave my studio they no longer have anything to do with me; they become completely alien.

DORIS SALCEDO

THERE WAS NOTHING IN
THE STUDIO BECAUSE I DIDN'T HAVE
MUCH MONEY FOR MATERIALS.
SO I WAS FORCED TO EXAMINE MYSELF
AND WHAT I WAS DOING THERE.
I WAS DRINKING A LOT OF COFFEE,
THAT'S WHAT I WAS DOING.

BRUCE NAUMAN

I RAN INTO JACOB LAWRENCE
ON THE STREET ONE DAY. HE SAID
HE HAD A STUDIO AND THERE
WAS ONE VACANT ABOVE HIM.
HE WAS LIVING AT 33 WEST 125TH
STREET. SO I WENT AND GOT
THIS STUDIO, MY FIRST STUDIO.
IT WAS EIGHT DOLLARS A MONTH
INCLUDING THE ELECTRICITY.

ROMARE BEARDEN

THE CAR IS MY STUDIO BY NOW. I GET MY IDEAS IN HERE, IN THIS KIND OF AUTONOMOUS CAPSULE LINKED TO THE OUTSIDE WORLD, PERHAPS PRECISELY BECAUSE ONE IS NOT IN AN EXACT PLACE.

ALBERTO GARUTTI

MY CAR BECAME MY HOME.
IT WAS A TWO-SEATER, WITH A SPECIAL
EXTRA-LARGE LUGGAGE COMPARTMENT.
I KEPT EVERYTHING THERE, AN EXTRA CAMERA,
CASES OF FLASH BULBS, EXTRA LOADED
HOLDERS, A TYPEWRITER, FIREMAN'S BOOTS,
BOXES OF CIGARS, SALAMI, INFRA-RED
FILM FOR SHOOTING IN THE DARK, UNIFORMS,
DISGUISES, A CHANGE OF UNDERWEAR,
AND EXTRA SHOES AND SOCKS.

WEEGEE

SOMEBODY OUGHT TO INVENT AN INFLATABLE STUDIO. THEN PAINTERS WOULD BE FREE TO TRAVEL. (THE PREDICAMENT OF SCULPTORS IS HOPELESS.)

ROBERT MOTHERWELL

I LOOK OUT OF MY WINDOWS HERE FROM THE STUDIO AND SEE AMAZING THINGS, THE SORT OF THINGS THAT YOU'D NEVER SEE IN AN ART GALLERY.

DOROTHEA TANNING

A STUDIO IS A TOOLBOX.

RYAN GANDER

YOU MUST CLEAN AND ARRANGE YOUR STUDIO IN A WAY THAT WILL FORWARD A QUIET STATE OF MIND. THIS CAUTIOUS CARE OF ATMOSPHERE IS REALLY NEEDED TO SHOW RESPECT FOR THE WORK.

AGNES MARTIN

To escape the classic solitude of the studio, I go and work at my printers in Paris. It's like going to a bistro for me. When I push open the door and smell the odor of the inks, I am in another world.

PIERRE ALECHINSKY

Whenever I'm in Cologne I go to the cathedral there several times a day because I find it absolutely magnificent inside. I've even referred to it before as my "atelier."

ISA GENZKEN

I can't allow myself self-pity or a morbid attitude. There's too much left to do in the studio. That's the source as well as the place for my optimism

ANTHONY CARO

MY STUDIO IS IN MY HEAD.

FRED WILSON

I HATE FLOWERS— I PAINT THEM BECAUSE THEY'RE CHEAPER THAN MODELS AND THEY DON'T MOVE!

GEORGIA O'KEEFFE

NUDIST CAMPS
WAS A TERRIFIC
SUBJECT FOR ME.

DIANE ARBUS

It is easier
for me to take
ten good pictures
in an airplane
bathroom than in
the gardens
at Versailles.

SALLY MANN

PHOTOGRAPHERS
ARE TOO POLITE.
THEY'RE ALWAYS
PHOTOGRAPHING
THE MOONRISE OR
THE SUNSET OR
THEIR GIRLFRIEND'S
ASS, AD NAUSEAM.

DUANE MICHALS

I PHOTOGRAPH ALL
THE "ISMS"—TOURISM,
CONSUMERISM….

MARTIN PARR

I lean toward
the enchantment,
the visual power,
of the aesthetically
rejected subject.

WALKER EVANS

**IT OCCURS
TO ME THAT
I'VE NEVER BEEN
ABLE TO EAT
ANYTHING THAT
I'VE USED AS
A MODEL, EVEN
WHEN IT WAS
STILL FRESH
AFTER THE POSE.**

HENRI MATISSE

I really must settle
down seriously
to drawing horses.
I shall go to some
stable or other every
morning; I shall go
to bed early, and get
up early as well.

EUGÈNE DELACROIX

I LIKE TO SEE HOW DIFFERENT EACH DOG MIGHT BE. SOME ARE HELPFUL; OTHERS ARE SLEEPY; SOME ARE IN BETWEEN.

EDWARD WESTON
MIGHT BE THE BEST
EXAMPLE OF AN ARTIST
WHO CAN MAKE THE
MOST GORGEOUS IMAGES
OF A CABBAGE LEAF
OR A DEAD BIRD.

UTA BARTH

YESTERDAY I MADE
PHOTOGRAPHIC HISTORY:
FOR I HAVE EVERY REASON
AND BELIEF THAT TWO
NEGATIVES OF KELP DONE IN
THE MORNING WILL SOMEDAY
BE SOUGHT AS EXAMPLES
OF MY FINEST EXPRESSION
AND UNDERSTANDING.

EDWARD WESTON

THE IMPORTANT PART
FOR ME, MORE IMPORTANT
THAN THE PHOTOGRAPHS,
IS THE RELATIONSHIP
I HAVE WITH THE PEOPLE
I PHOTOGRAPH.

ROBERT MAPPLETHORPE

WHEN YOU TAKE A
PHOTOGRAPH OF SOMEBODY
YOU HAVE A RELATIONSHIP
WITH THE <u>PICTURE</u>, NOT
NECESSARILY WITH THEM.
MOST OF THE PEOPLE YOU
DON'T SEE EVER AGAIN.

RINEKE DIJKSTRA

IT'S EXTREMELY DIFFICULT TO MAKE SOMEBODY LOOK DEAD, TO DRAIN THE BODY OF INTENTIONALITY. I WANT THEM TO LOOK REALLY DEAD. DO THEY SEEM DEAD TO YOU?

CHARLES RAY

NOW THE EASIEST KIND OF A JOB TO COVER WAS A MURDER BECAUSE THE STIFF WOULD BE LAYING ON THE GROUND. HE COULDN'T GET UP AND WALK AWAY OR GET TEMPERAMENTAL. HE WOULD BE GOOD FOR AT LEAST TWO HOURS. AT FIRES YOU HAD TO WORK VERY FAST.

WEEGEE

IN MAKING A PORTRAIT,
I AM INDEED "OBJECTIFYING"
MY SUBJECT. THERE
IS SOMETHING UNPLEASANT
ABOUT ALL OF THIS.
AND IF I SPEND TOO MUCH
TIME ANALYZING IT,
I'D PROBABLY JUST TAKE
PICTURES OF FLOWERS.

ALEC SOTH

ALL THE YOUNG
PHOTOGRAPHERS
ARE COMING TO
ME—"HOW DO
YOU PHOTOGRAPH
POVERTY NOW?"

DOROTHEA LANGE

I NEVER MADE
A PERSON LOOK BAD.
THEY DO THAT
THEMSELVES.
THE PORTRAIT IS
YOUR MIRROR.

AUGUST SANDER

FLESH
WAS THE
REASON OIL
PAINTING
WAS
INVENTED.

WILLEM DE KOONING

BELIEVING IN ONE'S OWN ART BECOMES HARDER AND HARDER WHEN THE PUBLIC RESPONSE GROWS FONDER.

CINDY SHERMAN

I DON'T TALK ABOUT SUCCESS. I DON'T KNOW WHAT IT IS. WAIT UNTIL I'M DEAD.

IMOGEN CUNNINGHAM

I cannot help it that
my pictures do not sell.
Nevertheless the time
will come when people will
see that they are worth
more than the price
of the paint....

VINCENT VAN GOGH

It is the duty of an artist
to work in order to gain
strength. This duty I have
fulfilled and everything
I bring with me from down
there, finds only admirers—
yet I achieve nothing.

PAUL GAUGUIN

When I was
described as the
highest-selling woman
artist, it had a strange
force. In South Africa,
you weren't proud
to be an artist: it felt
egocentric. I was
a bit ashamed.

MARLENE DUMAS

THEY ALL TALK ABOUT
HOW FABULOUS THE
PAINTINGS OF THE PAST
WERE, BUT IN THE
PAST I DON'T REMEMBER
ANYONE EVER LIKING
THEM THAT MUCH. IT IS
A FANTASY THAT I WAS
AT ONE TIME A POPULAR
ARTIST—I WAS NEVER A
POPULAR ARTIST.

FRANK STELLA

**I THINK IT'S
NOT SUCH A GOOD
IDEA TO BE SO
CAUGHT UP IN
THAT FAME GAME
KIND OF THING AS
A PHOTOGRAPHER
BECAUSE WHAT'S
WONDERFUL
IS THAT YOU CAN
GO OUT IN THE
WORLD AND PEOPLE
DON'T REALLY
KNOW YOU.**

BRUCE WEBER

THAT'S ME, THE TWENTY-FIVE-YEAR OVERNIGHT SENSATION.

ED RUSCHA

SUCCESS IS DANGEROUS. ONE BEGINS TO COPY ONESELF, AND TO COPY ONESELF IS MORE DANGEROUS THAN TO COPY OTHERS.

PABLO PICASSO

WHAT I'VE FOUND
IS THE MORE FAMOUS
I'VE BECOME, THE MORE
SUCCESS I'VE HAD,
THE LESS PEOPLE SEEM
REALLY INTERESTED
IN ME AS A PERSON.

PIPILOTTI RIST

MOST ARTISTS STRUGGLE
TO BE RECOGNIZED BUT
FAME MISRECOGNIZES.
THE MOMENT YOU TOUCH
SUCCESS, YOUR SENSE
OF BEING SOMEBODY
DISAPPEARS.

AI WEIWEI

SUCCESS PUTS YOU IN A BUBBLE..... I HARDLY SEE ANYONE ANYMORE. I'M SO FAR UNDERGROUND, I GET THE BENDS.

RICHARD PRINCE

I DRAW FLOWERS
EVERY DAY ON
MY IPHONE AND
SEND THEM
TO MY FRIENDS,
SO THEY GET
FRESH FLOWERS
EVERY MORNING.

DAVID HOCKNEY

In the 21st century, when we're used to clicking and browsing and having constant choice, painting simply sits there silently and begs you to notice the smallest of detail.

KEHINDE WILEY

Just because technology is simple doesn't mean it needs to be part of our miraculous lives every day.

JOHN GIORNO

We don't have this contemplative, Mark Rothko experience of sitting for 20 minutes in front of the painting. Now we have a minute at most, and we don't even look at it because we turn our backs to it to look at ourselves in the reflection of the iPhone.

PIA CAMIL

I use an electric metronome in the darkroom rather than a clock timer. Rather than having to look at a clock I can watch the print. I can watch for three seconds here and burn for five there. And all the time there's a timer going in my head.

ANSEL ADAMS

I just don't understand how people can bear to make video installations. They can be so crudely pixelated, it pains me.

TACITA DEAN

I'VE USED FLASH BUT VERY RELUCTANTLY, VERY RELUCTANTLY, AND WHEN I DO USE IT I DISGUISE IT, AND TRY NOT TO.

DOROTHEA LANGE

NEXT TIME I SEE ANOTHER 16MM FILM PROJECTOR RATTLING AWAY IN A GALLERY I WILL PERSONALLY KIDNAP IT AND TAKE THE POOR THING TO A PENSIONERS' HOME.

HITO STEYERL

I DON'T DO DIGITAL, I AM STILL A DINOSAUR.

ELLIOTT ERWITT

YES, THE TITLE DOES MATTER.

LYNDA BENGLIS

I DON'T TITLE ANYTHING.

HELEN LEVITT

MY TITLES
ARE SORT OF
LIKE A LASSO;
THEY'RE THROWN
INTO SPACE.

LOUISE NEVELSON

WHEN I'M FINISHED AND THE WORK IS OFF THE LOOM, IT SITS THERE AND RUMINATES. THEN IT STARTS HAVING A NAME IN SPITE OF MYSELF.

SHEILA HICKS

I DON'T LIKE SENTIMENTAL TITLES.

HELEN FRANKENTHALER

Part of the impetus to name things is that if you don't they get called Untitled, and that just gets to be a drag to have a thing referred to as "untitled."

JOHN MCCRACKEN

For me the title is simply a sort of suggestive pleasure.

JASPER JOHNS

I'm always trying to find titles that have several layers, like the paintings, and ambivalent or multiple meanings. They should also convey a feeling phonetically and capture something of the paintings.

CHARLINE VON HEYL

I HAVE THOUGHT A LOT ABOUT THE QUESTION OF TITLES. I MUST CONFESS THAT I CAN'T FIND ANY FOR THE WORKS THAT TAKE OFF FROM AN ARBITRARY STARTING POINT AND END WITH SOMETHING REAL.

JOAN MIRÓ

I have often taken the titles of the works from the names of the materials or the brushes or the supplier. I try to choose words which can't be associated with very much. I wouldn't title a painting Clouds, for instance. That would be really disastrous.

ROBERT RYMAN

THE TITLES OF
MY SHOWS ARE
REALLY RELEVANT.
IF YOU LIST THEM
YOU CAN SEE A
SORT OF GUIDING
LINE ACROSS
MY WORK.

LUC TUYMANS

THE TITLE SHOULD
BE SOMETHING
YOU GET TO HAVE,
ALMOST LIKE AN
OBJECT, AND THAT
IS THE FIRST GIFT
YOU ARE GIVING AND
IT SHOULD BE EASY
AND MEMORABLE.

MIRANDA JULY

THERE'S A LOT TO BE SAID FOR A COMPASS.

RICHARD LONG

YOU SENT ME A BRASS RULE,
AS IF I WERE A BUILDER OR
A CARPENTER AND HAD TO
CARRY IT AROUND WITH ME.
I WAS ASHAMED TO HAVE
IT IN THE HOUSE AND
GAVE IT AWAY.

MICHELANGELO

INDIA INK AND
SPEEDBALL PENS
WERE REAL TOOLS
FOR BEGINNING MY
INTEREST IN ART.

ED RUSCHA

I STARTED
USING STENCILS
BECAUSE THEY
WERE CHEAP,
DURABLE, AND
AN EFFICIENT WAY
OF CONVEYING
INFORMATION
USING PAINT,
WHICH IS A VERY
SENSUOUS,
TACTILE, AND
INEFFICIENT
MATERIAL.

GLENN LIGON

I don't begin
by drawing on the
canvas. I make
marks, and then
I use all sorts
of things to work
with: old brooms,
old sweaters,
and all kinds
of peculiar tools
and materials.

FRANCIS BACON

I grew up with tools.
I came from a family
of people who sold
tools, and I've always
been enchanted by
these objects made by
anonymous hands.

JIM DINE

USE SHORT, SMALL BRUSHES.

EUGÈNE DELACROIX

THE CAMERA IS
SOMETHING OF A
NUISANCE IN A WAY.
IT'S RECALCITRANT.
IT'S DETERMINED
TO DO ONE THING
AND YOU MAY WANT
TO DO SOMETHING
ELSE. YOU HAVE
TO FUSE WHAT YOU
WANT AND WHAT
THE CAMERA WANTS.
IT'S LIKE A HORSE.

DIANE ARBUS

HUMOR AND LAUGHTER—
NOT NECESSARILY
DEROGATORY
DERISION—ARE MY
PET TOOLS.

MARCEL DUCHAMP

WEATHER COMPLETELY CLEAR AGAIN. BUT WINDY. PAINTING IN THE HARBOR. COAL DUST IN MY EYES AND IN THE WATERCOLORS. WORKED ANYWAY!

PAUL KLEE

IT IS THIS RAINY
WEATHER ESPECIALLY,
WHICH WE STILL
HAVE TO EXPECT TO
CONTINUE FOR MONTHS,
THAT HANDICAPS
ME SO MUCH.

VINCENT VAN GOGH

A GOOD DAY IS ONE
WHERE I'VE OVERCOME
MY PROCRASTINATION,
ACTUALLY GOTTEN OUT
THE DOOR TO SHOOT,
WEATHER COOPERATING.

PAUL GRAHAM

SOMETIMES
A WORK IS AT ITS
BEST WHEN MOST
THREATENED
BY THE WEATHER.
A BALANCED ROCK
IS GIVEN ENORMOUS
TENSION AND
FORCE BY A WIND
THAT MIGHT CAUSE
ITS COLLAPSE.

ANDY GOLDSWORTHY

For two days I've been in a ghastly mood and don't know what's going to come of it. The sky is unsettled and is sprinkling us with an unconcern that proves how little feeling the Eternal Father has with regard to outdoor painters.

HENRI DE TOULOUSE-LAUTREC

ZERO WEATHER FOUND ME WANDERING THROUGH SNOW-DRIFTS—SEEKING THE ELUSIVE PATTERNS IN BLACK AND WHITE—WHICH COVERED THE GROUND—OR SUNSETS OVER THE PRAIRIE WASTES.

EDWARD WESTON

NEVER HAVE I BEEN SO UNLUCKY WITH THE WEATHER. NEVER THREE SUITABLE DAYS IN SUCCESSION, SO I HAVE TO BE ALWAYS MAKING CHANGES, FOR EVERYTHING IS GROWING AND TURNING GREEN.

CLAUDE MONET

It was the smoggy weather that got me thinking about new energies in painting. The styles and forms of Chinese landscape painting have benefitted from the unique scenery and aesthetic ideas of China.

YIN XIUZHEN

AS USUAL, I HAVE BEEN OCCUPIED
IN PAINTING, SKETCHING &C. THE
WEATHER HAS BEEN DELIGHTFUL—
A SOFT, BALMY ATMOSPHERE, LIKE THE
VERY FINEST OF OUR SPRING DAYS,
A CLEAR SKY AND SUNSETS, IN WHICH
THE AIR SEEMS LIKE MOLTEN GOLD.

THOMAS COLE

I WORK OUTSIDE. WHEN IT RAINS, YOU GET MILDEW, FINGERPRINTS AND THINGS THAT ALL BECOME PART OF THE PALIMPSEST AND THE WHOLE STASIS OF THE PAINTING.

JULIAN SCHNABEL

THE WEATHER,
RAINY AND DULL
ON OUR ARRIVAL,
HAS CLEARED UP,
THE SUN SHINES
AND HOPE SMILES
IN THE HEART.
I SHALL SOON GO
TO WORK.

PAUL CÉZANNE

ARTIST INDEX

BOTT, BERENICE 237
398–1991)

RAMOVIĆ, MARINA 57, 82, 145, 249
1946)

CONCI, VITO 30, 145, 268
1940)

AMS, ANSEL 203, 249, 289
902–1984)

WEIWEI 156, 286
1957)

TKEN, DOUG 186
1968)

KERMAN, CHANTAL 168, 190
950–2015)

BERS, ANNI 25, 209
899–1994)

BERS, JOSEF 45, 104, 118
888–1976)

LECHINSKY, PIERRE 154, 272
.1927)

LTHAMER, PAWEL 49, 179
.1967)

LŸS, FRANCIS 35
.1959)

NDERSON, LAURIE 20, 61, 168
.1947)

NDRE, CARL 84, 227, 257
.1935)

NTIN, ELEANOR 45, 112, 173
.1935)

NTONI, JANINE 81, 190
.1964)

RAKI, NOBUYOSHI 241
.1940)

ARBUS, DIANE 73, 112, 181, 275, 300
(1923–1971)

ARP, JEAN 78, 210, 259
(1886–1966)

ASAWA, RUTH 45, 259
(1926–2013)

BACON, FRANCIS 74, 143, 177, 300
(1909–1992)

BALDESSARI, JOHN 18, 42, 227
(b. 1931)

BARLOW, PHYLLIDA 41, 45, 74
(b. 1944)

BARNET, WILL 32, 82
(1911–2012)

BARNEY, MATTHEW 151, 165
(b. 1967)

BARNEY, TINA 12
(b. 1945)

BARTH, UTA 123, 160, 242, 277
(b. 1958)

BASQUIAT, JEAN-MICHEL 79, 140, 190, 263
(1960–1988)

BEARDEN, ROMARE 128, 269
(1911–1988)

BECKMANN, MAX 70, 101
(1884–1950)

BEECROFT, VANESSA 74, 106
(b. 1969)

BENGLIS, LYNDA 207, 292
(b. 1941)

BEUYS, JOSEPH 29, 40
(1921–1986)

BLACK, KARLA 181, 205
(b. 1972)

BLAKE, WILLIAM 65
(1757–1827)

BOLTANSKI, CHRISTIAN 32
(b. 1944)

BONNARD, PIERRE 94, 112, 255
(1867–1947)

BOURGEOIS, LOUISE 23, 139, 191, 247
(1911–2010)

BOVE, CAROL 212
(b. 1971)

BOYCE, SONIA 10
(b. 1962)

BRADFORD, MARK 131
(b. 1961)

BRADY, MATHEW 237
(1822–1896)

BRÂNCUȘI, CONSTANTIN 8
(1876–1957)

BRANDT, BILL 238
(1904–1983)

BRAQUE, GEORGES 196
(1882–1963)

BROWN, CECILY 123, 208
(b. 1969)

BRUGUERA, TANIA 43
(b. 1968)

BURDEN, CHRIS 17, 41, 81, 202
(1946–2015)

CAGE, JOHN 66, 77
(1912–1992)

CALDER, ALEXANDER 57, 99, 141, 233
(1898–1976)

CALLE, SOPHIE 168, 219
(b. 1953)

CAMERON, JULIA MARGARET 68, 158, 267
(1815–1879)

CAMIL, PIA 289
(b. 1980)

CARO, ANTHONY 257, 2
(1924–2013)

CARTIER-BRESSON, HENRI 1
(1908–2004)

CASSATT, MARY
(1844–1926)

CATTELAN, MAURIZIO 1
(b. 1960)

CELMINS, VIJA 117, 1
(b. 1938)

CÉZANNE, PAUL 97, 210, 224, 3
(1839–1906)

CHAMBERLAIN, JOHN 144, 2
(1927–2011)

CHAN, PAUL 158, 1
(b. 1973)

CHICAGO, JUDY 50, 134, 214, 2
(b. 1939)

CHRISTO
(b. 1935)

CLOSE, CHUCK 27, 132, 1
(b. 1940)

COLE, THOMAS 3
(1801–1848)

CONRAD, TONY 2
(1940–2016)

CONSTABLE, JOHN 71, 225, 2
(1776–1837)

COOKE, NIGEL 1
(b. 1973)

CORNELL, JOSEPH 2
(1903–1972)

COROT, CAMILLE 55, 18
(1796–1875)

COURBET, GUSTAVE 3
(1819–1877)

CREWDSON, GREGORY 85, 24
(b. 1962)

CUNNINGHAM, IMOGEN 217, 283
(1883–1976)

CURRIN, JOHN 228
(b. 1962)

DA VINCI, LEONARDO 200
(1452–1519)

DAGUERRE, LOUIS 201
(1787–1851)

DALÍ, SALVADOR 147, 158, 171, 244
(1904–1989)

DE KOONING, WILLEM 112, 136, 251, 281
(1904–1997)

DEAN, TACITA 95, 233, 289
(b. 1965)

DEGAS, EDGAR 28, 138, 200, 221, 227
(1834–1917)

DELACROIX, EUGÈNE 13, 65, 108, 116, 227,
(1798–1863) 245, 275, 300

DELAUNAY, SONIA 168
(1885–1979)

DEMAND, THOMAS 124, 216, 248
(b. 1964)

DESPONT, LOUISE 203
(b. 1983)

DIJKSTRA, RINEKE 278
(b. 1959)

DINE, JIM 191, 300
(b. 1935)

DION, MARK 114
(b. 1961)

DOIG, PETER 45
(b. 1959)

DUCHAMP, MARCEL 51, 59, 223, 231, 301
(1887–1968)

DUMAS, MARLENE 155, 263, 284
(b. 1953)

DURHAM, JIMMIE 45
(b. 1940)

EGGLESTON, WILLIAM 49, 80
(b. 1939)

EKBLAD, IDA 74
(b. 1980)

ELIASSON, OLAFUR 65
(b. 1967)

EMIN, TRACEY 36, 174
(b. 1963)

ERNST, MAX 233
(1891–1976)

ERWITT, ELLIOTT 104, 291
(b. 1928)

ESCOBAR, MARISOL 86
(1930–2016)

EVANS, WALKER 15, 161, 183, 275
(1903–1975)

FISCHL, ERIC 37, 49
(b. 1948)

FISCHLI, PETER 65
(b. 1952)

FLAVIN, DAN 198, 233
(1933–1996)

FLETCHER, HARRELL 12, 90
(b. 1967)

FRANK, ROBERT 24, 36, 177, 237
(b. 1924)

FRANKENTHALER, HELEN 76, 85, 295
(1928–2011)

FREUD, LUCIAN 96, 181, 188
(1922–2011)

GALLACCIO, ANYA 88
(b. 1963)

GALLAGHER, ELLEN 128
(b. 1965)

GANDER, RYAN 272
(b. 1976)

GARUTTI, ALBERTO 270
(b. 1948)

GATES, THEASTER (b. 1973)	66, 214	**HARRIS, JANE** (b. 1956)	104, 2
GAUGUIN, PAUL (1848–1903)	218, 262, 284	**HATOUM, MONA** (b. 1952)	23, 2
GENZKEN, ISA (b. 1948)	255, 272	**HEPWORTH, BARBARA** (1903–1975)	2
GIACOMETTI, ALBERTO (1901–1966)	235	**HESSE, EVA** (1936–1970)	206, 2
GILBERT & GEORGE (b. 1943 & 1942)	91, 113	**HEYL, CHARLINE VON** (b. 1960)	74, 230, 29
GIORNO, JOHN (b. 1936)	289	**HICKS, SHEILA** (b. 1934)	207, 29
GOLDIN, NAN (b. 1953)	119, 142, 176	**HINE, LEWIS** (1874–1940)	19
GOLDSWORTHY, ANDY (b. 1956)	208, 304	**HIRSCHHORN, THOMAS** (b. 1957)	20
GORMLEY, ANTONY (b. 1950)	31, 193	**HIRST, DAMIEN** (b. 1965)	33, 141, 206, 213, 26
GORNIK, APRIL (b. 1953)	9	**HOCKNEY, DAVID** (b. 1937)	146, 203, 28
GOYA, FRANCISCO DE (1746–1828)	178, 210	**HOLZER, JENNY** (b. 1950)	87, 17
GRAHAM, PAUL (b. 1956)	113, 240, 303	**HOPPER, EDWARD** (1882–1967)	56, 10
GROSSE, KATHARINA (b. 1961)	35	**INGRES, JEAN AUGUSTE DOMINIQUE** (1780–1867)	
HAACKE, HANS (b. 1936)	205	**IRWIN, ROBERT** (b. 1928)	15, 67, 115, 22
HAMILTON, ANN (b. 1956)	187	**JEANNE-CLAUDE** (1935–2009)	9
HAMILTON, RICHARD (1922–2011)	252	**JOHNS, JASPER** (b. 1930)	12, 47, 121, 255, 29
HAMMOND, JANE (b. 1950)	129	**JOHNSON, RAY** (1927–1995)	11
HARBUTT, CHARLES (1935–2015)	239	**JONAS, JOAN** (b. 1936)	20
HARING, KEITH (1958–1990)	141, 216	**JR** (b. 1983)	19

DD, DONALD		101, 211
928–1994)		
LY, MIRANDA		127, 297
1974)		
HLO, FRIDA		263
07–1954)		
NDINSKY, WASSILY		105
66–1944)		
POOR, ANISH		50, 90, 98, 207
1954)		
TZ, ALEX		126, 197
1927)		
LLEY, MIKE		35
54–2012)		
LLY, ELLSWORTH		23, 59, 109, 173, 336
23–2015)		
LLY, MARY		20
1941)		
ARTANSSON, RAGNAR		23
1976)		
EE, PAUL		173, 223, 302
79–1940)		
EIN, YVES		49
28–1962)		
INE, FRANZ		11, 101
10–1962)		
H, TERENCE		170
1977)		
ONS, JEFF		85, 89
1955)		
RASNER, LEE		95, 252
08–1984)		
RUGER, BARBARA		127
1945)		
SAMA, YAYOI		169, 210, 220
1929)		
NGE, DOROTHEA		12, 57, 236, 280, 289
95–1965)		

LAWRENCE, JACOB		39
(1917–2000)		
LE PARC, JULIO		90
(b. 1928)		
LEIBOVITZ, ANNIE		16, 120
(b. 1949)		
LEIPZIG, ARTHUR		237
(1918–2014)		
LEITER, SAUL		195, 232
(1923–2013)		
LEVITT, HELEN		293
(1913–2009)		
LEWITT, SOL		21, 42, 128
(1928–2007)		
LICHTENSTEIN, ROY		229
(1923–1997)		
LIGON, GLENN		171, 300
(b. 1960)		
LIN, MAYA		194
(b. 1959)		
LONG, RICHARD		57, 248, 298
(b. 1945)		
LYNCH, DAVID		199
(b. 1946)		
LYON, DANNY		194
(b. 1942)		
MAGRITTE, RENÉ		192
(1898–1967)		
MAN RAY		81, 224
(1890–1976)		
MANET, ÉDOUARD		104, 166, 214
(1832–1883)		
MANN, SALLY		275
(b. 1951)		
MAPPLETHORPE, ROBERT		162, 242, 263, 278
(1946–1989)		
MARCLAY, CHRISTIAN		168
(b. 1955)		

MARK, MARY ELLEN 120
(1940–2015)

MARSHALL, KERRY JAMES 54
(b. 1955)

MARTIN, AGNES 19, 151, 180, 272
(1912–2004)

MATISSE, HENRI 27, 101, 119, 130, 168, 275
(1869–1954)

MATTA-CLARK, GORDON 150, 258
(1943–1978)

MCCASLIN, MATTHEW 158
(b. 1957)

MCCRACKEN, JOHN 128, 295
(1934–2011)

MCCURRY, STEVE 102, 190
(b. 1950)

MICHALS, DUANE 275
(b. 1932)

MICHELANGELO 215, 299
(1475–1564)

MIRÓ, JOAN 123, 141, 181, 295
(1893–1983)

MONDRIAN, PIET 114, 173
(1872–1944)

MONET, CLAUDE 95, 157, 214, 223, 305
(1840–1926)

MOORE, HENRY 250, 257
(1898–1986)

MORRIS, ROBERT 127
(b. 1931)

MOTHERWELL, ROBERT 34, 155, 255, 271
(1915–1991)

MUNCH, EDVARD 23, 152
(1863–1944)

MURAKAMI, TAKASHI 89
(b. 1962)

MUTU, WANGECHI 30, 118
(b. 1972)

NAUMAN, BRUCE 70, 257, 2
(b. 1941)

NEEL, ALICE 16,
(1900–1984)

NEVELSON, LOUISE 2
(1899–1988)

NEWMAN, ARNOLD 54, 2
(1918–2006)

NOGUCHI, ISAMU 86, 209, 2
(1904–1988)

NOLAND, KENNETH 1
(1924–2010)

O'KEEFFE, GEORGIA 135, 149, 2
(1887–1986)

OFILI, CHRIS 105, 2
(b. 1968)

OLDENBURG, CLAES 23, 98, 120, 190, 2
(b. 1929)

ONO, YOKO 12, 146, 2
(b. 1933)

PAGLEN, TREVOR
(b. 1974)

PARKS, GORDON 1
(1912–2006)

PARR, MARTIN 104, 2
(b. 1952)

PAYNE, OLIVER
(b. 1977)

PENN, IRVING 1
(1917–2009)

PETTIBON, RAYMOND 1
(b. 1957)

PEYTON, ELIZABETH 13,
(b. 1965)

PICASSO, PABLO 103, 146, 199, 2
(1881–1973)

PISSARRO, CAMILLE 69, 119, 2
(1830–1903)

OLLOCK, JACKSON 35, 52, 125, 133, 247
912-1956)

RINCE, RICHARD 22, 81, 167, 214, 287
1949)

AMA, CAROL 204
918-2015)

AUSCHENBERG, ROBERT 46, 75, 93, 149
925-2008)

AY, CHARLES 279
1953)

EED, DAVID 163
1946)

EINHARDT, AD 150, 167, 229
913-1967)

EMBRANDT 13, 57
606-1669)

ENOIR, AUGUSTE 41, 74, 158, 216, 222
841-1919)

ICHTER, GERHARD 72, 108, 120, 234, 251
1932)

ILEY, BRIDGET 58, 227
1931)

INGGOLD, FAITH 128
1930)

IST, PIPILOTTI 148, 286
1962)

OCKBURNE, DOROTHEA 111, 139
1932)

ODIN, AUGUSTE 48, 139
840-1917)

OSLER, MARTHA 49
1943)

OSSETTI, DANTE GABRIEL 146
828-1882)

OTHKO, MARK 30, 63, 135, 253
903-1970)

UBINS, NANCY 90
1952)

RUSCHA, ED 24, 104, 230, 285, 299
(b. 1937)

RYMAN, ROBERT 101, 127, 158, 295
(b. 1930)

SACHS, TOM 17
(b. 1966)

SALA, ANRI 149, 233
(b. 1974)

SALCEDO, DORIS 268
(b. 1958)

SALLE, DAVID 119, 199
(b. 1952)

SAMARAS, LUCAS 49, 81
(b. 1936)

SANDBACK, FRED 210
(1943-2003)

SANDER, AUGUST 238, 280
(1876-1964)

SATTERWHITE, JACOLBY 181, 264
(b. 1986)

SAVILLE, JENNY 35, 268
(b. 1970)

SCHANKER, LOUIS 127
(1903-1981)

SCHIELE, EGON 185
(1890-1918)

SCHNABEL, JULIAN 127, 209, 306
(b. 1951)

SERRA, RICHARD 90, 205, 260
(b. 1939)

SHEELER, CHARLES 112
(1883-1965)

SHERMAN, CINDY 122, 184, 282
(b. 1954)

SHORE, STEPHEN 85, 161, 237
(b. 1947)

SILLMAN, AMY 41, 149
(b. 1955)

SIMMONS, LAURIE (b. 1949)	263	**TANNING, DOROTHEA** (1910–2012)	12, 23, 168, 2
SIMON, TARYN (b. 1975)	242	**THIEBAUD, WAYNE** (b. 1920)	
SISKIND, AARON (1903–1991)	81, 115	**THOMAS, MICKALENE** (b. 1971)	12, 2
SMITH, DAVID (1906–1965)	38, 60, 261	**TILLMANS, WOLFGANG** (b. 1968)	83, 135, 2
SMITH, KIKI (b. 1954)	76, 177, 205	**TOULOUSE-LAUTREC, HENRI DE** (1864–1901)	3
SMITHSON, ROBERT (1938–1973)	86, 162	**TROCKEL, ROSEMARIE** (b. 1952)	
SOTH, ALEC (b. 1969)	14, 65, 280	**TRUITT, ANNE** (1921–2004)	1
STARLING, SIMON (b. 1967)	79	**TURNER, J. M. W.** (1775–1851)	1
STARN, DOUG (b. 1961)	237	**TURRELL, JAMES** (b. 1943)	26, 199, 2
STEICHEN, EDWARD (1879–1973)	242	**TUYMANS, LUC** (b. 1958)	146, 175, 2
STELLA, FRANK (b. 1936)	141, 219, 258, 284	**TWOMBLY, CY** (1928–2011)	105, 2
STERNE, HEDDA (1910–2011)	69, 190	**VALADON, SUZANNE** (1865–1938)	
STEYERL, HITO (b. 1966)	233, 290	**VAN GOGH, VINCENT** (1853–1890)	65, 95, 137, 143, 284, 3
STIEGLITZ, ALFRED (1864–1946)	194, 220, 234	**WALKER, KARA** (b. 1969)	1
STOCKHOLDER, JESSICA (b. 1959)	120	**WALL, JEFF** (b. 1946)	
STRAND, PAUL (1890–1976)	164	**WARHOL, ANDY** (1928–1987)	65, 114, 146, 246, 2
SUGIMOTO, HIROSHI (b. 1948)	268	**WEARING, GILLIAN** (b. 1963)	62, 8
SZE, SARAH (b. 1969)	31, 74	**WEBB, ALEX** (b. 1952)	102, 2
TALBOT, WILLIAM HENRY FOX (1800–1877)	240	**WEBER, BRUCE** (b. 1946)	242, 2

EEGEE 128, 270, 279
(?99–1968)

EEMS, CARRIE MAE 31, 149
(?1953)

EGMAN, WILLIAM 276
(?1943)

EINER, LAWRENCE 25, 41
(?1942)

ESTON, EDWARD 64, 152, 277, 305
(?86–1958)

HITEREAD, RACHEL 141, 184, 226
(?1963)

LEY, KEHINDE 90, 214, 289
(?1977)

LSON, FRED 273
(?1954)

NOGRAND, GARRY 122, 216
(?928–1984)

WYETH, ANDREW 62, 115, 209
(1917–2009)

WYETH, N. C. 131
(1882–1945)

XU, BING 210
(b. 1955)

YIN, XIUZHEN 209, 254, 305
(b. 1963)

YUSKAVAGE, LISA 44
(b. 1962)

ZENG, FANZHI 119
(b. 1964)

ZHANG, HUAN 177, 189
(b. 1965)

ZHANG, XIAOGANG 53
(b. 1958)

ZITTEL, ANDREA 159, 249
(b. 1965)

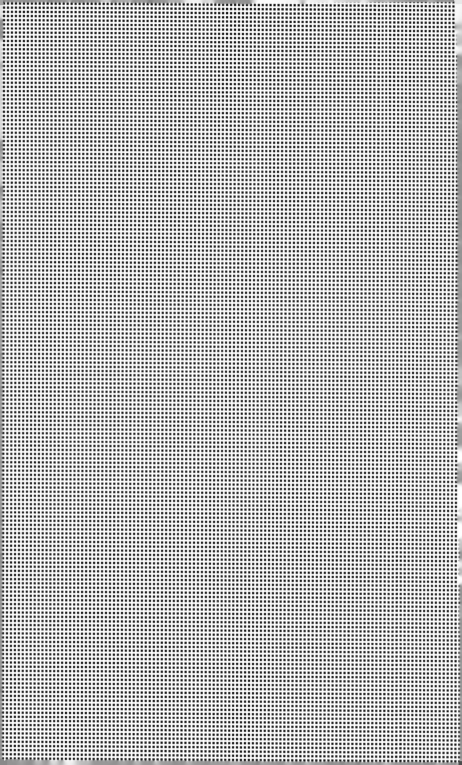

SOURCES

ADVICE

8 "YOU ARE AS GOOD"
Recounted by Isamu Noguchi, in
Katharine Kuh, The Artist's Voice:
Talks with Seventeen Artists
(New York: Harper & Row, 1962), 173.

9 "DRAW LINES, YOUNG MAN"
Keith Roberts, Degas (London: Phaidon
Press, 1982), 7.

9 "DON'T PRETEND"
Joe Fig, Inside the Painter's Studio
(New York: Princeton Architectural Press,
2009), 89.

10 "LET FRUSTRATION"
Interview by John Elmes, Times Higher
Education, December 17, 2015, https://www.
timeshighereducation.com/people/
interview-professor-sonia-boyce-university
-of-the-arts-london.

10 "THE MINUTE SOMETHING"
Interview by Isabelle Graw,
Artforum (March 2003), reprinted at
http://www.mutualart.com/OpenArticle/
Rosemarie-Trockel-talks-to-Isabelle-Graw/
A5731CDB94585CFE.

11 "IF A PAINTING DOESN'T"
Katharine Kuh, The Artist's Voice:
Talks with Seventeen Artists
(New York: Harper & Row, 1962), 145.

12 "MAKE SURE TO ALLOW"
Interview by Leigh Silver,
Complex, October 1, 2014, reprinted
at http://mickalenethomas.com/press_
pdfs/2014/Complex%202014_
Kavi%20Gupta.pdf.

12 "KEEP YOUR EYE"
John Glassie, "Oldest Living Surrealist
Tells All," Salon, February 11, 2002,
http://www.salon.com/2002/02/
11/tanning/.

12 "THE ADVICE THAT I GIVE"
May 26, 2014, entry, artist's website,
http://www.harrellfletcher.com/?cat=33.

12 "SIT DOWN WITH A PENCIL"
Anne-Celine Jaeger, Image Makers,
Image Takers (London: Thames & Hudson,
2007), 124.

12 "TAKE A CANVAS"
Originally published in Art and Literature,
no. 4 (1965): 185–92, reprinted in Jed Perl,
ed., Art in America, 1945–1970: Writings
from the Age of Abstract Expressionism,
Pop Art, and Minimalism, (New York: Library
of America, 2014), 626.

12 "DON'T GET RID"
March 27, 2016, tweet, artist's Twitter
account, https://twitter.com/yokoono/
status/714168108844523520.

12 "SOMETIMES IN A HOSTILE"
Oral history interview with Dorothea Lange,
May 22, 1964, Archives of American Art,
Smithsonian Institution.

13 "TRY TO PUT WELL"
Tryon Edwards, A Dictionary of Thoughts:
Being a Cyclopedia of Laconic Quotations
from the Best Authors of the World,
Both Ancient and Modern (Detroit: F. B.
Dickerson, 1908), 131.

13 "I FEEL LIKE I CAN"
Interview by Leanne Shapton,
Believer (October 2013), reprinted at
http://www.regenprojects.com/attachment/
en/54522d19cfaf3430698b4568/
Press/5485130ab7a8371e7a6cdee7.

13 "CULTIVATE A WELL-ORDERED"
April 15, 1823, entry, in The Journal of Eugène
Delacroix, 3rd. ed., ed. Hubert Wellington
(London: Phaidon Press, 1995), 12.

14 "FIND YOUR EYES"
Interview by Lou Noble, Photographic Journal,
April 30, 2015, http://thephotographicjournal.
com/interviews/alec-soth/.

15 "FOR THE NEXT WEEK"
Jori Finkel, "Artist of Light, Space and,
Now, Trees," New York Times,
October 14, 2007, http://www.nytimes.
com/2007/10/14/arts/design/14fink.html.

15 "STARE"
Walker Evans, Many Are Called (New Haven,
CT: Yale University Press, 2004), 197.

16 "ALL EXPERIENCE IS GREAT"
Alice Neel: Black and White (New York:
Robert Miller Gallery, 2002), 33.

16 "THE BEST THING"
Annie Leibovitz at Work (New York:
Random House, 2008), 212.

17 "DON'T HIDE THE SCREW"
Interview by Jon Kessler, Bomb, no. 83
(Spring 2003), http://bombmagazine.org/
article/2544/tom-sachs.

17 "THE FIRST TIME"
Kevin West, "Public Offering," W, May 2008,
http://www.wmagazine.com/culture/
art-and-design/2008/05/chris_burden/.

18 "INSTEAD OF LOOKING"
Interview by Karen Wright, Art in
America (October 2009), http://www.
artinamericamagazine.com/news-features/
magazine/john-baldessari/.

19 "YOUR PATH IS AT YOUR FEET"
Arne Glimcher, Agnes Martin: Paintings,
Writings, Remembrances (London:
Phaidon Press, 2012), tip-in, n.p.

20 "AS FAR AS 'DETOURS'"
Interview by Douglas Crimp, in Mary Kelly
(London: Phaidon Press, 1997), 30.

20 "I'M JUST GOING TO MENTION"
Interview by Terry Gross, "Laurie
Anderson Reflects on Life and Loss
in 'Heart of a Dog,'" Fresh Air, NPR,
November 19, 2015, http://www.npr.
org/2015/11/19/456655545/
laurie-anderson-reflects-on-life-and-
loss-in-heart-of-a-dog.

21 "LEARN TO SAY"
Letter to Eva Hesse, April 14, 1965, in
Letters of Note: An Eclectic Collection of
Correspondence Deserving of a Wider
Audience, comp. Shaun Usher (San Francisco:
Chronicle Books, 2014), 88.

ART

22 "MAKING ART"
"Birdtalk," artist's website, late June–early
July 2010, http://www.richardprince.com/
birdtalk/.

23 "I DON'T BELIEVE"
Calvin Tomkins, "Play It Again: How Ragnar
Kjartansson Turns Repetition Into Art,"
New Yorker, April 11, 2016, http://www.
newyorker.com/magazine/2016/04/11/
ragnar-kjartansson-on-repeat.

23 "ART SHOULDN'T PREACH"
Interview by Urs Steiner and Samuel Herzog,
"The Idea Is What Matters!" Neue Zürcher
Zeitung, November 20, 2004, trans. Isabel
Cole, reprinted at http://montrealserai.
com/_archives/2005_Volume_18/18_1/
Article_4.htm.

23 "ART HAS ALWAYS"
Alex Needham, "Dorothea Tanning,
Surrealist Artist, Dies Aged 101,"
Guardian, February 2, 2012,
http://www.theguardian.com/
artanddesign/2012/feb/02/dorothea-
tanning-surrealist-dies-101.

23 "WE MUST MAKE"
Tricia Y. Paik, Ellsworth Kelly (London:
Phaidon Press, 2015), 328.

23 "ART IS A WAY OF RECOGNIZING"
Donald Burton Kuspit, Bourgeois
(New York: Vintage Books, 1988), 82.

23 "I AM FOR AN ART"
Germano Celant, "Claes Oldenburg
and the Feeling of Things," in
Claes Oldenburg: An Anthology,
(New York: Guggenheim Museum
Publications, 1995), 96.

23 "I DO NOT BELIEVE"
Jill Lloyd and Reinhold Heller, eds.,
Munch and Expressionism (New York:
Prestel/Neue Gallery, 2016), 9.

23 "ULTIMATELY, ART IS TRYING"
"Trevor Paglen: Artist-Writer-Provocateur,"
Arts at MIT, September 2011,
http://arts.mit.edu/artists/trevor-paglen/.

24 "WHEN PEOPLE LOOK"
"Poet's Camera Sees Everything,"
Young Photographers Contest, Life,
November 26, 1951, 21.

24 "ART HAS TO BE SOMETHING"
Richard D. Marshall, Ed Ruscha (London:
Phaidon Press, 2003), 135.

25 "THE REASON I MAKE ART"
Interview by Marjorie Welish, Bomb, no. 54
(Winter 1996), http://bombmagazine.org/
article/1911/lawrence-weiner.

25 "I HAVE THIS VERY"
Oral history interview with Anni Albers,
July 5, 1968, Archives of American Art,
Smithsonian Institution.

26 "ART IS A COMPLETED PASS"
Julie L. Belcove, "Incredible Lightness:
Pace Artist James Turrell Prepares for
Superstardom," Harper's Bazaar online
slideshow, April 19, 2013, http://www.
harpersbazaar.com/culture/features/g2667/
james-turrell-interview-0513/?slide=4.

27 "WHAT I DREAM OF"
Alexander Liberman, The Artist in His Studio
(New York: Random House, 1988), 48.

27 "WHAT IS IT ABOUT PEOPLE"
Michael Kimmelman, Portraits: Talking
with Artists at the Met, the Modern,
the Louvre and Elsewhere (New York:
Random House, 1998), 232.

28 "IT IS ESSENTIAL"
Letter to Paul-Albert Bartholomé, January 17,
1886, in Natalia Brodskaïa, Edgar Degas (New
York: Parkstone Press International, 2012), 125.

29 "EVEN THE ACT OF PEELING"
Interview by Willoughby Sharp, Artforum
(December 1969): 46.

30 "WHAT I LOOK FOR"
Annie Cohen-Solal, Mark Rothko: Toward
the Light in the Chapel (New Haven, CT:
Yale University Press, 2015), 179.

30 "ART ALLOWS YOU"
Sarah Thornton, 33 Artists in 3 Acts
(New York: W. W. Norton, 2014), 59.

30 "I'M USING ART"
Interview by Cindy Nemser (1971), in
Amelia Jones, ed., Sexuality: Documents of
Contemporary Art (London: Whitechapel
Gallery; Cambridge, MA: The MIT Press,
2014), 183.

31 "ART IS ALWAYS"
Artist statement, in Antony Gormley:
Five Works (London: Serpentine Gallery/
Arts Council of Great Britain, 1987), reprinted
at http://www.antonygormley.com/
resources/essay-item/id/140.

31 "ART HAS SAVED MY LIFE"
Interview by Kristin Braswell, "Artist Carrie
Mae Weems on 30 Years of Genius," Ebony,
February 5, 2014, http://www.ebony.com/
entertainment-culture/artist-carrie-mae-
weems-on-30-years-of-genius-999/2.

31 "ART IS SUSTENANCE"
Almudena Tora and Carol Vogel,
"Sarah Sze's Triple Point," New York Times,
May 29, 2013, http://www.nytimes.com/
video/arts/design/100000002250357/
sarah-szes-triple-point.html.

32 "THROUGHOUT THE AGES"
Mary Anne Guitar, 22 Famous Painters
and Illustrators Tell How They Work
(New York: David McKay, 1964), 11.

32 "MUSEUMS HAVE TODAY"
Interview by Tamar Garb, in Christian
Boltanski (London: Phaidon Press, 1997), 11.

33 "ART WON'T LET YOU DOWN"
"A Conversation: Takashi Murakami and
Damien Hirst," in Damien Hirst: Requiem I
(London: Other Criteria/PinchukArtCentre,
2009), http://www.damienhirst.com/
texts/2009/feb--takashi-murakami.

ART MARKET

34 "ANY PICTURE IS FAIRLY PRICED"
Stephanie Terenzio, ed., The Collected
Writings of Robert Motherwell (New York:
Oxford University Press, 1992), 152.

35 "NO MORE GALLERIES"
Selden Rodman, Conversations with Artists:
35 American Painters, Sculptors,
and Architects Discuss Their Work and One
Another with Selden Rodman (New York:
Capricorn Books, 1961), 78.

35 "ALL THE RAZZMATAZZ"
Rachel Cooke, "Jenny Saville: 'I Want to Be a
Painter of Modern Life, and Modern Bodies,'"
Guardian, June 9, 2012, https://www.
theguardian.com/artanddesign/2012/
jun/09/jenny-saville-painter-modern-bodies.

35 "OUR SOCIETY IS EVOLVING"
Interview by Michele Robecchi, "The
Celebrated Walking Blues," Contemporary,
no. 78 (2006), http://www.contemporary-
magazines.com/interview78.htm.

35 "I LOOK FOR DEALERS"
Akademie X: Lessons in Art + Life
(London: Phaidon Press, 2015), 145.

35 "YOU WILL HAVE NOTICED"
Letters of Gustave Courbet, ed. and trans.
Petra ten-Doesschate Chu (Chicago:
University of Chicago Press, 1992), 291.

35 "I HAVE JUST RECEIVED $400"
Nancy Mowll Mathews, Mary Cassatt:
A Life (New Haven, CT: Yale University Press,
1998), 47.

35 "I DON'T FOLLOW AUCTIONS"
Tulsa Kinney, "Mike Kelley: Straight Outta
Detroit," Artillery, March 28, 2011,
http://artillerymag.com/mike-kelley-
straight-outta-detroit/.

36 "WHEN I FIRST STARTED"
Sean O'Hagan, "The Big Empty," Guardian,
October 23, 2004, http://www.theguardian.
com/artanddesign/2004/oct/24/photography.

36 "I MADE A BLANKET"
Interview by Alain Elkann, December 11,
2014, http://alainelkanninterviews.com/
tracey-emin/.

37 "NOW THE ART WORLD"
Interview by Robert Berlind, Brooklyn Rail,
July 15, 2014, http://brooklynrail.org/
2014/07/art/eric-fischl-with-robert-berlind.

38 "I PRODUCE AS MANY WORKS"
Elisa Lipsky-Karasz, "Jeff Wall's Unique
Photographic Vision," Wall Street Journal,
September 4, 2015, http://www.wsj.com/
articles/jeff-walls-unique-photographic-
vision-1441375796.

38 "IF I MAKE A CAST"
David Sylvester, Interviews with American
Artists (New Haven, CT: Yale University Press,
2001), 11.

39 "I DON'T THINK YOU CAN"
Oral history interview with Jacob Lawrence,
October 26, 1968, Archives of American Art,
Smithsonian Institution.

ART SCHOOL

40 "TO BE A TEACHER"
Interview by Willoughby Sharp, Artforum
(December 1969): 44.

41 "TO TRUST YOUR INTUITION"
Interview by Jon Bewley (1990),
in Adrian Searle, ed., Talking Art (Londo
Institute of Contemporary Arts, 1993)
26–27, reprinted in Lisa Le Feuvre, ed.,
Failure: Documents of Contemporary Ar
(London: Whitechapel Gallery; Cambrid
MA: MIT Press, 2010), 128.

41 "IT SHOULD NOT BE"
Interview by Mark Godfrey, "Learning
Experience," Frieze, no. 101 (Septembe
2006), http://friezenewyork.com/articl
learning-experience?language=de.

41 "TRYING TO GET STUDENTS TO DRA
Michael Kimmelman, Portraits: Talking
with Artists at the Met, the Modern,
the Louvre and Elsewhere (New York:
Random House, 1998), 159.

41 "I WAS AN EXTREMELY"
Barbara Ehrlich White, Renoir:
His Life, Art, and Letters (New York:
Harry N. Abrams, 1984), 16.

41 "WHEN ARE YOU GOING"
Interview by Andrew M. Goldstein,
"Amy Sillman on Painting, Stand-Up Com
and Making 'Inappropriate' Art," Artspac
March 5, 2014, http://www.artspace.con
magazine/interviews_features/qa/amy
sillman_interview-52042.

41 "YOU DON'T NEED"
Interview by Emily McDermott,
Interview, August 2, 2015, http://www
interviewmagazine.com/art/artists-at-wo
lawrence-weiner.

42 "I DON'T TEACH"
Oral history interview with Sol LeWitt,
July 15, 1974, Archives of American Art
Smithsonian Institution.

42 "STUDENTS ARE THE FIRST"
Interview by Julie Belcove, Financial Time
September 6, 2013, http://www.ft.com
cms/s/2/3a58622a-13c0-11e3-9289-
00144feabdc0.html.

43 "ONE THING THAT I REALLY LIKE"
Interview by Erik Wenzel, Artslant,
May 2013, http://www.artslant.com/
global/artists/rackroom/22895-
tania-bruguera.

44 "EVEN THOUGH I HAD"
Interview by Robert Enright,
Border Crossings, no. 103 (August 2007
http://bordercrossingsmag.com/article
the-overwhelmer-an-interview-with-
lisa-yuskavage.

45 "MARTIN CREED ACTUALLY SAID"
Kira Cochrane, "Phyllida Barlow: 'Just Goi
to Art School Doesn't Make You Famous,
Guardian, March 31, 2014, http://www
theguardian.com/artanddesign/2014/
mar/31/phyllida-barlow-sculptor-tate-
britain-interview.

45 "MY INTENTION AS A TEACHER"
Interview by Joe Fusaro (part 2),
ART21, January 15, 2009, http://blog.art2
org/2009/01/15/interview-with-eleano
antin-part-2/.

45 "IF A NONARTIST TEACHES"
Robert Sullivan, "Ruth Asawa:
The Subversively 'Domestic' Artist,"
New York Times, December 21, 2013,
http://www.nytimes.com/news/the-live
they-lived/2013/12/21/ruth-asawa/.

45 "ONE TEACHER SAID"
Interview by Kitty Scott, in Peter Doig
(London: Phaidon Press, 2007), 16.

45 "I TELL MY STUDENTS"
Charles Arsène-Henry, Shumon Basar, and
Ien Marta, eds., Hans Ulrich Obrist Interviews,
vol. 2 (New York: Charta, 2010), 477.

45 "AFTER HAVING TAUGHT"
Katharine Kuh, The Artist's Voice: Talks
with Seventeen Artists (New York:
Harper & Row, 1962), 16.

ARTIST

46 "PAINTING IS THE BEST"
alvin Tomkins, "Everything in Sight: Robert
Rauschenberg's New Life," New Yorker,
ay 23, 2005, http://www.newyorker.com/
agazine/2005/05/23/everything-in-sight.

47 "I DON'T KNOW"
Calvin Tomkins, Lives of the Artists
(New York: Henry Holt, 2008), 165.

48 "THE ARTIST MUST HAVE"
Rodin: The Man and His Art,
with Leaves from His Notebook (New York:
Century, 1917), 7.

48 "I PAINT WITH THE STUBBORNNESS"
Peter de Polnay, Enfant Terrible: The Life
and World of Maurice Utrillo (New York:
Morrow, 1969), 55.

49 "MY ROLE IS TO INTEGRATE"
Interview by Massimiliano Gioni,
"Beside Our Selves," in The Neighbors
New York: Rizzoli/New Museum, 2014), 59.

49 "I AM THE PAINTER"
Yves Klein, 1928–1962: A Retrospective
(Houston, TX: Institute for the Arts, Rice
University, 1982), 127.

49 "MY BELIEF"
nterview by Robert Berlind, Brooklyn Rail,
July 15, 2014, http://www.brooklynrail.
org/2014/07/art/eric-fischl-with-robert-
berlind.

49 "THE IDEA OF THE SUFFERING"
Sean O'Hagan, "Out of the Ordinary,"
Guardian, July 24, 2004, http://www.
theguardian.com/artanddesign/2004/
jul/25/photography1.

49 "IF AN ARTIST DOES NOT"
n Gruen, "The Apocalyptic Disguises of Lucas
amaras," ARTnews 75, no. 4 (April 1976): 37.

49 "THE ARTIST IS A CITIZEN"
Charles Arsène-Henry, Shumon Basar, and
ren Marta, eds., Hans Ulrich Obrist Interviews,
vol. 2 (New York: Charta, 2010), 494.

49 "ARTISTS MAKE THEMSELVES"
Interview by Leanne Shapton,
Believer (October 2013), reprinted at
tp://www.regenprojects.com/attachment/
en/54522d19cfaf3430698b4568/
Press/5485130ab7a8371e7a6cdee7.

50 "EARLY ON"
Judy Chicago, Beyond the Flower:
The Autobiography of a Feminist Artist
(New York: Viking, 1996), 17.

50 "BEING AN ARTIST"
nterview by John Tusa, BBC Radio 3, July 6,
003, http://www.bbc.co.uk/programmes/
000ncbc1, reprinted at http://anishkapoor.
m/180/in-conversation-with-john-tusa-2.

51 "I DON'T BELIEVE IN ART"
Thomas Girst, The Duchamp Dictionary
(London: Thames & Hudson, 2014), 22.

52 "PAINTING IS SELF-DISCOVERY"
Selden Rodman, Conversations with
Artists: 35 American Painters, Sculptors,
and Architects Discuss Their Work and
One Another with Selden Rodman
(New York: Capricorn Books, 1961), 82.

53 "FOR A LONG PERIOD"
Interview by Jonathan Fineberg and
Gary G. Xu, Beijing, October 4, 2011, in Zhang
Xiaogang (London: Phaidon Press, 2015), 24.

54 "EVERYBODY I HAVE"
Interview by Alexis Anne Clements, American
Suburb X, October 20, 2009, http://www.
americansuburbx.com/2009/10/interview-
interview-with-arnold-newman.html.

54 "MY AMBITION IS ALWAYS"
Oral history interview with Kerry James
Marshall, August 8, 2008, Archives of
American Art, Smithsonian Institution.

55 "IF MY TIME HAS COME"
Undated letter to M. Français, 1875, in Letters
of the Great Artists: From Blake to Pollock,
ed. Richard Friedenthal (New York: Random
House, 1963), 82.

AUDIENCE

56 "I PAINT ONLY FOR MYSELF"
Katharine Kuh, The Artist's Voice:
Talks with Seventeen Artists (New York:
Harper & Row, 1962), 141.

57 "I CAN'T PAINT"
Hendrik Willem van Loon, R.v.R.:
Being an Account of the Last Years and the
Death of One Rembrandt Harmenszoon van
Rijn (New York: H. Liveright, 1930), 378.

57 "MY FAN MAIL"
Calder: An Autobiography with Pictures
(New York: Pantheon Books, 1966), 271.

57 "BRING THE VIEWER"
Mark Durden, Dorothea Lange (London:
Phaidon Press, 2006), introduction, n.p.

57 "IF YOU DON'T GET LOVE"
Gillian Zoe Segal, Getting There: A Book
of Mentors (New York: Harry N. Abrams,
2015), 113.

57 "IT IS NOT MY INTENTION"
William Furlong, Speaking of Art: Four
Decades of Art in Conversation
(London: Phaidon Press, 2010), 66.

58 "MY WORK IS COMPLETED"
Jonathan Jones, "The Life of Riley," Guardian,
July 4, 2008, http://www.theguardian.com/
artanddesign/2008/jul/05/art1.

59 "IN 1952"
"Ellsworth Kelly," Art Now: New York 1,
no. 9 (November 1969): n.p.

59 "I HAVE A VERY DEFINITE"
William Furlong, Speaking of Art:
Four Decades of Art in Conversation
(London: Phaidon Press, 2010), 23.

60 "I HAVE NO CONSCIOUS PREMISE"
Selden Rodman, Conversations with
Artists: 35 American Painters, Sculptors,
and Architects Discuss Their Work and
One Another with Selden Rodman
(New York: Capricorn Books, 1961), 128.

61 "I REALLY TRUST AUDIENCES"
Interview by Amanda Stern, Believer
(January 2012), http://www.believermag.com/
issues/201201/?read=interview_anderson.

62 "I DON'T BELIEVE"
Interview by Donna De Salvo, in Gillian
Wearing (London: Phaidon Press, 1999), 12.

62 "WHEN I FIRST PAINTED"
Interview by Richard Meryman," Life,
May 14, 1965.

63 "THE PEOPLE WHO WEEP"
Selden Rodman, Conversations with Artists:
35 American Painters, Sculptors, and
Architects Discuss Their Work and One
Another with Selden Rodman (New York:
Capricorn Books, 1961), 93–94.

BEAUTY

64 "I HAVE BEEN PHOTOGRAPHING"
October 21, 1925, entry, The Daybooks of Edward
Weston, vol. 1, ed. Nancy Newhall (Rochester,
NY: George Eastman House, 1961), 132.

65 "THE UNPLEASANT AND PLEASANT"
Interview by Beate Söntgen, Peter Fischli David
Weiss (London: Phaidon Press, 2005), 34.

65 "THE BEAUTIFUL IMPLIES"
Undated entry, 1854, The Journal of Eugène
Delacroix, 3rd ed., ed. Hubert Wellington
(London: Phaidon Press, 1995), 232.

65 "I THINK HAVING LAND"
The Philosophy of Andy Warhol (From A to B
and Back Again) (New York: Harvest, 1977), 71.

65 "'BEAUTY' IS A DANGEROUS WORD"
Interview by Daniel Birnbaum, in Olafur
Eliasson (London: Phaidon Press, 2002), 27.

65 "I THINK A PEASANT GIRL"
Letter to his brother Theo, April 30, 1885, in
Letters of the Great Artists: From Blake to
Pollock, ed. Richard Friedenthal (New York:
Random House, 1963), 172.

65 "EXUBERANCE IS BEAUTY"
David V. Erdman, ed., The Complete Poetry
and Prose of William Blake (Berkeley:
University of California Press, 2008), 38.

65 "TO ME THE MOST BEAUTIFUL"
Mick Brown, "Photographer Alec Soth: 'To Me
the Most Beautiful Thing Is Vulnerability,'"
Telegraph, September 26, 2015, http://www.
telegraph.co.uk/photography/what-to-see/
alec-soth-americas-greatest-photographers/.

66 "I AM NOT INTERESTED"
Interview by Carol Becker, in Theaster Gates
(London: Phaidon Press, 2015), 44.

66 "IF WE DROP BEAUTY"
John Cage, "Composition as Process," in
Silence: Lectures and Writings (Middletown,
CT: Wesleyan University Press, 1973), 42.

67 "I'M IN THE BEAUTY BUSINESS"
Andrew Russeth, "Blink and You'll Miss It:
Robert Irwin Brings His Mind-Bending Art to
New York," Observer, September 11, 2012,
http://observer.com/2012/09/blink-and-
youll-miss-it-robert-irwin-brings-his-mind-
bending-art-to-new-york/.

68 "I LONGED TO ARREST"
Violet Hamilton, Annals of My Glass House:
Photographs by Julia Margaret Cameron
(Claremont, CA: Ruth Chandler Williamson
Gallery, 1996), 12.

69 "BLESSED ARE THEY"
Letter to his son Lucien, July 26, 1893,
in Letters of the Great Artists: From Blake to
Pollock, ed. Richard Friedenthal (New York:
Random House, 1963), 146.

69 "FOR THE SUBLIME"
Joan Simon, "Hedda Sterne," Art in
America (February 2007), http://www.
artinamericamagazine.com/news-features/
magazine/hedda-sterne/.

70 "I BELIEVE THAT HUMOR"
August 23, 1903, entry, in Self-Portrait
in Words: Collected Writings
and Statements, 1903–1950, ed. Barbara
Copeland Buenger (Chicago: University
of Chicago Press, 1997), 27.

70 "THE WORK IS GOOD"
Video segment, in Identity, ART21, PBS
Thirteen, n.d., http://www.pbs.org/art21/
artists/bruce-nauman/.

71 "I NEVER SAW AN UGLY THING"
C. R. Leslie, ed., Memoirs of the Life of John
Constable (London: Longman, Brown,
Green, and Longmans, 1845), 308.

CHANCE

72 "I'M OFTEN ASTONISHED"
Interview by Benjamin H. D. Buchloh (1986),
in Gerhard Richter: Text; Writings, Interviews
and Letters, 1961–2007, eds. Dietmar Elger
and Hans Ulrich Obrist (London: Thames &
Hudson, 2009), 182, reprinted at
https://www.gerhard-richter.com/en/
quotes/other-aspects-6.

73 "I NEVER HAVE TAKEN"
Marvin Israel and Doon Arbus, eds.,
Diane Arbus (New York: Aperture, 1972), 15.

74 "I AM ENJOYING WORKING"
Barbara Ehrlich White, Renoir: His Life,
Art, and Letters (New York: Harry N. Abrams,
1984), 96.

74 "I PUSH THINGS"
Ann Landi, "Charline von Heyl:
Unexpected Collisions," ARTnews,
December 16, 2013, http://www.artnews.
com/2013/12/16/charline-von-heyl-
unexpected-collisions/.

74 "THERE'S SOMETHING ABOUT"
Interview by Zoe Pilger, Frieze, no. 170
(April 2015), http://www.frieze.com/issue/
article/free-forms/.

74 "I BELIEVE IN"
Michael Kimmelman, Portraits: Talking
with Artists at the Met, the Modern, the Louvre
and Elsewhere (New York: Random House,
1998), 43.

74 "MY WORK"
Interview by David Shapiro, Museo
(2008), http://www.museomagazine.com/
VANESSA-BEECROFT.

74 "THE IDEA OF KNOWING"
Andrea K. Scott, "A Million Little Pieces:
The Sculptural Maelstroms of Sarah Sze,"
New Yorker, May 14, 2012, http://www.
newyorker.com/magazine/2012/05/14/a-
million-little-pieces.

74 "I LIKE DOING THINGS"
Interview by Hans Ulrich Obrist, in Sara
Harrison, ed., Phyllida Barlow: Fifty Years
of Drawings (Zurich: JRP | Ringier; London:
Hauser & Wirth, 2014), 226.

75 "I DON'T KNOW WHERE"
Calvin Tomkins, "Everything in Sight:
Robert Rauschenberg's New Life,"
New Yorker, May 23, 2005, http://www.
newyorker.com/magazine/2005/05/
23/everything-in-sight.

76 "I'LL ARRANGE WAYS"
Michael Kimmelman, "The Intuitionist,"
New York Times, November 5, 2006,
http://www.nytimes.com/2006/11/05/
magazine/05kiki.html?ref=kikismith.

76 "THERE ARE MANY ACCIDENTS"
Oral history interview with Helen
Frankenthaler, 1968, Archives of American
Art, Smithsonian Institution.

77 "IF YOU USE"
Interview by Joan Retallack, in
Musicage: Cage Muses on Words, Art, Music
(Middletown, CT: Wesleyan University
Press, 2011), 124.

CHILDHOOD

78 "EVER SINCE MY CHILDHOOD"
Serge Fauchereau, Arp (New York:
Random House, 1988), 22.

79 "I WAS A REALLY"
Interview by Henry Geldzahler, Interview,
April 18, 2012, http://www.
interviewmagazine.com/art/new-again-jean-
michel-basquiat-.

79 "ONE OF MY FORMATIVE"
Interview by Francesco Manacorda, in Simon
Starling (London: Phaidon Press, 2012), 27.

80 "I WOULD PLAY MUSIC"
Interview by Harmony Korine, Interview,
November 27, 2008, http://www.
interviewmagazine.com/art/william-
eggleston/.

81 "I HAD A VERY SENSUOUS"
Interview by Douglas Dreishpoon,
Art in America (October 2009), http://www.
artinamericamagazine.com/news-features/
magazine/janine-antoni/.

81 "WHEN I WAS GROWING UP"
"Birdtalk," artist's website, March 23, 2012,
http://www.richardprince.com/birdtalk/.

81 "I WANT TO BE A CHILD"
John Gruen, The Artist Observed: 28
Interviews with Contemporary Artists
(Pennington, NJ: a cappella books, 1991), 231.

81 "I REMEMBERED WHEN"
Excerpt from Man Ray, Self-Portrait, in
Photography in Print: Writings from 1816 to
the Present, ed. Vicki Goldberg (New York:
Touchstone, 1981), 268.

81 "WHEN I WAS I THINK 11 OR 12"
Oral history interview with Aaron Siskind,
September 28–October 2, 1982, Archives of
American Art, Smithsonian Institution.

81 "I THINK I WAS ALWAYS"
Andrew Russeth, "Weapons of Choice: Chris
Burden Talks Porsches, Cannons, Maelstroms
and Meteorites," Observer, October 15, 2013,
http://observer.com/2013/10/weapons-of-
choice-chris-burden-talks-porsches-cannons-
sailboats-and-meteorites/.

82 "WHEN I WAS TWELVE"
Gillian Zoe Segal, Getting There:
A Book of Mentors (New York: Harry N.
Abrams, 2015), 109.

82 "I NEVER WANTED TO BE"
Mary Anne Guitar, 22 Famous Painters
and Illustrators Tell How They Work
(New York: David McKay, 1964), 10.

83 "I WAS NEVER BROUGHT UP"
Interview by Peter Halley, in Wolfgang
Tillmans, 2nd ed. (London: Phaidon Press
2014), 9.

84 "I FEEL I HAVEN'T LEARNED"
David Sylvester, Interviews with
American Artists (New Haven, CT: Yale
University Press, 2001), 282.

85 "FROM THE TIME"
Ibid., 343.

85 "ONE OF MY FAVORITE"
Barbara Hess, Abstract Expressionism
(Cologne: Taschen, 2006), 80.

85 "THE MAGIC OF PHOTOGRAPHY"
"Heroes and Mentors: Stephen Shore and
Gregory Crewdson," Photo District News,
July 20, 2011, http://www.pdnonline.com
features/Heroes-and-Mentors-St-3200.shtr

85 "MY FATHER IS A PSYCHOANALYST"
Interview by Bradford Morrow, Bomb, no.
61 (Fall 1997), http://bombmagazine.org.
article/2090/gregory-crewdson.

86 "I REMEMBER THE SMELL"
Oral history interview with Marisol,
February 8, 1968, Archives of American Ar
Smithsonian Institution.

86 "I SUPPOSE I WAS ALWAYS"
Tim Adams, "Gillian Wearing: 'I've Always
Been a Bit of a Listener,'" Guardian,
March 3, 2012, http://www.theguardian.
com/artanddesign/2012/mar/04/gillian
wearing-whitechapel-gallery-feature.

86 "WHEN I WAS VERY SMALL"
Phoebe Hoban, Alice Neel: The Art
of Not Sitting Pretty (New York: St. Martin'
Press, 2010), 13.

86 "I REMEMBER THAT"
Katharine Kuh, The Artist's Voice:
Talks with Seventeen Artists (New York:
Harper & Row, 1962), 171.

86 "WHEN I WAS"
Oral history interview with Robert Smithso
July 14–19, 1972, Archives of American Ar
Smithsonian Institution.

87 "AS A LITTLE FEMALE KID"
Stuart Jeffries, "Jenny Holzer: Drawn to the
Dark Side," Guardian, June 4, 2012, http://
www.theguardian.com/artanddesign/2012
jun/04/jenny-holzer-interview.

COLLABORATION

88 "IT'S A COLLABORATION"
Rebecca Fortnum, Contemporary British
Women Artists: In Their Own Words
(London: I. B. Tauris, 2007), 3.

89 "I CREATE SYSTEMS"
Sarah Thornton, 33 Artists in 3 Acts
(New York: W. W. Norton, 2014), 80.

89 "I CHOSE TO BE AN ARTIST"
"A Conversation: Takashi Murakami
and Damien Hirst," in Damien Hirst:
Requiem I (London: Other Criteria/
PinchukArtCentre, 2009), http://www.
damienhirst.com/texts/2009/
feb--takashi-murakami.

90 "I'VE WORKED WITH RIGGERS"
Calvin Tomkins, Lives of the Artists
(New York: Henry Holt, 2008), 94.

90 "THE PROBLEM WITH STONE"
terview by John Tusa, BBC Radio 3, July 6,
3, http://www.bbc.co.uk/programmes/
0ncbc1, reprinted at http://anishkapoor.
/180/in-conversation-with-john-tusa-2.

90 "ANY ARTIST WHO WANTS"
al history interview with Kehinde Wiley,
otember 29, 2010, Archives of American
Art, Smithsonian Institution.

90 "I SOMETIMES USED"
terview by Howard Halle, Time Out New
rk, July 14, 2014, http://www.timeout.
/newyork/art/nancy-rubins-interview-
-really-wonderful-work-of-art-one-plus-
one-equals-three.

90 "I HAVE VERY EARLY"
March 15, 2014, entry, artist's website,
tp://www.harrellfletcher.com/?p=873.

90 "I CONSIDER MY PRODUCTION"
Interview by Marina Reyes-Franco,
rtpulse, http://artpulsemagazine.com/
ere-is-a-light-that-never-goes-out-an-
interview-with-julio-le-parc.

91 "IT IS 'US' DOING IT"
rles Green, The Third Hand: Collaboration
rt from Conceptualism to Postmodernism
ydney: University of New South Wales
Press, 2001), 185.

91 "I COULDN'T SEE MYSELF"
harles Arsène-Henry, Shumon Basar, and
n Marta, eds., Hans Ulrich Obrist Interviews,
vol. 2 (New York: Charta, 2010), 876.

92 "I DON'T DRAW"
art Chernow, Christo and Jeanne-Claude:
An Authorized Biography (New York:
St. Martin's Press, 2005), 196.

2 "THE DRAWINGS ARE THE SCHEME"
Ibid., 196.

93 "A GOOD COLLABORATION"
terview by Barbara Rose, in Rauschenberg
w York: Vintage Books/Elizabeth Avedon
Editions, 1987), 85.

COLOR

94 "ONE CANNOT HAVE"
ita Amory, ed., Pierre Bonnard: The Late
Still Lifes and Interiors (New Haven, CT:
Yale University Press, 2009), 23.

95 "WHEN YOU GO OUT"
xander Liberman, The Artist in His Studio
New York: Random House, 1988), 18.

95 "THE BEST PICTURES"
Letters of Vincent Van Gogh to His Brother,
72–1886 (London: Constable, 1927), 555.

95 "DON'T ASK ME WHY"
Cindy Nemser, Art Talk: Conversations
with 12 Women Artists (New York:
Scribner, 1975), 101.

95 "LEARNING THAT COLOR"
avid Batchelor, ed., Colour: Documents of
ontemporary Art (London: Whitechapel
ss; Cambridge, MA: MIT Press, 2008), 235.

96 "FULL, SATURATED COLORS"
an Freud: Naked Portraits (Ostfildern-Ruit,
Germany: Hatje Cantz, 2001), 79.

97 "COLOR IS THE PLACE"
Michael Doran, ed., Conversations with
Cézanne (Berkeley: University of California
Press, 2001), 113.

98 "MY MOTHER WARNED ME"
Barbara Haskell, Claes Oldenburg:
Object into Monument (Los Angeles:
Ward Ritchie Press, 1971), 89.

98 "RED IS A COLOR"
Interview by John Tusa, BBC Radio 3, July 6,
2003, http://www.bbc.co.uk/programmes/
p00ncbc1, reprinted at http://anishkapoor.
com/180/in-conversation-with-john-tusa-2.

99 "I LOVE RED SO MUCH"
Katharine Kuh, The Artist's Voice:
Talks with Seventeen Artists
(New York: Harper & Row, 1962), 41.

100 "I'M MORE CONCERNED"
Ibid., 140.

101 "I DON'T THINK OF MY WORK"
Interview by David Batchelor, Frieze,
no. 10 (May 1993), http://www.frieze.com/
article/paintings-and-pictures.

101 "THE WHITES, OF COURSE"
David Sylvester, Interviews with
American Artists (New Haven, CT:
Yale University Press, 2001), 61.

101 "MY BLUE COMES OUT OF A TUBE"
Interview by Pierre Courthion, in Chatting
with Henri Matisse: The Lost 1941 Interview,
ed. Serge Guilbaut, trans. Chris Miller
(Los Angeles: Getty Publications, 2013), 38.

101 "I KNEW AS A CHILD"
Donald Judd, "Some Aspects of Color in
General and Red and Black in Particular"
(1994), reprinted at http://newcomplexity.
com/post/3035630628/donald-judd.

101 "IF I ONLY THINK"
Letter to his wife, Minna Beckmann-Tube,
in Stephan Lackner, Max Beckmann
(New York: Harry N. Abrams, 1991), 50.

102 "YOU GO TO MEXICO"
Interview by Marek Grygiel and Adam Mazur,
"Things That Seem Paradoxical Can Coexist,"
in Fototapeta, n.d., http://fototapeta.art.
pl/2005/axwe.php.

102 "I DON'T WANT THE PICTURE"
Anthony Bannon, Steve McCurry (London:
Phaidon Press, 2005), introduction, n.p.

103 "THE BLUE PERIOD"
Alexander Liberman, "Picasso," Vogue,
November 1, 1956, 134.

104 "YOU CAN DO PLEIN AIR"
Juliet Wilson-Bareau, ed., Manet by Himself:
Correspondence and Conversation, Paintings,
Pastels, Prints and Drawings (London:
Time Warner Books, 2004), 203.

104 "IN THE '70S"
Emily Gosling, "'Most of the Photographs
I Take Are Bad': Martin Parr Brings the
Good Stuff to a Stunning New Retrospective,"
It's Nice That, February 5, 2016,
http://www.itsnicethat.com/articles/
martin-parr-rhubarb-triangle-hepworth-
wakefield-050216.

104 "LOOK!"
Dianne Feinberg Appleman, "My Memory
of Josef Albers: 1955," undated note, JAAF
archive, in Frederick A. Horowitz and Brenda

Danilowitz, Josef Albers: To Open Eyes
(London: Phaidon Press, 2006), 199.

104 "OFTEN, IF I'M STUCK"
Rebecca Fortnum, Contemporary British
Women Artists: In Their Own Words
(London: I. B. Tauris, 2007), 21.

104 "I STARTED"
Murray Sayle, "The World and Elliott Erwitt,"
in Elliott Erwitt: Snaps (London: Phaidon Press,
2001), introduction.

104 "THERE'S ROOM"
Rachel Cooke, "Ed Ruscha: 'There's Room
for Saying Things in Bright Shiny Colors,'"
Guardian, September 11, 2010, http://
www.theguardian.com/artanddesign/2010/
sep/12/ed-ruscha-obama-pop-art.

105 "I HAD FOUND"
Calvin Tomkins, "Into the Unknown,"
New Yorker, October 6, 2014, http://www.
newyorker.com/magazine/2014/10/06/
unknown-6.

105 "IN THE HIERARCHY"
Wassily Kandinsky, Concerning the Spiritual
in Art, and Painting in Particular (New York:
Wittenborn, Schultz, 1947), 59.

105 "I REALIZED IN THAT GREAT ROOM"
Interview by Nicholas Serota, Rome
(2007), http://www.cytwombly.info/
twombly_writings5.htm.

106 "I AM NOT ABLE"
Interview by David Shapiro, Museo
(2008), http://www.museomagazine.com/
VANESSA-BEECROFT.

107 "IF I COULD FIND"
Philip Gilbert Hamerton, The Life of J. M. W.
Turner (Boston: Roberts Brothers, 1879), 296.

108 "GRAY IS THE EPITOME"
David Batchelor, ed., Colour: Documents of
Contemporary Art (London: Whitechapel Press;
and Cambridge, MA: MIT Press, 2008), 167.

108 "REMEMBER THAT GRAY"
Undated entry, 1852, in The Journal of Eugène
Delacroix, 3rd. ed., ed. Hubert Wellington
(London: Phaidon Press, 1995), 177.

109 "GRAY GOES WITH"
Interview by Gwyneth Paltrow, Interview,
October 5, 2011, http://www.interviewmagazine.
com/art/ellsworth-kelly/#page2.

CREATIVE PROCESS

110 "I DO WHAT I'M FEELING"
Interview by Ava DuVernay, The Writers Guild
Theater, October 11, 2014, http://www.
thebroad.org/programs/un-private-collection-
kara-walker-and-ava-duvernay.

111 "A PAINTING OF MINE WORKS"
John Gruen, The Artist Observed:
28 Interviews with Contemporary Artists
(Pennington, NJ: a cappella books, 1991), 312.

112 "I WANT A PICTURE"
Harry F. Gaugh, Willem de Kooning:
Modern Masters Series (New York:
Abbeville Press, 1983), 109.

112 "SINCE MY WORKS ARE ALWAYS"
Joe Fusaro, "Myths, Metaphors, and
More: Interview with Eleanor Antin" (part 1),
January 14, 2009, ART21, http://www.art21.
org/texts/eleanor-antin/interview-myths-
metaphors-and-more-interview-with-eleanor-.

112 "FOR MANY YEARS NOW"
Oral history interview with Charles Sheeler, June 18, 1959, Archives of American Art, Smithsonian Institution.

112 "A PICTURE IS A SUCCESSION"
"Conversation with M. Tériade," 1942, in Letters of the Great Artists: From Blake to Pollock, ed. Richard Friedenthal (New York: Random House, 1963), 242.

112 "I RESPOND COMPLETELY"
Oral history interview with Ray Johnson, April 17, 1968, Archives of American Art, Smithsonian Institution.

112 "I DON'T PRESS"
Postcard to Marvin Israel, February 4, 1960, quoted in Arthur Lubow, "About the Photographs: Unveiled," New York Times, September 14, 2003, http://www.nytimes.com/2003/09/14/magazine/14PORTFOLIO.html.

113 "BOREDOM IS PART"
Philip Gefter, "Paul Graham and Seizing the Everyday Moments," New York Times, February 18, 2016, http://www.nytimes.com/2016/02/21/arts/design/paul-graham-and-seizing-the-everyday-moments.html.

113 "WE DON'T LIKE WORK"
Interview by Andrew Wilson, Journal of Contemporary Art, n.d., http://www.jca-online.com/gilbertandgeorge.html.

114 "FORGIVE ME"
Letter to Theo van Doesburg, November 20, 1915, in Letters of the Great Artists: From Blake to Pollock, ed. Richard Friedenthal (New York: Random House, 1963), 234.

114 "SEEING A PAINTING"
Interview by Miwon Kwon, in Mark Dion (London: Phaidon Press, 1997), 25.

114 "I CAN MAKE A PICTURE"
Interview by John Giorno, in I'll Be Your Mirror: The Selected Andy Warhol Interviews, 1962–1987, ed. Kenneth Goldsmith (New York: Carroll & Graf, 2004), 22.

114 "THE GROUND COMES FIRST"
William Furlong, Speaking of Art: Four Decades of Art in Conversation (London: Phaidon Press, 2010), 207.

115 "IF YOU WANTED TO WATCH"
Jori Finkel, "Artist of Light, Space and, Now, Trees," New York Times, October 14, 2007, http://www.nytimes.com/2007/10/14/arts/design/14fink.html.

115 "I WOULD NEVER LET"
Interview by Richard Meryman, Life, May 14, 1965, 114.

115 "I WORKED WITH A CAMERA"
Oral history interview with Aaron Siskind, September 28–October 2, 1982, Archives of American Art, Smithsonian Institution.

116 "ONE ALWAYS HAS TO SPOIL"
April 13, 1853, entry, in The Journal of Eugène Delacroix 3rd. ed., ed. Hubert Wellington (London: Phaidon Press, 1995), 181.

117 "I HATE TO STOP"
Interview by Robert Gober, in Vija Celmins (London: Phaidon Press, 2004), 20.

118 "I'M A SCISSOR MANIAC"
Sarah Thornton, 33 Artists in 3 Acts (New York: W. W. Norton, 2014), 57.

118 "I PAINT THE WAY"
Nicholas Fox Weber and Martin Filler, Josef + Anni Albers: Designs for Living (London: Merrell, 2004), 18.

119 "SOMETIMES I PAINT"
Sonia Kolesnikov-Jessop, "Zeng Fanzhi: Amid Change, the Art of Isolation," New York Times, May 3, 2007, http://www.nytimes.com/2007/05/03/arts/03iht-jessop.1.5546075.html.

119 "YOU TAKE A THOUSAND"
Rebecca Bengal, "A Conversation with Nan Goldin on the 30th Anniversary of The Ballad of Sexual Dependency," Vogue, October 26, 2015, http://www.vogue.com/13364942/nan-goldin-interview-ballad-of-sexual-dependency-30th-anniversary/.

119 "I AM MORE THAN EVER"
Letter to his son Lucien, April 26, 1892, in Letters of the Great Artists: From Blake to Pollock, ed. Richard Friedenthal (New York: Random House, 1963), 144.

119 "I USED TO HAVE MY FILM"
Interview by Rachel Small, Interview, November 8, 2013, http://www.interviewmagazine.com/art/david-salle-ghost-paintings-skarstedt-gallery/.

119 "CUTTING STRAIGHT INTO COLOR"
Dorothy Kosinski, Jay McKean Fisher, and Steven Nash, Matisse: Painter as Sculptor (New Haven, CT: Yale University Press, 2007), 260.

120 "IF YOU GET A COUPLE"
Interview by Allen Frame, Bomb, no. 28 (Summer 1989), http://bombmagazine.org/article/1213/mary-ellen-mark.

120 "YOU COULD SAY"
Richard H. Axsom and David Platzker, eds., Printed Stuff: Prints, Posters, and Ephemera by Claes Oldenburg; A Catalogue Raisonné (New York: Hudson Hills Press, 1997), 11.

120 "THE SMUDGING MAKES"
Interview by Astrid Kaspar (2000), in Gerhard Richter: Text; Writings, Interviews and Letters, 1961–2007, eds. Dietmar Elger and Hans Ulrich Obrist (London: Thames & Hudson, 2009), 368, reprinted at https://www.gerhard-richter.com/en/quotes/techniques-5.

120 "THE PROCESS IS WHAT MATTERS"
Interview by Lynne Tillman, in Jessica Stockholder (London: Phaidon Press, 1995), 15.

120 "MUSIC CAN MAKE"
Annie Leibovitz at Work (New York: Random House, 2008), 210.

121 "I FREQUENTLY DO PAINTINGS"
David Sylvester, Interviews with American Artists (New Haven, CT: Yale University Press, 2001),164.

122 "I DO ALL THE DEVELOPING"
Interview by Barbaralee Diamonstein, in Visions and Images: American Photographers on Photography (New York: Rizzoli, 1981), 186, reprinted at http://www.jnevins.com/garywinograndreading.htm.

122 "I WASN'T THINKING IN TERMS"
Interview by David Frankel, Artforum (March 2003): 54.

123 "I DON'T ACTUALLY ENJOY"
Interview by George Stolz, May 2012, http://utabarth.net/wp-content/uploads/2014/05/2012-george-stoltz-in view-2012-galeria-elvira-gonzalez-website

123 "YOU POSE A CERTAIN SET"
Perri Lewis, "Cecily Brown: I Take Thing Too Far When Painting," Guardian, September 20, 2009, http://www.theguardian.com/artanddesign/2009/sep/20/guide-to-painting-cecily-brow

123 "WHEN A PAINTING DOES NOT"
Interview by Yvon Taillandier, "I Work Li Gardener," February 15, 1959, in Joan M Selected Writings and Interviews, ed. Mar Rowell (New York: Da Capo Press, 1992),

124 "OF COURSE YOU CAN ALWAYS"
Interview by Sven Schumann, purple, no. 19 (Spring/Summer 2013) http://purple.fr/article/thomas-deman

125 "THE PAINTING HAS A LIFE"
Possibilities 1, no. 1 (Winter 1947–48): 7

DAY JOB

126 "AT ONE TIME"
Oral history interview with Alex Katz, October 20, 1969, Archives of American Smithsonian Institution.

127 "I WORKED IN THE WHEAT FIELDS
Oral history interview with Louis Schanl ca. 1963, Archives of American Art, Smithsonian Institution.

127 "MY FIRST JOB"
Oral history interview with Robert Ryma October 13–November 7, 1972, Archives American Art, Smithsonian Institution.

127 "I SPENT SOME TIME"
Oral history interview with Robert Morr March 10, 1968, Archives of American A Smithsonian Institution.

127 "I DID FREELANCE"
Interview by Christopher Bollen, Interview, February 28, 2013, http://www.interviewmagazine.com/ar barbara-kruger#page2.

127 "IN THE '70S"
Lanie Goodman, "20 Odd Questions for Julian Schnabel," Wall Street Journal, November 7, 2013, http://www.wsj.com articles/SB10001424052702303936904 177484123001974.

127 "MY VERY LAST JOB"
Charles Arsène-Henry, Shumon Basar, an Karen Marta, eds., Hans Ulrich Obrist Intervi vol. 2 (New York: Charta, 2010), 812.

127 "I DIDN'T START PHOTOGRAPHY"
Oral history interview with Gordon Park December 30, 1964, Archives of American Smithsonian Institution.

128 "I DID ODD JOBS"
Oral history interview with John McCrack April 19–August 4, 2010, Archives of American Art, Smithsonian Institution

128 "I WAS A DAY LABORER"
Weegee by Weegee: An Autobiography (New York: Ziff-Davis Publishing, 1961),

128 "WHEN I WAITED TABLES"
Bim Adewunmi, "Ellen Gallagher: Wigs, Waterworlds, and Wile E. Coyote,

Guardian, May 7, 2013, http://www.
heguardian.com/artanddesign/2013/
may/07/ellen-gallagher-artist.

128 "I TAUGHT FOR EIGHTEEN"
Interview by Ben Portis, New York,
March 18, 2008, http://faithringgold.
logspot.com/2007/11/welcome.html.

128 "ONE SUMMER"
Oral history interview with Sol LeWitt,
uly 15, 1974, Archives of American Art,
Smithsonian Institution.

128 "I WORKED AS AN EXPERT"
al history interview with Romare Bearden,
ne 29, 1968, Archives of American Art,
Smithsonian Institution.

129 "FIND SOMETHING TO DO"
Fig, Inside the Painter's Studio (New York:
rinceton Architectural Press), 99.

DISCIPLINE

130 "RENOIR PAINTED"
nterview by Pierre Courthion, in Chatting
h Henri Matisse: The Lost 1941 Interview,
ed. Serge Guilbaut, trans. Chris Miller
os Angeles: Getty Publications, 2013), 90.

131 "IT'S THE HARDEST WORK"
avid Michaelis, N. C. Wyeth: A Biography
New York: Alfred A. Knopf, 1998), 294.

131 "I WORK WHEN I'M SICK"
alvin Tomkins, "What Else Can Art Do?"
New Yorker, June 22, 2015, http://www.
ewyorker.com/magazine/2015/06/22/
what-else-can-art-do.

132 "INSPIRATION IS FOR"
Fig, Inside the Painter's Studio (New York:
Princeton Architectural Press, 2009), 42.

133 "THE MOST DEMANDING PART"
ne Truitt, Daybook: The Journal of an Artist
ew York: Simon and Schuster, 2013), 184.

133 "PAINTING IS"
Selden Rodman, Conversations
with Artists: 35 American Painters,
Sculptors, and Architects Discuss
heir Work and One Another with Selden
Rodman (New York: Capricorn Books,
1961), 87.

134 "I'VE BEEN WILLING TO PAY"
nterview by Lynn Hershman, Hayward, CA,
ovember 9, 1990, https://lib.stanford.edu/
omen-art-revolution/transcript-interview-
judy-chicago-1990.

135 "I REALLY WORK LIKE"
etter to Anita Pollitzer, October 20, 1958,
in Lovingly, Georgia: The Complete
Correspondence of Georgia O'Keeffe
and Anita Pollitzer, ed. Clive Giboire
New York: Simon and Schuster, 1990), 317.

135 "IT SOUNDS A BIT SQUARE"
Interview by Dominic Eichler, Frieze
(October 2004): 231.

135 "THE MOST IMPORTANT TOOL"
ffrey Weiss, Mark Rothko (New Haven, CT:
Yale University Press, 2000), 341.

136 "I KNOW THERE IS A TERRIFIC"
Talk delivered at the "What Is Abstract
Art?" symposium, Museum of Modern Art,
New York, February 5, 1951, http://www.
dekooning.org/documentation/words/
what-abstract-art-means-to-me.

137 "ONE MUST GO ON"
The Letters of Vincent Van Gogh to His Brother,
1872–1886 (London: Constable, 1927), 53.

DRAWING

138 "MAKE A DRAWING"
Ann Dumas, "Degas and His Collection,"
in The Private Collection of Edgar Degas
vol. 1 (New York: Metropolitan Museum of
Art, 1997), 36.

139 "I'M CONVINCED THAT"
John Gruen, The Artist Observed:
28 Interviews with Contemporary Artists
(Pennington, NJ: a cappella books, 1991), 308.

139 "MY PARENTS WERE"
Adrian Searle, "Louise Bourgeois: A Web of
Emotions," Guardian, June 1, 2010, http://
www.theguardian.com/artanddesign/2010/
jun/01/louise-bourgeois.

139 "WHEN I WAS QUITE YOUNG"
Rodin: The Man and His Art, with Leaves from
His Notebook (New York: Century, 1917), 7.

140 "BELIEVE IT OR NOT"
Interview by Marc Miller (1982), in Benedict
O'Donohoe, ed., Severally Seeking Sartre,
(Newcastle upon Tyne, UK: Cambridge
Scholars Publishing, 2013), 52.

141 "THEY USED TO SELL"
Calder: An Autobiography with Pictures
(New York: Pantheon Books, 1966), 61.

141 "I HAVE WANTED"
Interview by Bice Curiger, Tate Etc., no. 20
(Autumn 2010), http://www.tate.org.uk/
context-comment/articles/process-drawing-
writing-diary-its-nice-way-thinking-about-
time-passing.

141 "THE ONLY DRAWING"
David Sylvester, Interviews with American
Artists (New Haven, CT: Yale University Press,
2001), 195.

141 "MY CONTRIBUTION TO THE WORLD"
March 18, 1982, entry, in Keith Haring
Journals (New York: Viking, 1996), 76.

141 "I'VE BEEN DOODLING"
Interview by Francesc Trabal, July 14, 1928,
in Joan Miró: Selected Writings and
Interviews, ed. Margit Rowell (New York:
Da Capo Press, 1992), 92.

141 "I DID TECHNICAL DRAWING"
William Furlong, Speaking of Art:
Four Decades of Art in Conversation
(London: Phaidon Press, 2010), 226–27.

DRUGS + ALCOHOL

142 "THEY SAY NOBODY"
Interview by Stephen Westfall, Bomb,
no. 37 (Fall 1991), http://bombmagazine.org/
article/1476/nan-goldin.

143 "IT IS A CERTAIN FACT"
Undated letter to Mr. and Mrs. Ginoux,
1890, in The Complete Letters of Vincent
van Gogh vol. 3 (Greenwich, CT: New York
Graphic Society, 1958), 281.

143 "I OFTEN WORK BEST"
Michael Peppiatt, Francis Bacon:
Anatomy of an Enigma (New York: Skyhorse
Publishing, 2009), 196–97.

144 "I ONCE HAD A DRINK"
Randy Kennedy, "A Crusher of Cars, a Molder

of Metal," New York Times, May 8, 2011, http://
www.nytimes.com/2011/05/09/arts/design/
john-chamberlain-the-crushed-car-sculptor.html.

145 "I WAS NEVER"
Oral history interview with Vito Acconci,
June 21–28, 2008, Archives of American Art,
Smithsonian Institution.

145 "I DON'T DRINK OR SMOKE"
Interview by Sean O'Hagan, Guardian,
October 2, 2010, http://www.theguardian.
com/artanddesign/2010/oct/03/interview-
marina-abramovic-performance-artist.

146 "WHEN I CLOSE THE DOOR"
Ben Eastham, "A Necessary Realism: Interview
with Luc Tuymans," Apollo, August 8, 2015,
http://www.apollo-magazine.com/a-necessary-
realism-interview-with-luc-tuymans/.

146 "THE SMELL OF OPIUM"
Recounted in Jean Cocteau, Opium:
The Illustrated Diary of His Cure
(London: Peter Owen, 1990), 64.

146 "ALCOHOL HAS DAMAGED"
Andy McSmith, "Painter Sees Red:
Is David Hockney the Grumpiest Man in
Britain?," Independent, June 4, 2008,
http://www.independent.co.uk/news/
people/profiles/painter-sees-red-is-
david-hockney-the-grumpiest-man-in-
britain-840532.html.

146 "I THINK ACID"
Interview by Tim Teeman, "Yoko Ono,"
Daily Beast, October 13, 2015, http://www.
thedailybeast.com/articles/2015/10/13/
yoko-ono-i-still-fear-lennon-s-killer.html.

146 "I ATTRIBUTE ANY POSSIBLE"
William Michael Rossetti, ed., Dante Gabriel
Rossetti: His Family-Letters,
vol. 1 (London: Ellis and Elvey, 1895), 342.

146 "CERTAINLY I WOULD"
"My Favorite Superstar: Notes on My Epic,
Chelsea Girls," in I'll Be Your Mirror:
The Selected Andy Warhol Interviews,
1962–1987, ed. Kenneth Goldsmith
(New York: Carroll & Graf, 2004), 130.

147 "TAKE ME"
Dali by Dali (New York: Harry N. Abrams,
1970), 97.

EXHIBITION

148 "EXHIBITING MY ART"
Interview by Hans Ulrich Obrist, in Pipilotti
Rist (London: Phaidon Press, 2001), 20.

149 "WHEN YOU KNOW"
Interview by Carol Diehl, Art in America,
December 18, 2013, http://www.
artinamericamagazine.com/news-features/
interviews/like-it-or-lump-it-amy-sillman/.

149 "WHEN YOU'RE OFFERED A SHOW"
Interview by Hans Ulrich Obrist, in Anri Sala
(London: Phaidon Press, 2006), 27.

149 "I'M THE FIRST"
Andrea K. Scott, "A Place at the Table:
Carrie Mae Weems's Cultural Diplomacy
at the Guggenheim," New Yorker, January
27, 2014, http://www.newyorker.com/
magazine/2014/01/27/a-place-at-the-table.

149 "HOW CAN YOU BUILD"
Interview by Barbara Rose, in Rauschenberg
(New York: Vintage Books/Elizabeth Avedon
Editions, 1987), 72.

149 "I'VE SPENT A GREAT DEAL"
Katharine Kuh, The Artist's Voice:
Talks with Seventeen Artists (New York:
Harper & Row, 1962), 198.

150 "I'VE NEVER FELT"
Interview by Liza Bear, WBAI-FM,
New York, March 1967, in Gordon Matta-Clark
(London: Phaidon Press, 2003), 175.

150 "MY PAINTING DOESN'T"
Barbara Rose, ed., Art as Art: The Selected
Writings of Ad Reinhardt (New York:
Viking Press, 1975), 16.

151 "I HAVE ONLY ONE WORRY"
Arne Glimcher, Agnes Martin: Paintings,
Writings, Remembrances (London:
Phaidon Press, 2012), tip-in, n.p.

151 "ART NEEDS TO BE DEFENDED"
Michael Kimmelman, "The Importance of
Matthew Barney," New York Times Magazine,
October 10, 1999, http://www.nytimes.
com/1999/10/10/magazine/the-importance-
of-matthew-barney.html?pagewanted=all.

152 "I WAS...GIVEN"
Munch and Expressionism (New York:
Prestel/Neue Gallery, 2016), 44.

152 "THE EXHIBIT IS OVER"
November 1, 1924, entry, in The Daybooks
of Edward Weston vol. 1, ed. Nancy Newhall
(Rochester, NY: George Eastman House,
1961), 101.

153 "IT'S NICE TO HAVE"
Interview by Dennis Cooper, in Raymond
Pettibon (London: Phaidon Press, 2001), 13.

154 "A RETROSPECTIVE"
John Gruen, The Artist Observed:
28 Interviews with Contemporary Artists
(Pennington, NJ: a cappella books, 1991), 303.

155 "RETROSPECTIVES ARE NOT"
Gaby Wood, "Marlene Dumas: 'Retrospectives
Are Not Very Good for You,'" Telegraph,
February 7, 2015, http://www.telegraph.
co.uk/culture/art/11380195/Marlene-
Dumas-interview-worlds-most-successful-
female-artist.html.

155 "HAVING A RETROSPECTIVE"
Stephanie Terenzio, ed., The Collected
Writings of Robert Motherwell (New York:
Oxford University Press, 1992), 154.

FAILURE

156 "THE ONLY THING"
Lee Ambrozy, ed. and trans., Ai Weiwei's
Blog: Writings, Interviews, and Digital Rants,
2006–2009 (Cambridge, MA: MIT Press,
2011), 86.

157 "I AM DISTRESSED"
Letter to Gustave Geffroy, April 24, 1889,
in Letters of the Great Artists: From Blake to
Pollock, ed. Richard Friedenthal (New York:
Random House, 1963), 129.

158 "USUALLY I DON'T"
"Robert Ryman: Color, Surface, and Seeing,"
ART21, n.d., http://www.art21.org/texts/
robert-ryman/interview-robert-ryman-color-
surface-and-seeing.

158 "I BEGAN WITH NO"
Violet Hamilton, Annals of My Glass House:
Photographs by Julia Margaret Cameron
(Claremont, CA: Ruth Chandler Williamson
Gallery, 1996), 12.

158 "THE FEAR OF FAILURE"
Charles Arsène-Henry, Shumon Basar, and
Karen Marta, eds., Hans Ulrich Obrist Interviews,
vol. 2 (New York: Charta, 2010), 805.

158 "I WIPE OUT"
Barbara Ehrlich White, Renoir: His Life,
Art, and Letters (New York: Harry N. Abrams,
1984), 155.

158 "I THINK THE MOMENT"
Calvin Tomkins, Lives of the Artists
(New York: Henry Holt, 2008), 147.

158 "MISTAKES ARE"
Salvador Dali, Diary of a Genius
(New York: Doubleday, 1965), 27.

158 "I'M REALLY MORE INTERESTED"
Judith Olch Richards, ed., Inside the Studio:
Two Decades of Talks with Artists in New
York (New York: Independent Curators
International, 2004), 240.

159 "YOU HAVE TO LEARN"
Interview by Stefano Basilico, Bomb, no. 75
(Spring 2001), http://bombmagazine.org/
article/2381/andrea-zittel.

FRAME

160 "TAKE A MONDRIAN"
Interview by Paul Soto, Art in America,
October 18, 2011, http://www.
artinamericamagazine.com/news-features/
interviews/uta-barth/.

161 "STIEGLITZ WOULDN'T"
Interview by Leslie Katz (1971),
in Photography in Print: Writings from
1816 to the Present, ed. Vicki Goldberg
(New York: Touchstone, 1981), 363.

161 "WHAT HAPPENS WHEN"
Interview by Rong Jiang, International
Center of Photography, New York,
June 4, 2007, reprinted at http://www.
americansuburbx.com/2012/01/interview-
stephen-shore-the-apparent-is-the-
bridge-to-the-real-2007.html.

162 "I DON'T THINK YOU CAN"
"Fragments of a Conversation,"
William C. Lipke, ed., in The Writings of
Robert Smithson, ed. Nancy Holt (New York:
New York University Press, 1979), 170,
reprinted at http://www.robertsmithson.
com/essays/fragments.htm.

162 "IF IT MAKES A BETTER"
Judith Olch Richards, ed., Inside the Studio:
Two Decades of Talks with Artists in
New York (New York: Independent Curators
International, 2004), 25.

163 "I'VE ALWAYS ADMIRED"
Ibid., 171.

164 "IF YOU START CUTTING"
Henri Cartier-Bresson, The Decisive Moment
(New York: Simon and Schuster; Paris: Éditions
Verve, 1952), introduction, n.p.

164 "IN GENERAL, I AGREE"
Calvin Tomkins, "Look to the Things Around
You," New Yorker, September 16, 1974, 92.

165 "IT'S WHAT'S OUTSIDE THE FRAME"
Hermione Hoby, "Matthew Barney Interview:
'It's What's Outside the Frame That's Scary,'"
Telegraph, July 13, 2013, http://www.telegraph.
co.uk/culture/art/art-features/10153609/
Matthew-Barney-interview-Its-whats-outside-
the-frame-thats-scary.html.

IDENTITY

166 "WHO IS THIS MONET"
Juliet Wilson-Bareau, Manet by Himself:
Correspondence and Conversation,
Paintings, Pastels, Prints, and Drawings
(New York: Barnes & Noble Books, 2004).

167 "I RAN INTO THE GUY"
"Birdtalk," artist's website, April 21, 201
http://www.richardprince.com/birdtalk

167 "MAYBE I'M JUST SIMPLE"
Selden Rodman, Conversations with Artis
35 American Painters, Sculptors, and
Architects Discuss Their Work and One
Another with Selden Rodman
(New York: Capricorn Books, 1961), 99

168 "I NEVER THOUGHT OF MYSELF"
Lara Prendergast, "Better than Robert?
Sonia Delaunay at Tate Modern Reviewed
Spectator, April 18, 2015, http://www
spectator.co.uk/2015/04/better-than-rob
sonia-delaunay-at-tate-modern-reviewed

168 "YOU MAY BE A WOMAN"
Interview by Carlo McCormick, Bomb, n
33 (Fall 1990), http://bombmagazine.org
article/1353/dorothea-tanning.

168 "AT HEART"
Interview by Kenneth R. Fletcher, Smithsor
Magazine (August 2008), http://www.
smithsonianmag.com/arts-culture/laurie
anderson-779875/.

168 "I DISCOVERED MYSELF"
Interview by Guillaume Apollinaire (1907
in Matisse on Art, ed. Jack Flam (Berkeley
University of California Press, 1995), 28

168 "I DON'T WANT PEOPLE"
Daniel Zalewski, "The Hours," New Yorke
March 12, 2012, http://www.newyorke
com/magazine/2012/03/12/the-hours
daniel-zalewski.

168 "I STILL THINK OF MYSELF"
Elisabeth Lebovici, "No Idolatry and Losin
Everything That Made You a Slave," Mousse
no. 31, http://moussemagazine.it/articol
mm?id=763.

168 "I MUST BE MANY THINGS"
Interview by Sheila Heti, Believer (June 201
reprinted at http://archive.sheilaheti.com
othermedia/Calle_TB90.pdf.

169 "I CONSIDER MYSELF"
Interview by Grady T. Turner, Bomb, no. 6
(Winter 1999), http://bombmagazine.org
article/2192/.

170 "I THINK I'M A MUTANT"
Charles Arsène-Henry, Shumon Basar, and
Karen Marta, eds., Hans Ulrich Obrist Intervie
vol. 2 (New York: Charta, 2010), 920.

171 "THE TWO LUCKIEST"
Winthrop Sargeant, "Dali," Life,
September 24, 1945, 64.

171 "THE 'ONE' THAT I AM"
Interview by Phyllis Rosenzweig, in Yourself
the World: Selected Writings and Interview
ed. Scott Rothkopf (New Haven, CT: Yale
University Press; New York: Whitney Museu
of American Art, 2011), 76.

INFLUENCE

172 "I WANTED TO BE"
Stuart Jeffries, "Jenny Holzer: Drawn to the

Dark Side," <u>Guardian</u>, June 4, 2012, http://www.theguardian.com/artanddesign/2012/jun/04/jenny-holzer-interview.

173 "THE FIRST GROWN-UP"
Oral history interview with Eleanor Antin, May 8–9, 2009, Archives of American Art, Smithsonian Institution.

173 "I WAS A BIRD WATCHER"
Interview by Gwyneth Paltrow, <u>Interview</u>, October 5, 2011, http://www.interviewmagazine.com/art/ellsworth-kelly/#page3.

173 "I WAS INFLUENCED BY SEEING"
Harry Holtzman and Martin S. James, eds., <u>The New Art—The New Life: The Collected Writings of Piet Mondrian</u> (Boston: G. K. Hall, 1986), 15.

173 "CURRENTLY I AM PAINTING"
Felix Klee, ed., <u>The Diaries of Paul Klee, 1898–1918</u> (Berkeley: University of California Press, 1964), 89.

174 "EGON SCHIELE"
Interview by Nicholas Forrest, <u>Blouin Artinfo</u>, May 21, 2015, http://uk.blouinartinfo.com/news/story/1163145/interview-tracey-emin-on-where-i-want-to-go-in-vienna.

175 "THE MOST IMPORTANT EXPERIENCE"
Interview by Juan Vicente Aliaga, in <u>Luc Tuymans</u> 2nd ed. (London: Phaidon Press, 2003), 12.

176 "I LEARNED EVERYTHING"
Rebecca Bengal, "A Conversation with Nan Goldin on the 30th Anniversary of <u>The Ballad of Sexual Dependency</u>," <u>Vogue</u>, October 26, 2015, http://www.vogue.com/13364942/nan-goldin-interview-ballad-of-sexual-dependency-30th-anniversary/.

176 "I SAW THREE"
Charles Arsène-Henry, Shumon Basar, and Karen Marta, eds., <u>Hans Ulrich Obrist Interviews</u>, vol. 2 (New York: Charta, 2010), 798.

177 "WHEN I FIRST STARTED"
John Gruen, <u>The Artist Observed: 28 Interviews with Contemporary Artists</u> (Pennington, NJ: a cappella books, 1991), 8.

177 "PUNK DEFINITELY"
Interview by Paul Laster, reprinted at http://www.elcalamo.com/zhanghuan.html.

177 "I FEEL LESS KINSHIP"
Interview by Lisa Yuskavage, <u>Bomb</u>, no. 52 (Summer 1995), http://bombmagazine.org/article/1868/chuck-close.

177 "I GET TATTOOS"
Michael Kimmelman, "Making Metaphors of Art and Bodies," <u>New York Times</u>, November 15, 1996, http://www.nytimes.com/1996/11/15/arts/making-metaphors-of-art-and-bodies.html.

177 "WHEN I FIRST LOOKED"
Robert Frank, "A Statement . . . ," in <u>US Camera Annual</u> (New York: US Camera Publishing, 1958), 115.

178 "I HAVE HAD THREE MASTERS"
Masters in Art: A Series of Illustrated Monographs (Boston: Bates & Guild, 1906), 31.

179 "OF COURSE, IN HISTORY"
Rachel Small, "Drawing with Pawel Althamer," <u>Interview</u>, February 13, 2014, http://www.interviewmagazine.com/art/pawel-althamer-new-museum/.

INSPIRATION

180 "INSPIRATION IS"
Arne Glimcher, <u>Agnes Martin: Paintings, Writings, Remembrances</u> (London: Phaidon Press, 2012), tip-in, n.p.

181 "I USE THE GALLERY"
Michael Kimmelman, <u>Portraits: Talking with Artists at the Met, the Modern, the Louvre and Elsewhere</u> (New York: Random House, 1998), 97.

181 "I LIKE TO PUT THINGS"
Hilton Als, "Arbus Speaks," <u>New Yorker</u>, September 26, 2011, http://www.newyorker.com/books/page-turner/arbus-speaks.

181 "I REMEMBER FIRST SEEING"
Interview by Robert Gober, in <u>Vija Celmins</u> (London: Phaidon Press, 2004), 16–19.

181 "I LOVE CAVE PAINTING"
Andrew Russeth, "'I Work Purely Out of Desire': Karla Black Conjures Ethereal Beauty at David Zwirner," <u>ARTnews</u>, March 23, 2016, http://www.artnews.com/2016/03/23/i-work-purely-out-of-desire-karla-black-conjures-ethereal-beauty-at-david-zwirner/.

181 "THE PLATE THAT A PEASANT"
Interview by Yvon Taillandier, "I Work Like a Gardener," February 15, 1959, in <u>Joan Miró: Selected Writings and Interviews</u>, ed. Margit Rowell (New York: Da Capo Press, 1992), 247.

181 "AS A KID"
Interview by Evan Moffitt, "Body Talk," <u>Frieze</u>, no. 178 (April 2016): 102.

182 "WRITINGS ON PAINTINGS"
Michael Bracewell, <u>Nigel Cooke</u> (London: Koenig Books, 2010), 10.

183 "I HAVE LOVED"
Oral history interview with Walker Evans, October 13–December 23, 1971, Archives of American Art, Smithsonian Institution.

184 "I HAVE THIS JUVENILE"
Interview by Therese Lichtenstein, <u>Journal of Contemporary Art</u> (1992), http://www.jca-online.com/sherman.html.

184 "OFTEN, WHEN I GO"
Interview by Bice Curiger, <u>Tate Etc.</u>, no. 20 (Autumn 2010), http://www.tate.org.uk/context-comment/articles/process-drawing-writing-diary-its-nice-way-thinking-about-time-passing.

185 "I MUST SEE NEW THINGS"
Reinhard Steiner, <u>Egon Schiele, 1890–1918: The Midnight Soul of the Artist</u> (Cologne: Taschen, 2000), 37.

186 "I AM FASCINATED"
Interview by William Oliver, <u>Dazed Digital</u> (2011), http://www.dazeddigital.com/artsandculture/article/7347/1/doug-aitken-on-art.

186 "THE FLOWERS RAISE"
Undated entry, 1857, in <u>Letters of the Great Artists: From Blake to Pollock</u>, ed. Richard Friedenthal (New York: Random House, 1963), 81.

187 "I LOVE READING"
Interview by Krista Tippett, <u>On Being</u>, November 19, 2015, http://www.onbeing.org/program/ann-hamilton-making-and-the-spaces-we-share/transcript/8149.

INTENTION

188 "I'M ONLY TRYING"
Michael Kimmelman, <u>Portraits: Talking with Artists at the Met, the Modern, the Louvre and Elsewhere</u> (New York: Random House, 1998), 109.

189 "I WANT TO MAKE WORK"
Interview by Roselee Goldberg (2000), reprinted at http://www.zhanghuan.com/ShowText.asp?id=7&sClassID=3.

190 "I MAKE ART BECAUSE"
Interview by Douglas Dreishpoon, <u>Art in America</u> (October 2009), http://www.artinamericamagazine.com/news-features/magazine/janine-antoni/.

190 "AT THE BOTTOM"
Germano Celant, "Claes Oldenburg and the Feelings of Things," in <u>Claes Oldenburg: An Anthology</u> (New York: Guggenheim Museum Publications, 1995), 21.

190 "I WANT TO MAKE PAINTINGS"
Anthony Haden-Guest, "Burning Out," <u>Vanity Fair</u> (November 1988), http://www.vanityfair.com/news/1988/11/jean-michel-basquiat.

190 "I WANT TO SHOW"
Moira Weigel, "Chantal Akerman: Remembering a Pioneering Feminist Filmmaker," <u>New York Times</u>, October 6, 2015, http://nytlive.nytimes.com/womenintheworld/2015/10/06/chantal-akerman-remembering-a-pioneering-feminist-filmmaker/.

190 "WHAT I WANT TO SAY"
Anthony Bannon, <u>Steve McCurry</u> (London: Phaidon Press, 2005), introduction, n.p.

190 "I SEE MYSELF"
Interview by Anney Bonney, <u>Bomb</u>, no. 39 (Spring 1992), http://bombmagazine.org/article/1527/hedda-sterne.

190 "MY WISH"
<u>IR: Can Art Change the World?</u> (London: Phaidon Press, 2015), 38.

191 "I MAKE DRAWINGS"
Marie-Laure Bernadac and Hans-Ulrich Obrist, eds., <u>Louise Bourgeois: Destruction of the Father/Reconstruction of the Father; Writings and Interviews, 1923–1997</u> (London: Violette Editions, 1998), 363.

191 "I DON'T PAINT"
Ilka Skobie, "Lone Wolf: An Interview with Jim Dine," <u>Artnet</u>, n.d., http://www.artnet.com/magazines/features/scobie/jim-dine6-28-10.asp.

192 "IT IS NOT MY INTENTION"
Jacques Meuris, <u>Magritte</u> (Cologne: Taschen, 1994), 64.

193 "THERE ARE TWO THINGS"
Lewis Hine, <u>Men at Work: Photographic Studies of Modern Men and Machines</u> (Mineola, NY: Dover Publications, 1977), introduction, n.p.

193 "I WANT TO MAKE"
Interview by Enrique Juncosa, Centro Galego de Arte Contemporánea, Santiago de Compostela, Spain, 2002, http://www.antonygormley.com/resources/interview-item/id/137.

194 "CAN I DO SOMETHING"
Interview by Rebecca Gross, <u>NEA Arts Magazine</u>, no. 4 (2011), https://www.arts.gov/NEARTS/2011v4-what-innovation/maya-lin.

194 "THE SEARCH FOR TRUTH"
Exhibition catalog (New York: Anderson
Galleries, 1921), quoted in Graham Clarke,
Alfred Stieglitz (London: Phaidon Press, 2006),
introduction, n.p.

194 "I WANTED TO EXPERIENCE"
Memories of Myself: Essays by Danny Lyon
(London: Phaidon Press, 2009), preface, n.p.

195 "MY AIM IN LIFE"
Recounted in Max Kozloff, ed., Saul Leiter:
Early Black and White (Göttingen,
Germany: Steidl, 2015), foreword, n.p.

LIGHT

196 "LIGHT IS"
Alexander Liberman, The Artist in His Studio
(New York: Random House, 1988), 143.

197 "I WILL NOT PUT ON"
David Sylvester, Interviews with
American Artists (New Haven, CT: Yale
University Press, 2001), 250.

197 "I SHARE WITH MANY"
Brooks Johnson, ed., Photography Speaks:
150 Photographers on Their Art
(New York: Aperture, 2004), 248.

198 "ONE MIGHT NOT"
Michael Gibson, "The Strange Case of
the Fluorescent Tube," Art International,
no. 1 (Autumn 1987): 105.

199 "I LIKE TO WORK"
Dore Ashton, ed., Picasso on Art: A Selection
of Views (New York: Da Capo Press, 1988), 98.

199 "I LOVE CHRISTMAS TREE BULBS"
Ben Davis, "'I'm Happier and Happier':
A Tortuous Q&A with David Lynch on the
Inspiration for His New Paintings," Blouin
Artinfo, March 27, 2012, http://www.
blouinartinfo.com/news/story/763771/
im-happier-and-happier-a-tortuous-qa-
with-david-lynch-on-the.

199 "I TREAT SOUND AND LIGHT"
Calvin Tomkins, Lives of the Artists
(New York: Henry Holt, 2008), 100.

199 "THE SUBJECT EXISTS INSIDE"
Interview by Georgia Marsh, Bomb, no. 13
(Fall 1985), http://bombmagazine.org/
article/690/david-salle.

200 "A BROAD LIGHT"
Jean Paul Richter, ed., The Literary
Works of Leonardo da Vinci, vol. 1
(London: Sampson, Low, Marston, Searle &
Rivington, 1883), 257.

200 "DAYLIGHT IS TOO EASY"
Jean Sutherland Boggs, Degas
(New York: Metropolitan Museum
of Art; Ottawa: National Gallery of
Canada, 1988), 535.

201 "I HAVE SEIZED THE LIGHT"
John Thomson, ed., A History and Handbook
of Photography (London: Sampson, Low,
Marston, Low, & Searle, 1876), 24.

LIMITATION

202 "'LIMITS' IS A RELATIVE TERM"
Alanna Martinez, "Experimental
Performance Artist and Sculptor Chris Burden
Dead at 69," Observer, May 12, 2015, http://
observer.com/2015/05/experimental-
performance-artist-and-sculptor-chris-
burden-dead-at-69/.

203 "THE RULES ARE ALWAYS"
Rebecca Fortnum, Contemporary
British Women Artists: In Their Own Words
(London: I. B. Tauris, 2007), 19.

203 "LIMITATIONS ARE REALLY GOOD"
Martin Gayford, A Bigger Message:
Conversations with David Hockney
(New York: Thames & Hudson, 2011), 100.

203 "ONE OF THE THINGS"
Interview by Milton Esterow, ARTnews
(Summer 1984), reprinted at http://www.
maryellenmark.com/text/magazines/art%20
news/905N-000-001.html.

203 "I WAS INTRIGUED"
Charles Arsène-Henry, Shumon Basar,
and Karen Marta, eds., Hans Ulrich
Obrist Interviews, vol. 2 (New York:
Charta, 2010), 468.

203 "I WORK WITH COLORED PENCIL"
Interview by Brett Littman, Drawing Center,
New York, January 15, 2016, http://
thebottomline.drawingcenter.org/2016/01/15/
interview-with-louise-despont/.

MATERIALS

204 "TIRES HAVE GIVEN"
Interview by Corrado Levi and Filippo Fossati,
September 1996, http://www.essogallery.
com/Carol%20Rama/InterviewCR.html.

205 "I WORK PURELY"
Andrew Russeth, "'I Work Purely
Out of Desire': Karla Black Conjures Ethereal
Beauty at David Zwirner," ARTnews,
March 23, 2016, http://www.artnews.
com/2016/03/23/i-work-purely-out-of-
desire-karla-black-conjures-ethereal-beauty-
at-david-zwirner/.

205 "PASTEL IS A NUTTY"
Michael Kimmelman, Portraits:
Talking with Artists at the Met, the Modern,
the Louvre and Elsewhere (New York:
Random House, 1998), 76.

205 "I WANTED TO DEAL"
Rory Carroll, "James Turrell: 'More People Have
Heard of Me Through Drake Than Anything
Else,'" Guardian, November 11, 2015,
http://www.theguardian.comartanddesign/
2015/nov/11/james-turrell-more-people-
have-heard-of-me-through-drake-than-
anything-else.

205 "TRADITIONALLY, ARTISTS"
Interview by Urs Steiner and Samuel Herzog,
"The Idea Is What Matters!" Neue Zürcher
Zeitung, November 20, 2004, trans. Isabel
Cole, reprinted at http://montrealserai.
com/_archives/2005_Volume_18/18_1/
Article_4.htm.

205 "I OFTEN WORK WITH"
Interview by Molly Nesbit, in Hans Haacke
(London: Phaidon Press, 2004), 12.

205 "I'M USING TONS OF STEEL"
Calvin Tomkins, Lives of the Artists
(New York: Henry Holt, 2008), 94.

206 "I'VE ALWAYS HAD A THING"
Interview by Hans Ulrich Obrist, London,
2007, http://www.damienhirst.com/
texts/20071/feb--huo.

206 "THE MATERIAL THAT I AM"
Interview by Cindy Nemser, in
Mignon Nixon, ed., Eva Hesse,
(Cambridge, MA: MIT Press, 2002), 19.

207 "SOME MATERIALS HAVE"
Interview by Danielle Mysliwiec,
Brooklyn Rail, April 2, 2014, http://www
brooklynrail.org/2014/04/art/sheila-hicks-
with-danielle-mysliwiec.

207 "SPACE IS A MATERIAL"
Interview by Donna De Salvo, in
David Anfam, Anish Kapoor (London:
Phaidon Press, 2009), 404.

207 "I FEEL THE CLAY"
Tracy Zwick, "Dancing with Clay:
An Interview with Lynda Benglis,"
Art in America, January 30, 2014, http://
wwwartinamericamagazine.com/news-
features/interviews/dancing-with-clay-an-
interview-with-lynda-benglis/.

208 "STONE TO SOME EXTENT"
Tim Adams,"Natural Talent," Guardian,
March 10, 2007, http://www.theguardian.com
artanddesign/2007/mar/11/art.features3.

208 "TAPE, CARDBOARD, PAPER"
Interview by Paul Schmelzer, Centerpoints,
Walker Art Center Blog, November
6, 2006, http://blogs.walkerart.org/
centerpoints/2006/11/06/audio-blog-
thomas-hirschhorn/.

208 "I WANTED TO WORK"
Interview by Leigh Silver, Complex, October
1, 2014, http://www.complex.com/
style/2014/10/interview-mickalene-thomas

208 "I USE THE MATERIAL"
Interview by Karin Schneider, Bomb, no. 112
(Summer 2010), http://bombmagazine.org/
article/3521/joan-jonas.

208 "THE BOUNDARIES OF PAINTING"
Perri Lewis, "Cecily Brown: I Take Things
Too Far When Painting," Guardian, Septembe
20, 2009, http://www.theguardian.com/
artanddesign/2009/sep/20/guide-to-
painting-cecily-brown.

209 "EVERYTHING I DO"
Katharine Kuh, The Artist's Voice:
Talks with Seventeen Artists (New York:
Harper & Row, 1962), 175.

209 "TO WORK WITH THREADS"
Anni Albers, "Material as Metaphor," talk
delivered at the panel "The Art/Craft
Connection: Grass Roots or Glass Houses,"
College Art Association meeting, February
25, 1982, http://www.albersfoundation.org/
artists/selected-writings/anni-albers/#tab4.

209 "I LIKE CLOTHING"
Yu Yang, "Interweaving Past and Present:
Yin Xiuzhen's Urban Tales of Cement
and Clothes," NY Arts, http://www.
nyartsmagazine.com/?p=11430.

209 "TRUTH IS"
Interview by Richard Meryman," Life,
May 14, 1965, 108.

209 "ONE THING GETS BORN"
Suzanne Slesin, "Two New Stores Set a Style,"
New York Times, April 21, 1988, http://www
nytimes.com/1988/04/21/garden/two-
new-stores-set-a-style.html.

210 "I GLUED MALE SEXUAL PATTERNS"
Interview by Grady T. Turner, Bomb,
no. 66 (Winter 1999), http://bombmagazine.
org/article/2192/.

210 "I'M STILL MANAGING TO WORK"
Letter to Camille Pissarro, October 23, 1866, in

he Letters of Paul Cézanne, ed. and trans. Alex Danchev (Los Angeles: Getty Publications, 2013), 128.

10 "I LIKE TO USE LOCAL MATERIALS"
Joyce Lau, "Xu Bing: An Artist Who ridges East and West," New York Times, May 19, 2011, http://www.nytimes. n/2011/05/20/arts/20iht-Xu20.html.

210 "I DON'T MAKE"
Fred Sandback (Munich: Kunstraum, 1975), 11–12, reprinted at http:// edsandbackarchive.org/atxt_1975.html.

210 "EVERYTHING CAN BE USED"
Diane Waldman, Joseph Cornell New York: George Braziller, 1977), 31.

210 "ART CAN BE EXPRESSED"
Herbert Read, The Art of Jean Arp New York: Harry N. Abrams, 1968), 122.

210 "GIVE ME A PIECE OF CHARCOAL"
Enriqueta Harris, Goya (London: Phaidon Press, 1994), 24.

11 "THERE'S NOTHING SACROSANCT"
erview by Bruce Glaser, ed. Lucy Lippard, ARTnews (September 1966), reprinted at http://web.mit.edu/allanmc/www/ stellaandjudd.pdf.

MONEY

212 "BECOMING AN ARTIST"
Akademie X: Lessons in Art + Life (London: Phaidon Press, 2015), 57.

213 "I DON'T MIND SAYING"
"A Conversation: Takashi Murakami and amien Hirst," in Damien Hirst: Requiem I ondon: Other Criteria/PinchukArtCentre, 2009), http://www.damienhirst.com/ texts/2009/feb--takashi-murakami.

214 "I AM LITERALLY PENNILESS"
Undated letter to the publisher Georges Charpentier, 1878, in Letters of the Great Artists: From Blake to Pollock, ed. Richard Friedenthal (New York: Random House, 1963), 128.

214 "WHEN I WAS BROKE"
erview by Carol Becker, in Theaster Gates (London: Phaidon Press, 2015), 17.

214 "I WENT TO SEE MONET"
Undated letter to Théodore Duret, 1875, n Letters of the Great Artists: From Blake to Pollock, ed. Richard Friedenthal (New York: Random House, 1963), 121.

214 "I LIVE MONTH TO MONTH"
erview by Lynn Hershman, Hayward, CA, vember 9, 1990, https://lib.stanford.edu/ men-art-revolution/transcript-interview- judy-chicago-1990.

214 "I REMEMBER WHEN I HAD"
nterview by Leah Sandals, Canadian Art, ebruary 18, 2014, http://canadianart.ca/ eatures/interview-with-kehinde-wiley/.

214 "I NEVER HAD A PENNY"
From the painting Untitled (Joke - I never had a penny to my name, so I changed my name…) (1987).

215 "PAINTING AND SCULPTURE"
ter to Luigi del Riccio, October/November, 542, in The Letters of Michelangelo, vol. 2, d. E. H. Ramsden (Stanford, CA: Stanford University Press, 1963), 26.

216 "LIFE IS MUCH MORE FUN"
Barbara Ehrlich White, Renoir: His Life, Art, and Letters (New York: Harry N. Abrams, 1984), 175.

216 "MONEY IS A FRAGILE THING"
Letter to his son Lucien, April 26, 1900, in Letters of the Great Artists: From Blake to Pollock, ed. Richard Friedenthal (New York: Random House, 1963), 149.

216 "I DON'T SEE ANYTHING WRONG"
Interview by Laura Barnett, "Portrait of the Artist: Thomas Demand," Guardian, April 25, 2011, http://www.theguardian.com/ artanddesign/2011/apr/25/thomas-demand- artist-photographer.

216 "USUALLY THE PEOPLE"
July 7, 1986, entry, in Keith Haring Journals (New York: Viking, 1996), 100.

216: "I'M SHOCKED"
Interview by Barbaralee Diamonstein, in Visions and Images: American Photographers on Photography (New York: Rizzoli, 1981), 182, reprinted at http://www.jnevins.com/ garywinograndreading.htm.

217 "I THINK BEING REASONABLY"
Oral history interview with Imogen Cunningham, June 9, 1975, Archives of American Art, Smithsonian Institution.

218 "ART IS MY CAPITAL"
Undated letter, June 1889, in Kuno Mittelstädt, Paul Gauguin: Self-Portraits (Oxford: Bruno Cassirer, 1968), 27.

219 "I DON'T MAKE SCULPTURES"
Interview by Sheila Heti, Believer (June 2012), reprinted at http://archive.sheilaheti.com/ othermedia/Calle_TB90.pdf.

219 "IT'S A LOT OF PRESSURE"
Interview by Karen Rosenberg, Artspace, October 28, 2015, http://www.artspace. com/magazine/interviews_features/ qa/frank-stella-on-his-2015-whitney- retrospective-53230.

220 "I HAVE HAD"
Dorothy Norman, Alfred Stieglitz: An American Seer (New York: Random House, 1973), 206.

220 "MONEY IS NOT"
Interview by Damien Hirst (extract), in Yayoi Kusama (London: Phaidon Press, 2000), 137.

221 "YOUR PICTURES WOULD"
Letter to Jean-Baptiste Faure, March 14, 1877, in Jean Sutherland Boggs, Degas (New York: Metropolitan Museum of Art; Ottawa: National Gallery of Canada, 1988), 222.

NATURE

222 "I'M IN LOVE"
Barbara Ehrlich White, Renoir: His Life, Art, and Letters (New York: Harry N. Abrams, 1984), 108.

223 "AUTUMN IS QUITE"
Thomas Girst, The Duchamp Dictionary (London: Thames & Hudson, 2014), 70.

223 "THERE IS ALWAYS SOMETHING"
Felix Klee, ed., The Diaries of Paul Klee, 1898–1918 (Berkeley: University of California Press, 1968), 378.

223 "I HAVE NO OTHER WISH"
Alexander Liberman, The Artist in His Studio (New York: Random House, 1988), 20.

224 "THE BLUE LIGHT"
Letter to Julian Edwin Levi, June 26, 1929, in More Than Words: Illustrated Letters from the Smithsonian's Archives of American Art, ed. Liza Kirwin (New York: Princeton Architectural Press, 2005), 120.

224 "THE LOUVRE IS"
John Rewald, ed., Paul Cézanne: Letters (London: Bruno Cassirer, 1941), 236.

225 "THE DIFFICULTY OF SKIES"
Letter to the Rev. John Fisher, October 23, 1821, in Memoirs of the Life of John Constable, 3rd ed., ed. C. R. Leslie (London: Phaidon Press, 1995), 73.

225 "THE SKY IS EVERYTHING"
Randy Kennedy, "Robert Irwin's Big Visions, Barely Seen," New York Times, January 1, 2016, http://www.nytimes. com/2016/01/03/arts/design/robert- irwins-big-visions-barely-seen.html.

ORIGINALITY

226 "EVERYONE REPEATS"
Rachel Cooke, "Rachel Whiteread: 'I Couldn't Say No. It Felt Right to Do This One,'" Guardian, July 7, 2012, http://www.theguardian.com/uk/ 2012/jul/07/rachel-whiteread- whitechapel-art-interview.

227 "PLAGIARISM, OF WHICH"
Isamu Noguchi: A Sculptor's World (Göttingen, Germany: Steidl, 2004), 27.

227 "I THINK IT'S COPYING"
Interview by David Salle, Interview, October 9, 2013, http://www. interviewmagazine.com/art/john-baldessari/.

227 "I COULD NOT BELIEVE"
John Gruen, The Artist Observed: 28 Interviews with Contemporary Artists (Pennington, NJ: a cappella books, 1991), 157.

227 "THE NEW IS VERY OLD"
June 8, 1850, entry, in The Journal of Eugène Delacroix, 3rd. ed., ed. Hubert Wellington (London: Phaidon Press, 1995), 127.

227 "IT'S WONDERFUL WHEN"
David Sylvester, Interviews with American Artists (New Haven, CT: Yale University Press, 2001), 283.

227 "IT IS ALL VERY WELL"
Elisabeth Bronfen, "Facing Defacement: Degas's Portraits of Women," in Degas Portraits, eds. Felix Baumann and Marianne Karabelnik (London: Merrell, 1994), 227.

228 "THE FACT IS"
Interview by Bill Powers, ARTnews, March 30, 2015, http://www.artnews. com/2015/03/30/bill-powers-talks- with-john-currin/.

229 "MY WORK IS ACTUALLY"
G. R. Swenson, "What Is Pop Art? Interviews with Eight Painters," ARTnews 62, no. 7 (November 1963): 25–27.

229 "I HAVEN'T MADE ONE"
Barbara Rose, ed., Art as Art: The Selected Writings of Ad Reinhardt (New York: Viking Press, 1975), 19.

230 "I'D RATHER HAVE NO STYLE"
Richard D. Marshall, Ed Ruscha (London: Phaidon Press, 2003), 60.

230 "I HAVEN'T BEEN WORRIED"
Interview by Shirley Kaneda, Bomb,
no. 113 (Fall 2010), http://bombmagazine.
org/article/3655/charline-von-heyl.

231 "YOU THINK YOU'RE DOING"
Calvin Tomkins, Marcel Duchamp:
The Afternoon Interviews (Brooklyn:
Badlands Unlimited, 2013), 49.

PHILOSOPHY

232 "I DON'T HAVE A PHILOSOPHY"
Interview by Dean Brierly, Photographers
Speak, April 22, 2009, http://
photographyinterviews.blogspot.
com/2009/04/saul-leiter-quiet-iconoclast-
saul.html.

233 "I USE THE EXPRESSION"
Rebecca Fortnum, Contemporary British
Women Artists: In Their Own Words
(London: I. B. Tauris, 2007), 101.

233 "I BELIEVE IN TEMPORARY"
Interview by Tiffany Bell,
July 13, 1982, in Dan Flavin:
A Retrospective (New York:
Dia Art Foundation, 2004), 199,
reprinted at http://www.fluxstudio.net/
Light-Space_Art/wp-content/
uploads/2012/09/Dan-Flavin-
interviewed-by-Tiffany-Bell.pdf.

233 "I DON'T BELIEVE IN FUNERALS"
Interview by Rosanna Greenstreet,
Guardian, December 20, 2014, http://www.
theguardian.com/lifeandstyle/2014/dec/20/
yoko-ono-interview.

233 "I DON'T BELIEVE IN HEROES"
Interview by Göksu Kunak,
Berlinartlink, November 19, 2013, http://
www.berlinartlink.com/2013/11/19/
interview-hito-steyerl-zero-probability-and-
the-age-of-mass-art-production/.

233 "WOMAN'S NAKEDNESS"
Ida Gianelli, Max Ernst: Sculptures
(Milan: Charta, 1996), 37.

233 "I BELIEVE THAT IT'S VERY"
Interview by Hans Ulrich Obrist, in Anri Sala
(London: Phaidon Press, 2006), 9–10.

233 "I FEEL THAT IF ONE"
Calder: An Autobiography with Pictures
(New York: Pantheon Books, 1966), 124.

234 "I BELIEVE THAT YOU"
Interview by Nicholas Serota (2011), in
Gerhard Richter: Panorama; A Retrospective
(London: Tate Publishing, 2011), 24.

234 "MY CLOUD PHOTOGRAPHS"
Dorothy Norman, Alfred Stieglitz:
An American Seer (New York: Random House,
1973), 144.

235 "IN A BURNING BUILDING"
James Lord, Giacometti: A Biography
(New York: Macmillan, 1997), 299.

PHOTOGRAPHY

236 "WHO PAYS ATTENTION"
Oral history interview with Dorothea Lange,
May 22, 1964, Archives of American Art,
Smithsonian Institution.

237 "NO ONE WILL EVER KNOW"
Roy Meredith, Mr. Lincoln's Camera Man,
2nd ed. (Mineola, NY: Dover Publications,
1974), vii.

237 "FROM THE TIME"
Kristine McKenna, "Double Vision:
Doug and Mike Starn Look to the
Old Masters for the Images that Make
Their Massive Photo Collages Click,"
Los Angeles Times, October 21, 1990,
http://articles.latimes.com/1990-10-21/
entertainment/ca-4390_1_art-world.

237 "IT IS IMPORTANT TO SEE"
"Robert Frank: Statement (1958),"
in Photography in Print: Writings from
1816 to the Present, ed. Vicki Goldberg
(New York: Touchstone, 1981), 401.

237 "NO PHOTOGRAPH"
Arthur Leipzig, Next Stop New York
(Munich: Prestel, 2009), 9.

237 "THERE IS AN OLD"
Interview by Rong Jiang, International
Center of Photography, New York,
June 4, 2007, reprinted at http://www.
americansuburbx.com/2012/01/interview-
stephen-shore-the-apparent-is-the-bridge-to-
the-real-2007.html.

237 "MY FAVORITE PICTURE?"
Berenice Abbott, "My Favorite Picture,"
Popular Photography 6, no. 2 (February
1940): 19.

238 "NOTHING IS MORE HATEFUL"
August Sander: Photographs of an Epoch,
1904–1959 (New York: Aperture, 1980), 27.

238 "I AM NOT INTERESTED"
"A Statement (1970)," in Bill Brandt:
Selected Texts and Bibliography, ed. Nigel
Warburton (New York: G. K. Hall, 1993), 32.

239 "PART OF WHAT EXCITES ME"
James Estrin, "Alex Webb: Rendering a
Complex World, in Color and Black-and-
White," Lens, New York Times, January
8, 2013, http://lens.blogs.nytimes.
com/2013/01/08/alex-webb-rendering-a-
complex-world-in-color-and-black-and-white/.

239 "I DON'T TAKE PICTURES;"
Charles Harbutt, Travelog (Cambridge, MA:
MIT Press, 1974), epilogue, n.p.

240 "THE TERM 'PHOTOGRAPHY'"
William Henry Fox Talbot, The Pencil of
Nature (London: Longman, Brown, Green and
Longmans, 1844), 1.

240 "I'M HAPPY TO HAVE FOUND"
Interview by Gillian Wearing, in Paul Graham
(London: Phaidon Press, 1996), 23.

241 "YOU LEARN THINGS"
Akiko Miki, Yoshiko Isshiki, and Tomoko
Sato, eds., Nobuyoshi Araki: Self, Life, Death
(London: Phaidon Press, 2005), 19.

242 "I'D LIKE TO KNOW WHO"
Quoted in the New York Times, March 6, 1923,
in Photography in Print: Writings from
1816 to the Present, ed. Vicki Goldberg
(New York: Touchstone, 1981), 294.

242 "STREET PHOTOGRAPHY"
Judith Olch Richards, ed., Inside the Studio:
Two Decades of Talks with Artists in
New York (New York: Independent Curators
International, 2004), 23.

242 "I DIDN'T START TAKING PICTURES"
Interview by Marc Erwin Babej, American
Photo, March 13, 2014, http://www.
americanphotomag.com/interview-gregory-
crewdson-mystery-everyday-life.

242 "THE MAJORITY OF MY WORK"
Sean O'Hagan, "Taryn Simon: The Woman
the Picture," Guardian, May 21, 2011, http:
www.theguardian.com/artanddesign/20
may/22/taryn-simon-tate-modern-interv

242 "IF YOU ARE A SHY KID"
Interview by Sam Shahid, n.d., http://ww
bruceweber.com/FILE/1541.pdf.

242 "PAINTING IS AN ADDITIVE"
Interview by George Stolz, May 2012,
http://utabarth.net/wp-content/
uploads/2014/05/2012-george-stoltz
interview-2012-galeria-elvira-gonzale
website.pdf.

243 "YOU HAVE TO HOLD"
Ysabel de la Rosa, "Dinner with Arnold:
Conversation with Arnold Newman in Mad
Apogee Photo, n.d., http://www.apogeeph
com/mag5-6/dinner_with_arnold.shtm

ROUTINE

244 "IT IS IMPORTANT TO ME"
The Museum of Modern Art Artists' Cookb
(New York: Museum of Modern Art, 1977)

245 "I THINK MY SYSTEM"
October 18, 1852, entry, in The Journa
of Eugène Delacroix, 3rd. ed., ed. Huber
Wellington (London: Phaidon Press, 1995),

246 "I SLEEP WITH"
Interview by Jordan Crandall, Splash no.
(1986), in I'll Be Your Mirror: The Select
Andy Warhol Interviews, 1962–1987,
ed. Kenneth Goldsmith (New York:
Carroll & Graf, 2004), 355.

247 "I'VE GOT THE OLD EIGHTH STREET
"Unframed Space," New Yorker, August
5, 1950, http://www.newyorker.com/
magazine/1950/08/05/unframed-spac

247 "MY LIFE HAS BEEN"
Interview by Douglas Maxwell, Modern
Painters (Summer 1993): 239.

248 "I GO SWIMMING"
Interview by Andrea Blanch, Musée Magazi
online, June 10, 2014.

248 "I LIKE GETTING UP"
William Furlong, Speaking of Art: Four
Decades of Art in Conversation (London
Phaidon Press, 2010), 69.

249 "I GET UP, I MOVE AROUND"
Interview by Milton Esterow, ARTnews
(Summer 1984), reprinted at http://www
maryellenmark.com/text/magazines/art%
news/905N-000-001.html.

249 "BEING LIFTED OUT"
Interview by Stefano Basilico, Bomb, no. 7
(Spring 2001), http://bombmagazine.org
article/2381/andrea-zittel.

249 "IN THE END"
Michael Kimmelman, "Wake Up.
Wash Face. Do Routine. Now Paint," New Y
Times, May 8, 2005, http://www.nytime
com/2005/05/08/arts/design/wake-up
wash-face-do-routine-now-paint.html.

249 "IT IS IMPOSSIBLE"
Interview by Laurie Anderson, Bomb, no. 8
(Summer 2003), http://bombmagazine.or
article/2561/marina-abramovi.

249 "I WORK ONE DAY ON"
Randy Kennedy, "A Crusher of Cars, a Mold

of Metal," <u>New York Times</u>, May 8, 2011,
http://www.nytimes.com/2011/05/09/
rts/design/john-chamberlain-the-crushed-
car-sculptor.html.

SCALE

250 "THERE IS A RIGHT"
"The Sculpture Speaks," August 18, 1937,
n <u>Letters of the Great Artists: From Blake to
ollock</u>, ed. Richard Friedenthal (New York:
Random House, 1963), 252.

251 "WHEN I HAVEN'T DONE"
terview by Anna Tilroe (1987), in <u>Gerhard
chter: Text; Writings, Interviews and Letters,
1961–2007</u>, eds. Dietmar Elger and Hans
Ulrich Obrist (London: Thames & Hudson,
2009), 192, reprinted at https://www.
chard-richter.com/en/quotes/techniques-5.

251 "I LIKE SQUARISH"
terview by Harold Rosenberg, <u>ARTnews</u>,
o. 71 (September 1972): 54–59, in Harry F.
augh, <u>Willem de Kooning: Modern Masters</u>
(New York: Abbeville Press, 1983), 74, .

252 "I THINK YOU CAN HAVE"
indy Nemser, <u>Art Talk: Conversations with 12
omen Artists</u> (New York: Scribner, 1975), 105.

252 "ART HAS BEEN SUBJECT"
Charles Arsène-Henry, Shumon Basar, and
aren Marta, eds., <u>Hans Ulrich Obrist Interviews</u>,
vol. 2 (New York: Charta, 2010), 155–56.

253 "I PAINT VERY LARGE"
cob Baal-Teshuva, <u>Rothko</u> (Cologne: Taschen,
2003), 46.

254 "I SHRINK THE BUILDINGS"
Interview by Hou Hanru, in <u>Yin Xiuzhen</u>
(London: Phaidon Press, 2015), 33.

255 "I TEND TO BE EXCITED"
Stephanie Terenzio, ed., <u>The Collected
Writings of Robert Motherwell</u> (New York:
Oxford University Press, 1992), 136.

255 "THE ONLY CHANCE"
ulian Bell, <u>Bonnard</u> (London: Phaidon Press,
1994), 19.

255 "I DON'T LIKE TO MAKE"
David Sylvester, <u>Interviews with American
rtists</u> (New Haven, CT: Yale University Press,
2001), 158.

255 "I THINK I COULD CONTROL"
Cindy Nemser, <u>Art Talk: Conversations
with 12 Women Artists</u> (New York:
Scribner, 1975), 215.

255 "THE TRUE SIZE"
Interview by Diedrich Diederichsen, in
a Genzken (London: Phaidon Press, 2006), 29.

SCULPTURE

256 "I KNOW HOW TO CARVE"
Cindy Nemser, <u>Art Talk: Conversations
with 12 Women Artists</u> (New York:
Scribner, 1975), 25.

257 "I LOVE MY SCULPTURES"
Interview by Nicholas Serota, Rome (2007),
http://www.cytwombly.info/twombly_
writings5.htm.

257 "THE FIRST HOLE"
"The Sculpture Speaks," August 18, 1937,
in <u>Letters of the Great Artists: From Blake to
Pollock</u>, ed. Richard Friedenthal (New York:
Random House, 1963), 251.

257 "I THOUGHT THAT OUTDOOR"
Peter Plagens, <u>Bruce Nauman: The True Artist</u>
(London: Phaidon Press, 2014), 70.

257 "UP TO A CERTAIN TIME"
Interview by David Bourdon (1966), quoted
in Calvin Tomkins, "The Materialist,"
<u>New Yorker</u>, December 5, 2011, http://www.
newyorker.com/magazine/2011/12/05/
the-materialist.

257 "SOME SCULPTURES GIVE OFF"
Amanda Renshaw, ed., <u>Anthony Caro</u>,
(London: Phaidon Press, 2014), 78.

258 "ONE OF MY FAVORITE"
Interview by Donald Wall, "Gordon Matta
Clark's Building Dissections," in
<u>Arts Magazine</u> (May 1976): 74–79, reprinted
in <u>Gordon Matta-Clark</u>, ed. Corinne Diserens
(London: Phaidon Press, 2003), 182.

258 "SCULPTURES ARE PAINTINGS"
Nadja Sayej, "Frank Stella: 'If You Get Into Art
to Make Money, You're Deluded,'"
<u>Guardian</u>, September 1, 2015, http://www.
theguardian.com/artanddesign/2015/
sep/01/frank-stella-art-money-whitney-
retrospective.

259 "SCULPTURE IS LIKE"
Daniell Cornell, ed., <u>The Sculpture of Ruth
Asawa: Contours in the Air</u> (Berkeley:
University of California Press, 2006), 10.

259 "SCULPTURE SHOULD WALK"
Marcel Jean, ed., <u>Arp on Arp: Poems, Essays,
Memories</u> (New York: Viking, 1972), 327.

260 "I WAS IN ANALYSIS"
Interview by Charlie Rose, <u>Charlie Rose</u>,
PBS, December 14, 2001.

261 "GRAVITATION IS"
Selden Rodman, <u>Conversations with
Artists: 35 American Painters, Sculptors,
and Architects Discuss Their Work and One
Another with Selden Rodman</u> (New York:
Capricorn Books, 1961), 129.

SEX

262 "WHOM ONE GETS INTO BED"
<u>Paul Gauguin's Intimate Journals</u>, trans.
Van Wyck Brooks (Bloomington: Indiana
University Press, 1958), 18.

263 "SEX?"
Interview by Kirsty Young, <u>Desert Island Discs</u>,
BBC Radio 4, May 17, 2013.

263 "THE MOST EXCITING THING"
<u>The Philosophy of Andy Warhol
(From A to B and Back Again)</u>
(New York: Harvest, 1977), 41.

263 "CLUBBING AND SEX"
Interview by Peter Halley, in <u>Wolfgang Tillmans</u>,
2nd ed. (London: Phaidon Press, 2014) 13.

263 "IF I SEE SEX"
Anthony Haden-Guest, "Burning Out," <u>Vanity
Fair</u> (November 1988), http://www.vanityfair.
com/news/1988/11/jean-michel-basquiat.

263 "I THINK THE PICTURES"
Brooks Johnson, ed., <u>Photography Speaks:
150 Photographers on Their Art</u>
(New York: Aperture, 2004), 250.

263 "I WAS OBSESSED"
Interview by Linda Yablonsky, <u>Bomb</u>,
no. 57 (Fall 1996), http://bombmagazine.org/
article/1985/laurie-simmons.

263 "MY BEST WORKS ARE EROTIC"
Gaby Wood, "Retrospectives Are Not Very
Good for You," <u>Telegraph</u>, February 7, 2015,
http://www.telegraph.co.uk/culture/
art/11380195/Marlene-Dumas-interview-
worlds-most-successful-female-artist.html/.

263 "I HAVE THE TASTE"
Sarah M. Lowe, ed., <u>The Diary of Frida Kahlo:
An Intimate Self-Portrait</u> (New York:
Harry N. Abrams, 1995), 216.

264 "I WASN'T TRYING TO BE"
Interview by Evan Moffitt, "Body Talk,"
<u>Frieze</u>, no. 178 (April 2016): 105.

265 "THE EROTIC OR THE SEXUAL"
Germano Celant, "Claes Oldenburg and
the Feeling of Things," in <u>Claes Oldenburg:
An Anthology</u> (New York: Guggenheim
Museum Publications, 1995), 13.

STUDIO

266 "I AM MOST ANXIOUS"
Letter to the Rev. John Fisher, October 23,
1821, in <u>Memoirs of the Life of John Constable</u>,
ed. C. R. Leslie (London: Phaidon Press,
1995), 72.

267 I TURNED MY COAL-HOUSE"
Violet Hamilton, <u>Annals of My Glass House:
Photographs by Julia Margaret Cameron</u>
(Claremont, CA: Ruth Chandler Williamson
Gallery, 1996), 12.

267 "I HAD RENTED"
Judy Chicago, <u>Beyond the Flower:
The Autobiography of a Feminist Artist</u>
(New York: Viking, 1996), 24.

268 "I WASN'T AN ARTIST"
Oral history interview with Vito Acconci,
June 21–28, 2008, Archives of American Art,
Smithsonian Institution.

268 "I AM ON THE ELEVENTH FLOOR"
"Hiroshi Sugimoto: Tradition," <u>ART21</u>, n.d.,
http://www.art21.org/texts/hiroshi-sugimoto/
interview-hiroshi-sugimoto-tradition.

268 "WE HAD THIS BIG OLD HOUSE"
Rachel Cooke, "Jenny Saville: 'I Want to Be
a Painter of Modern Life, and Modern Bodies,'"
<u>Guardian</u>, June 9, 2012, https://www.
theguardian.com/artanddesign/2012/
jun/09/jenny-saville-painter-modern-bodies.

268 "WHEN WORKS LEAVE"
Interview by Carlos Basualdo, in <u>Doris Salcedo</u>
(London: Phaidon Press, 2000), 27.

269 "THERE WAS NOTHING"
Tony Godfrey, <u>Conceptual Art</u> (London:
Phaidon Press, 1998), 127–28.

269 "I RAN INTO JACOB LAWRENCE"
Oral history interview with Romare Bearden,
June 29, 1968, Archives of American Art,
Smithsonian Institution.

270 "THE CAR IS MY STUDIO"
Charles Arsène-Henry, Shumon Basar, and
Karen Marta, eds., <u>Hans Ulrich Obrist Interviews</u>,
vol. 2 (New York: Charta, 2010), 531.

270 "MY CAR BECAME MY HOME"
<u>Weegee by Weegee: An Autobiography</u>
(New York: Ziff-Davis Publishing, 1961), 52.

271 "SOMEBODY OUGHT TO INVENT"
Stephanie Terenzio, ed., <u>The Collected
Writings of Robert Motherwell</u> (New York:
Oxford University Press, 1992), 151.

272 "I LOOK OUT"
Interview by Carlo McCormick, <u>Bomb</u>,
no. 33 (Fall 1990), http://bombmagazine.org/
article/1353/dorothea-tanning.

272 "A STUDIO IS A TOOLBOX"
Charles Arsène-Henry, Shumon Basar, and
Karen Marta, eds., <u>Hans Ulrich Obrist Interviews</u>,
vol. 2 (New York: Charta, 2010), 848.

272 "YOU MUST CLEAN"
Arne Glimcher, <u>Agnes Martin: Paintings,</u>
<u>Writings, Remembrances</u> (London:
Phaidon Press, 2012), tip-in, n.p.

272 "TO ESCAPE THE CLASSIC SOLITUDE"
John Gruen, <u>The Artist Observed: 28</u>
<u>Interviews with Contemporary Artists</u>
(Pennington, NJ: a cappella books, 1991), 305.

272 "WHENEVER I'M IN COLOGNE"
Interview by Diedrich Diederichsen, in <u>Isa</u>
<u>Genzken</u> (London: Phaidon Press, 2006), 22.

272 "I CAN'T ALLOW MYSELF"
Interview by Tim Marlow, <u>Cambridge</u>
<u>Alumni Magazine</u> (Lent Term, 1997),
reprinted at http://www.anthonycaro.org/
Interview-moS.htm.

273 "MY STUDIO IS IN MY HEAD"
Phoebe Hoban, "The Shock of the Familiar,"
<u>New York</u>, July 28, 2003, http://nymag.com/
nymetro/arts/features/n_9014/.

SUBJECT

274 "I HATE FLOWERS"
Laurie Lisle, <u>Portrait of an Artist:</u>
<u>A Biography of Georgia O'Keeffe</u> (New York:
Washington Square Press, 1997), 177.

275 "NUDIST CAMPS"
Marvin Israel and Doon Arbus, eds.,
<u>Diane Arbus</u> (New York: Aperture, 1972), 4.

275 "IT IS EASIER FOR ME"
Sally Mann, <u>Hold Still: A Memoir with</u>
<u>Photographs</u> (New York: Little, Brown,
2015), xii.

275 "PHOTOGRAPHERS ARE TOO POLITE"
Interview by David Seidner, <u>Bomb</u>, no. 20
(Summer 1987), http://bombmagazine.org/
article/923/duane-michals.

275 "I PHOTOGRAPH ALL"
Emily Gosling, "'Most of the Photographs
I Take are Bad': Martin Parr Brings the
Good Stuff to a Stunning New Retrospective,"
<u>It's Nice That</u>, February 5, 2016,
http://www.itsnicethat.com/articles/
martin-parr-rhubarb-triangle-hepworth-
wakefield-050216.

275 "I LEAN TOWARD"
Interview by <u>Yale Alumni Magazine</u>
(1974), in <u>Image Magazine</u> 17,
no. 4 (December 1974), reprinted at
http://www.americansuburbx.
com/2011/10/interview-walker-evans-
with-students.html.

275 "IT OCCURS TO ME"
Interview by Pierre Courthion, in
<u>Chatting with Henri Matisse: The Lost</u>
<u>1941 Interview</u>, ed. Serge Guilbaut,
trans. Chris Miller (Los Angeles: Getty
Publications, 2013), 137.

275 "I REALLY MUST"
April 15, 1823, entry, in <u>The Journal of Eugène</u>
<u>Delacroix</u>, 3rd. ed., ed. Hubert Wellington
(London: Phaidon Press, 1995), 11.

276 "I LIKE TO SEE"
Sarah Trigg, <u>Studio Life: Rituals,</u>
<u>Collections, Tools, and Observations on</u>
<u>the Artistic Process</u> (New York: Princeton
Architectural Press, 2013), 78.

277 "EDWARD WESTON MIGHT BE"
Interview by George Stolz, May 2012,
http://utabarth.net/wp-content/
uploads/2014/07/2012-george-stoltz-
interview-2012-galeria-elvira-gonzalez-
website.pdf.

277 "YESTERDAY I MADE"
Edward Weston, "Daybooks,
1923–1930," in <u>Photography in Print:</u>
<u>Writings from 1816 to the</u>
<u>Present</u>, ed. Vicki Goldberg (New York:
Touchstone, 1981), 309.

278 "THE IMPORTANT PART FOR ME"
Judith Olch Richards, ed., <u>Inside the</u>
<u>Studio: Two Decades of Talks with Artists</u>
<u>in New York</u> (New York: Independent
Curators International, 2004), 23.

278 "WHEN YOU TAKE"
Sabine Mirlesse, "The Vulnerables:
Interview with Rineke Dijkstra,"
<u>Art in America</u>, July 13, 2012,
http://www.artinamericamagazine.com/
news-features/interviews/rineke-
dijkstra-guggenheim-sfmoma/.

279 "IT'S EXTREMELY DIFFICULT"
Calvin Tomkins, "Meaning Machines:
The Sculptures of Charles Ray,"
<u>New Yorker</u>, May 11, 2015, http://www.
newyorker.com/magazine/2015/05/11/
meaning-machines.

279 "NOW THE EASIEST KIND OF A JOB"
Transcript of recording courtesy
of the International Museum of Photography
at George Eastman House, <u>Bomb</u>, no. 20
(Summer 1987), http://bombmagazine.org/
article/941/weegee.

280 "IN MAKING A PORTRAIT"
Interview by Aaron Schuman,
<u>SeeSaw</u> (August 2004), reprinted
at http://www.aaronschuman.com/
sothinterview.html.

280 "ALL THE YOUNG"
Oral history interview with Dorothea Lange,
May 22, 1964, Archives of American Art,
Smithsonian Institution.

280 "I NEVER MADE A PERSON"
August Sander (London: Gordon Fraser
Gallery, 1977).

281 "FLESH WAS THE REASON"
Barbara Hess, <u>Willem de Kooning,</u>
<u>1904–1997</u> (Cologne: Taschen, 2004), 8.

SUCCESS

282 "BELIEVING IN ONE'S OWN ART"
Brooks Johnson, ed., <u>Photography</u>
<u>Speaks: 150 Photographers on Their Art</u>
(New York: Aperture, 2004), 284.

283 "I DON'T TALK ABOUT"
Oral history interview with Imogen
Cunningham, June 9, 1975, Archives of
American Art, Smithsonian Institution.

284 "I CANNOT HELP IT"
Letter to his brother Theo, October 20, 1888,
in <u>The Complete Letters of Vincent van Gogh</u>,
vol. 3 (Greenwich, CT: New York Graphic
Society, 1958), 92.

284 "IT IS THE DUTY"
Letter, November 24, 1887, in Kuno
Mittelstädt, <u>Paul Gauguin: Self-Portraits</u>,
(Oxford: Bruno Cassirer, 1968), 27.

284 "WHEN I WAS DESCRIBED"
Rachel Cooke, "The Daring Art of Marlene
Dumas: Duct-Tape, Pot Bellies and Bin Laden,"
<u>Guardian</u>, January 10, 2015, http://www.
theguardian.com/artanddesign/2015/
jan/11/the-daring-art-of-marlene-dumas-
duct-tape-pot-bellies-and-bin-laden.

284 "THEY ALL TALK ABOUT"
Interview by Saul Ostrow, <u>Bomb</u>, no. 71
(Spring 2000), http://bombmagazine.org/
article/2296/frank-stella.

284 "I THINK IT'S NOT"
Interview by Sam Shahid, n.d., http://www.
bruceweber.com/FILE/1541.pdf.

285 "THAT'S ME"
Calvin Tomkins, "Ed Ruscha's L.A.,"
<u>New Yorker</u>, July 1, 2013,
http://www.newyorker.com/
magazine/2013/07/01/ed-ruschas-l-a.

285 "SUCCESS IS DANGEROUS"
Alexander Liberman, "Picasso," <u>Vogue</u>,
November 1, 1956, 134.

286 "WHAT I'VE FOUND"
Jane Harris, "Psychedelic, Baby: An Interview
with Pipilotti Rist," <u>Art Journal</u> 59, no. 4
(Winter 2000), reprinted at http://www.
johnstuartarchitecture.com/Spring_2009_
Video_Readings_files/Harris%20
Interview%20Pipilotti%20Rist.pdf.

286 "MOST ARTISTS STRUGGLE"
Sarah Thornton, <u>33 Artists in 3 Acts</u>
(New York: W. W. Norton, 2014), 114.

287 "SUCCESS PUTS YOU"
"A Conversation: Richard Prince and Damien
Hirst," in <u>Damien Hirst: Requiem II</u> (London:
Other Criteria/PinchukArtCentre, 2009),
reprinted at http://www.damienhirst.com/
texts/2009/jan--richard-prince.

TECHNOLOGY

288 "I DRAW FLOWERS"
Martin Gayford, "David Hockney's iPad
Art," <u>Telegraph</u>, October 20, 2010,
http://www.telegraph.co.uk/culture/art/art
features/8066839/David-Hockneys-
iPad-art.html.

289 "IN THE 21ST CENTURY"
Oral history interview with Kehinde Wiley,
September 29, 2010, Archives of American
Art, Smithsonian Institution.

289 "JUST BECAUSE TECHNOLOGY"
Interview by Rob Pruitt, <u>Interview</u>, April 2,
2013, http://www.interviewmagazine.com/
culture/john-giorno/.

289 "WE DON'T HAVE THIS"
Karen Rosenberg, "Artist Pia Camil on
Infiltrating Instagram With Her Subversive
Takes on Shopping and Other 'Capitalist
Strategies,'" <u>Artspace</u>, January 23, 2016,
http://www.artspace.com/magazine/
interviews_features/qa/pia-camil-new-
museum-interview-53434.

289 "I USE AN ELECTRIC"
Interview by Milton Esterow, <u>ARTnews</u>
(Summer 1984), reprinted at http://www.
maryellenmark.com/text/magazines/art%20
news/905N-000-001.html.

289 "I JUST DON'T UNDERSTAND"
Rebecca Fortnum, <u>Contemporary British</u>
<u>Women Artists: In Their Own Words</u>
(London: I. B. Tauris, 2007), 98.

289 "I'VE USED FLASH BUT"
ral history interview with Dorothea Lange,
May 22, 1964, Archives of American Art,
Smithsonian Institution.

290 "NEXT TIME I SEE"
Interview by Daniel Rourke, <u>Rhizome</u>,
March 28, 2013, http://rhizome.org/
editorial/2013/mar/28/artifacts/.

291 "I DON'T DO DIGITAL"
Jemima Sissons, "20 Odd Questions
for Elliott Erwitt," <u>Wall Street Journal</u>,
January 9, 2014, http://www.wsj.com/
icles/SB1000142405270230393310457930424220075718.

TITLE

292 "YES, THE TITLE DOES"
Tracy Zwick, "Dancing with Clay,"
<u>Art in America</u>, January 30, 2014, http://
www.artinamericamagazine.com/news-
eatures/interviews/dancing-with-clay-an-
interview-with-lynda-benglis.

293 "I DON'T TITLE ANYTHING"
Charles Arsène-Henry, Shumon Basar,
and Karen Marta, eds., <u>Hans Ulrich</u>
<u>Obrist Interviews</u>, vol. 2 (New York:
Charta, 2010), 84.

294 "MY TITLES ARE SORT OF"
David Sylvester, <u>Interviews with</u>
<u>American Artists</u> (New Haven, CT:
Yale University Press, 2001), 19.

294 "WHEN I'M FINISHED"
Interview by Danielle Mysliwiec,
<u>Brooklyn Rail</u>, April 2, 2014, http://www.
rooklynrail.org/2014/04/art/sheila-hicks-
with-danielle-mysliwiec.

295 "I DON'T LIKE SENTIMENTAL"
David Batchelor, ed., <u>Colour:</u>
<u>Documents of Contemporary Art</u>
(London: Whitechapel Press; Cambridge,
MA: MIT Press, 2008), 131.

295 "PART OF THE IMPETUS"
William Furlong, <u>Speaking of Art:</u>
<u>Four Decades of Art in Conversation</u>
(London: Phaidon Press, 2010), 169.

295 "FOR ME THE TITLE"
David Sylvester, <u>Interviews with America</u>
rtists (New Haven, CT: Yale University Press,
2001), 148.

295 "I'M ALWAYS TRYING TO FIND"
Interview by Shirley Kaneda, <u>Bomb</u>, no. 113
(Fall 2010), http://bombmagazine.org/
article/3655/charline-von-heyl.

295 "I HAVE THOUGHT A LOT"
Letter to Pierre Matisse, October 12, 1934,
in <u>Joan Miró: Selected Writings and</u>
<u>Interviews</u>, ed. Margit Rowell (New York:
Da Capo Press, 1992), 124.

295 "I HAVE OFTEN TAKEN"
Interview by David Batchelor, <u>Frieze</u>,
no. 10 (May 1993), http://www.frieze.com/
article/paintings-and-pictures.

296 "THE TITLES OF MY SHOWS"
Interview by Juan Vicente Aliaga,
in <u>Luc Tuymans</u>, 2nd ed. (London: Phaidon
Press, 2003), 31.

297 "THE TITLE SHOULD BE"
Charles Arsène-Henry, Shumon Basar,
and Karen Marta, eds., <u>Hans Ulrich</u>
<u>Obrist Interviews</u>, vol. 2 (New York:
Charta, 2010), 821.

TOOLS

298 "THERE'S A LOT TO BE SAID"
William Cook, "Richard Long
Interview: 'I Was Always an Artist,
Even When I Was Two Years Old,'" <u>Spectator</u>,
August 8, 2015, http://www.spectator.
co.uk/2015/08/richard-long-interview-
i-was-always-an-artist-even-when-i-was-
two-years-old/.

299 "YOU SENT ME A BRASS RULE"
Letter, September 3, 1547, in
<u>The Letters of Michelangelo</u>, vol. 2 (Stanford,
CA: Stanford University Press, 1963), 79.

299 "INDIA INK AND SPEEDBALL PENS"
Richard D. Marshall, <u>Ed Ruscha</u>
(London: Phaidon Press, 2003), 61.

300 "I STARTED USING STENCILS"
Interview by Phyllis Rosenzweig,
in <u>Yourself in the World: Selected</u>
<u>Writings and Interviews</u>, ed. Scott Rothkopf
(New Haven, CT: Yale University Press;
New York: Whitney Museum of
American Art, 2011), 73.

300 "I DON'T BEGIN BY DRAWING"
John Gruen, <u>The Artist Observed:</u>
<u>28 Interviews with Contemporary Artists</u>
(Pennington, NJ: a cappella books, 1991), 7.

300 "I GREW UP WITH TOOLS"
"Meet the Artist: Jim Dine,"
Tate video, January 29, 2009, http://
www.tate.org.uk/context-comment/
video/meet-artist-jim-dine.

300 "USE SHORT, SMALL"
April 1, 1824, entry, in <u>The Journal of Eugène</u>
<u>Delacroix</u>, 3rd. ed., ed. Hubert Wellington
(London: Phaidon Press, 1995), 28.

300 "THE CAMERA IS SOMETHING"
Marvin Israel and Doon Arbus,
eds., <u>Diane Arbus</u> (New York:
Aperture, 1972), 11.

301 "HUMOR AND LAUGHTER"
Katharine Kuh, <u>The Artist's Voice:</u>
<u>Talks with Seventeen Artists</u>
(New York: Harper & Row, 1962), 90.

WEATHER

302 "WEATHER COMPLETELY CLEAR"
Felix Klee, ed., <u>The Diaries of Paul Klee,</u>
<u>1898–1918</u> (Berkeley: University of
California Press, 1968), 288.

303 "IT IS THIS RAINY WEATHER"
<u>The Letters of Vincent Van Gogh</u>
<u>to His Brother, 1872–1886</u>, vol. 2 (London:
Constable and Co., 1927), 295.

303 "A GOOD DAY IS ONE"
Philip Gefter, "Paul Graham and Seizing
the Everyday Moments," <u>New York Times</u>,
February 18, 2016, http://www.nytimes.
com/2016/02/21/arts/design/paul-graham-
and-seizing-the-everyday-moments.html.

304 "SOMETIMES A WORK"
<u>Rain, Sun, Snow, Hail, Mist, Calm:</u>
<u>Photoworks by Andy Goldsworthy</u>
(Leeds, UK: Henry Moore Centre for the
Study of Sculpture, 1985), 4–5.

305 "FOR TWO DAYS"
Undated letter to his mother, July 1887,
in <u>The Letters of Henri de Toulouse-Lautrec</u>,
ed. Herbert D. Schimmel (Oxford: Oxford
University Press, 1991), 115.

305 "ZERO WEATHER"
Nancy Newhall, ed., <u>The Daybooks</u>
<u>of Edward Weston</u>, vol. 1 (Rochester, NY:
George Eastman House, 1961), 3.

305 "NEVER HAVE I BEEN"
Letter to Gustave Geffroy,
April 24, 1889, in <u>Letters of the Great Artists:</u>
<u>From Blake to Pollock</u>, ed. Richard
Friedenthal (New York: Random House,
1963), 129.

305 "IT WAS THE SMOGGY"
Interview by Hou Hanru, in <u>Yin Xiuzhen</u>
(London: Phaidon Press, 2015), 51.

306 "AS USUAL, I HAVE BEEN"
Letter to his wife, Maria Cole, December 3,
1841, in <u>The Life and Works of Thomas Cole</u>,
3rd. ed., ed. Rev. Louis L. Noble (New York:
Sheldon, Blakeman, 1856), 312.

306 "I WORK OUTSIDE"
Lanie Goodman, "20 Odd Questions
for Julian Schnabel," <u>Wall Street Journal</u>,
November 7, 2013, http://www.wsj.com/
articles/SB10001424052702303936904579177484123001974.

307 "THE WEATHER, RAINY"
John Rewald, ed., <u>Paul Cézanne: Letters</u>
(New York: Da Capo Press, 1995), 248.

LAST PAGE

336 "WHEN I SEE"
Kimberly Chou, "An Abstract Master
Puts on a Plant Show," <u>Wall Street Journal</u>,
May 25, 2012, http://www.wsj.com/
articles/SB10001424052702304840904577422631184571536.

Phaidon Press Limited
Regent's Wharf
All Saints Street
London N1 9PA

Phaidon Press Inc.
65 Bleecker Street
New York, NY 10012

phaidon.com

First published 2016
© 2016 Phaidon Press Limited

ISBN 978 0 7148 7243 8

A CIP catalog record for this book is available from the
British Library and the Library of Congress.

Researcher and Project Editor: Sara Bader
Production Controller: Leonie Kellman
Design: Julia Hasting
Typesetting: Elana Schlenker

Title quotation by Gerhard Richter: documenta 7,
vol. 1 (Kassel, Germany: D + V Paul Dierichs, 1982),
443, exhibition catalog.

Printed in China

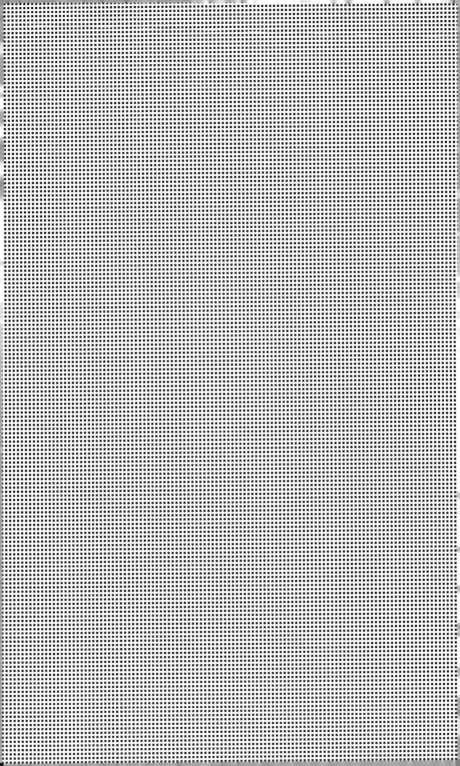

WHEN I SEE A
WHITE PIECE OF
PAPER, I FEEL
I'VE GOT TO DRAW.
AND DRAWING
FOR ME IS THE
BEGINNING
OF EVERYTHING.

ELLSWORTH KELLY